THE ART OF
Landscape Photography

MARK BAUER & ROSS HODDINOTT

AMMONITE
PRESS

First published 2014 by
Ammonite Press
An imprint of AE Publications Ltd
166 High Street, Lewes,
East Sussex, BN7 1XU, UK

ISBN 978-1-78145-052-9

Publisher Jonathan Bailey
Production Manager Jim Bulley
Managing Editor Richard Wiles
Senior Project Editor Dominique Page
Editor Chris Gatcum
Managing Art Editor Gilda Pacitti
Designer Simon Goggin
Cover Designer Robin Shields

Set in Frutiger
Colour origination by GMC Reprographics
Printed in China

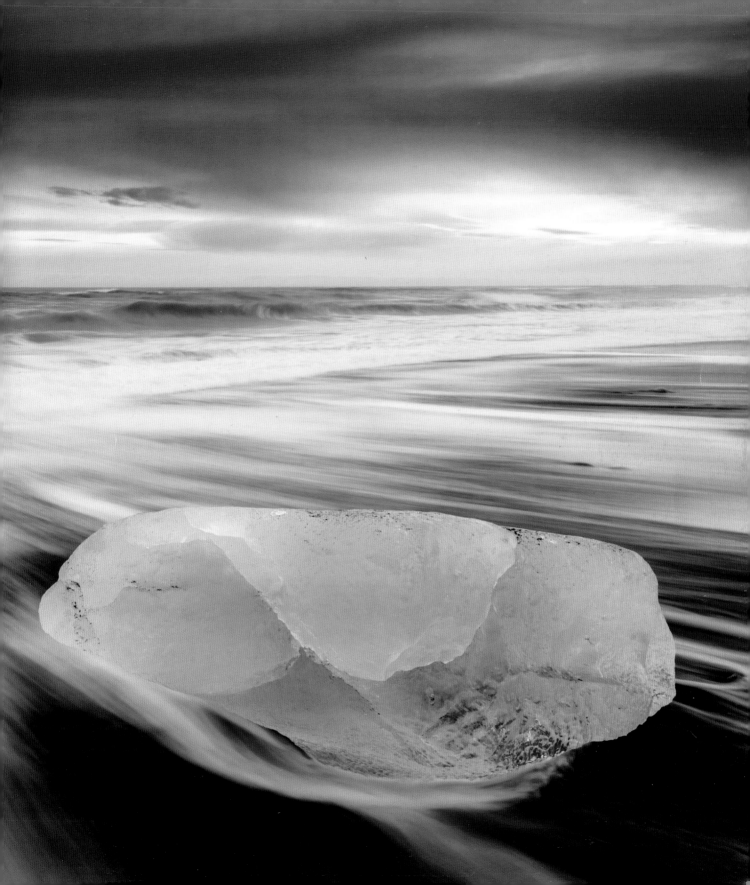

CONTENTS

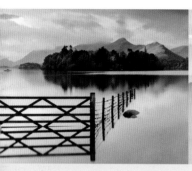
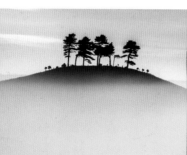
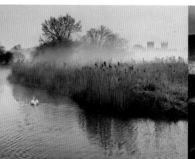
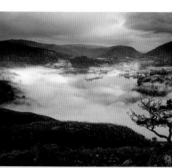

INTRODUCTION

ART/aːt/ (Noun)

The expression or application of human creative skill and imagination, typically in a visual form such as painting or sculpture, producing works to be appreciated primarily for their beauty or emotional power.

Since its inception, there has been debate about whether or not photography qualifies as art. It is a debate that continues to this day. Those who reject its status as art do so on the basis that it is representational and relies on technology. However, if we accept the above dictionary definition, it clearly meets many of the criteria: it is a visual medium through which people express their creativity; there is skill involved in the process of its creation; viewers appreciate its beauty, and done well, it is capable of evoking powerful emotional responses.

Skill is involved on two levels: in controlling the equipment necessary to make photographs and in creating powerful compositions. In our first book on landscape photography, *The Landscape Photography Workshop*, we took an overview of the topic, covering everything from choosing equipment, the specific techniques you need to master in order to create a technically sound landscape photograph, and the basics of composition, through to producing a digital print. In this book we assume a basic familiarity with the technical elements and focus much more deeply on aesthetics – on the art of landscape photography. This is not to say that we are ignoring equipment and technique, but it is discussed mostly with regard to how it impacts upon composition.

Of course, teaching and learning the technical aspects of photography is relatively straightforward compared to teaching and learning the creative side. Creativity is intensely personal, and because it depends on what the individual wishes to express, arguably it cannot be taught. That said, art has been practised and analysed for centuries, so there are many widely accepted theories on which elements work in a composition, which don't, and what innately appeals to the human sense of 'beauty.' In this book we will examine the theory and practice of these principles, using our own images to illustrate the points.

However, simply following established compositional guidelines isn't enough to guarantee good results. Done without consideration it can produce images that are predictable, sterile and (ironically) lacking in creativity. Once you have understood the theories of composition you should be able to use them as a framework for your own creative expression, so that composition ultimately becomes an unconscious, instinctive, but considered process.

To be truly creative, an artist needs to establish a recognisable personal style. This can be a long and challenging process, and while no one else can do it for you, we have tried to give some pointers to help you on your way. Establishing a personal style is not the end of the journey, however, as your photography and style should evolve and change over time.

We hope that this book will provide the inspiration for you to begin your creative journey.

Mark Bauer and Ross Hoddinott

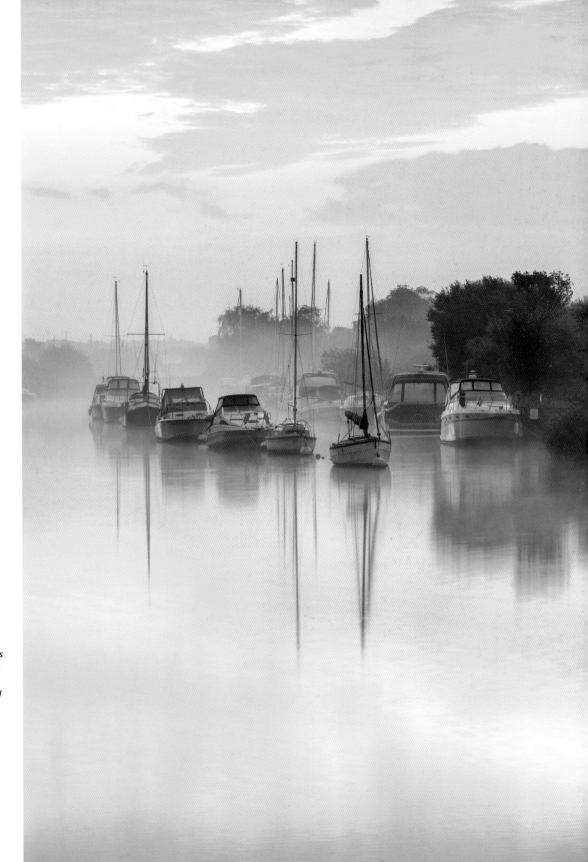

MISTY RIVER
An understanding of balance, harmony and what appeals to people's aesthetic sense will help you to create images that evoke an emotional response in the viewer.

▶ CHAPTER ONE > EQUIPMENT

While the art of composition might be a creative one, a photographer still requires the appropriate 'hardware' to capture an image that truly encapsulates their skill and vision. Your choice of camera, the type of lens you use and the focal length will greatly influence the look and feel of the final photograph. A good tripod is essential for supporting your set-up and you also need to invest in the right type of tripod head – one that will allow you to make precise adjustments to fine-tune your composition. Even in the digital age, a handful of in-camera filters remain essential for both corrective and creative purposes and there are other useful camera accessories that will aid you while out in the field.

Therefore, before we progress to the more creative, artistic and theoretical side of photography we shall first address the practical considerations: the camera equipment you need to become a landscape photographer.

TECHNICAL ACCURACY
Although photography is a creative art, don't neglect the technical and practical side of taking photos. When I took this particular image, the light and conditions were truly magical. However, had I not selected the right focal length, filtration and support, I could have easily wasted the opportunity.

CAMERA FORMATS

There are several camera formats available to photographers. Simply speaking, the camera format is based on the size of the sensor – the light sensitive chip that is at the hub of a camera. Not only will the size of the sensor affect the quality of the images you take, but its dimensions will also determine the aspect ratio (see opposite) of the photographs you take, which can have a significant impact on how you frame your pictures.

FULL-FRAME DIGITAL SLRS

The most popular type of camera among landscape photographers is the single lens reflex (SLR) camera. With this type of camera, the photographer looks through the lens when they peer through the viewfinder. SLRs employ a mechanical mirror system and pentaprism to direct light from the lens to an optical viewfinder at the rear of the camera.

Most professional and enthusiast landscape photographers favour using a full-frame digital SLR, which is a camera that uses a digital sensor that is approximately the same size as a traditional 35mm film frame (36 x 24mm). This means a lens attached to it will give the same field of view that it would on a 35mm film camera, retaining the original characteristics of that lens type.

Full-frame digital SLRs are small enough to be easily portable, yet the format is large enough to offer high image quality. Their high ISO and low light performance is excellent; their handling and ergonomics are superb; they offer a big, bright viewfinder image and Live View to aid precise focusing and composing, and they also boast a wide dynamic range, which can be incredibly important for landscape photography.

FULL-FRAME SLRS
Larger sensors have larger light-gathering photosites, which enables them to capture images with less noise. As a result, images should be smoother, more detailed and sharper. For this reason, full frame digital SLRs such as Nikon's D800E are a popular choice among landscape enthusiasts.

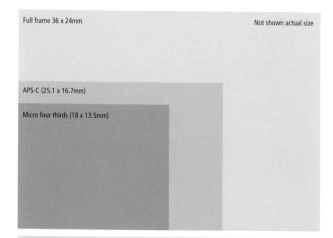

Full frame 36 x 24mm

Not shown actual size

APS-C (25.1 x 16.7mm)

Micro four thirds (18 x 13.5mm)

FORMATS

A camera's format is linked directly to the size of its sensor (or film). A full-frame camera is the traditional 35mm format (36 x 24mm); an APS-C sensor is typically 25.1 x 16.7mm; the Four Thirds and Micro Four Thirds standards are approximately 18 x 13.5mm. Anything bigger than full frame / 35mm is medium format, until the frame size reaches 5 x 4in (127 x 102mm). This and larger sizes are known as large format.

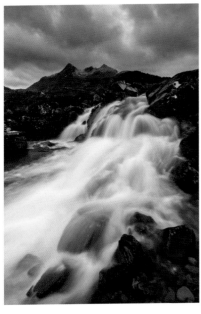

Aspect ratio 3:2

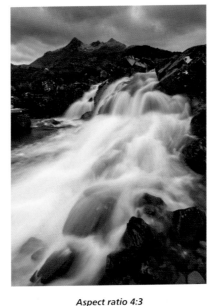

Aspect ratio 4:3

ASPECT RATIO

The 35mm film format, full-frame SLRs and most cameras with an APS-C sized sensor have a native aspect ratio of 3:2, while Four Thirds is 4:3. This comparison helps illustrate the subtle, yet significant difference between the two. The aspect ratio of your camera can greatly influence composition and impact – either negatively or positively – on how you frame a photograph.

However, you don't need to adhere to your camera's native aspect ratio. Most cameras allow you to change the format in-camera, and a choice of 3:2, 4:3, 16:9 and 1:1 aspect ratios is not uncommon. Alternatively, you can easily alter an image's aspect ratio during processing by cropping the image, which can greatly enhance a photograph's balance and impact. Be warned, though: changing the aspect ratio from the camera's native format (either in-camera or during processing) will reduce the overall size of your image.

CROPPED SENSOR DIGITAL SLRS

Most consumer digital SLRs use a sensor that is smaller than full frame. The most common format is known as APS-C, which is approximately the same size as the Advanced Photo System film format of the same name. The size of an APS-C format sensor can vary from 20.7 x 13.8mm to 28.7 x 19.1mm, depending on the manufacturer.

Being smaller than the 35mm standard, this format is often regarded as being a 'cropped type', as it effectively multiplies the focal length of the lens attached. This is known as the camera's multiplication factor – or focal length multiplier – which ranges from 1.3x to 1.6x depending on the specific size of the sensor. As an example, a 24–70mm lens attached to a camera with a multiplication factor of 1.5x would behave like a 36–105mm lens on a full frame sensor. Depending on the subject of your image, a camera's multiplication factor can prove either advantageous or disadvantageous.

FOUR THIRDS AND MICRO FOUR THIRDS

Cameras conforming to the Four Thirds standard employ a sensor with a diagonal measurement of 21.63mm. The sensor is not restricted to a specific shape or ratio, although most Four Thirds cameras use a 17.3 x 13mm, 4:3 ratio sensor. This is squarer than full frame and APS-C sensors (which typically have a 3:2 ratio), and can influence how you compose your images. The small sensor also effectively multiplies the focal length of an attached lens by a factor of 2x, enabling manufacturers to produce compact, lighter lenses.

A more recent development is the Micro Four Thirds (MFT) standard. This shares the Four Thirds sensor size, but as MFT cameras are designed without a mirror and prism mechanism it allows smaller, lighter and more portable cameras to be designed. However, due to the lack of an optical viewfinder, it is only possible to compose images via an electronic viewfinder (EVF), Live View on the rear LCD screen or with a supplementary optical viewfinder (similar to a rangefinder).

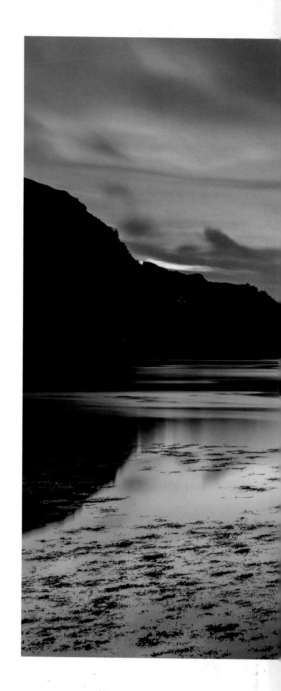

MEDIUM FORMAT

A camera with a sensor exceeding 36 x 24mm (full-frame) is considered 'medium format'. The key advantage of this camera format is that, due to the larger physical size of the sensor, it is able to produce high-resolution images with smoother tonal transitions and extraordinary detail. Digital medium format cameras typically have a resolution exceeding 40-megapixels. However, as sensor size increases, depth of field becomes shallow, as you have to use longer focal lengths to maintain the same field of view. While this can naturally present opportunities for enhanced creativity, it also means your technique and focusing must be flawless.

Despite their undoubted quality, the cost and size of medium format systems restricts their appeal to a relatively small, select market.

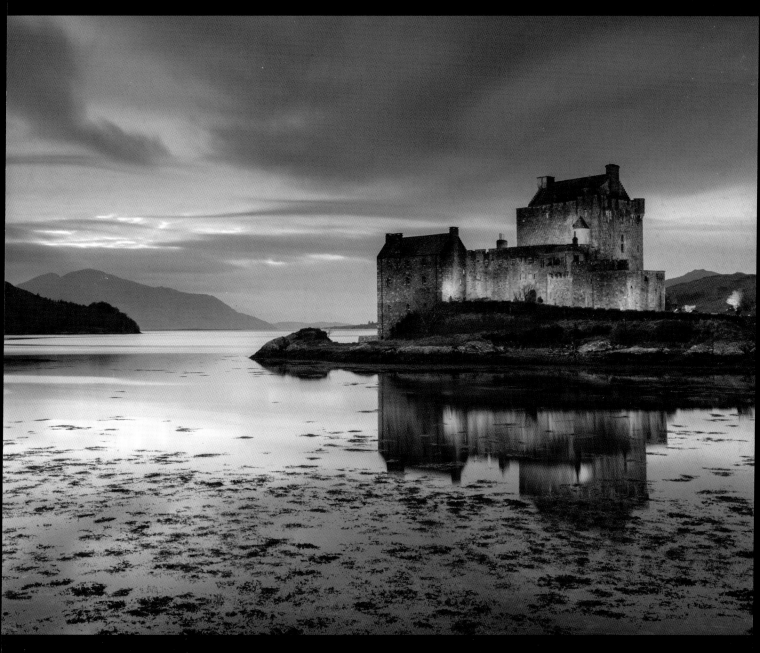

FULL-FRAME DIGITAL
Medium format and large format cameras offer the highest image quality, but the extra weight, cost and larger size of the system makes them less appealing. Instead, most professional landscape

LENSES

One of the main benefits of the camera formats we've highlighted is that they are all compatible with a wide range of interchangeable lenses, making them truly versatile systems. Perhaps the most important characteristic of a lens is its focal length. A lens's focal length determines the angle of view, which will not only influence how you frame your subject, but also affect the look and feel of the final image. Focal length is measured in millimetres, with a low number indicating a short focal length (wide angle of view) and a high number representing a long focal length (narrow angle of view). Over the following pages we will briefly look at the most useful lens types for landscape photography, together with their key characteristics.

WIDE-ANGLE LENSES

Any lens with a focal length shorter than 50mm (on 35mm/full frame) is generally considered a wide-angle lens. This lens type is an essential tool for landscape photography; while they don't suit every vista, you will probably find that you capture the vast majority of your landscape images using a wide-angle lens.

Due to the wide angle of view, wide-angle lenses can capture large, sweeping views, but a key characteristic is the way in which they appear to stretch – or distort – the relationship between near and far elements. Using a short focal length enables you to exaggerate the scale of foreground subjects, making them appear more imposing. Consequently, it is possible to capture images with a genuine three-dimensional feel. Wide-angle lenses also appear to have an inherently large depth of field (see page 38).

While a focal length in the region of 24–28mm is generally considered to be a typical wide-angle focal length, more dynamic results come from using a super wide-angle – a length of, or equivalent to, 16–22mm. Although this might not seem like a significant shift in focal length, at this end of the spectrum just a couple of millimetres difference can radically alter coverage and the way in which you can frame your subject.

Wide-angle lenses are particularly well suited to shooting 'big views', or for when you wish to integrate key foreground elements into your composition. Employed well, they can help you produce truly striking results, with an enhanced feeling of depth. A word of warning, though: if you fail to include suitable or strong foreground interest in wide-angle images, you risk producing dull compositions with large amounts of empty space.

WIDE-ANGLE ZOOM

A wide-angle zoom in the region of 16–35mm is an ideal and versatile choice for landscape photography. However, if you own a digital SLR with an APS-C sized sensor, you will require a wider focal length to achieve a similar angle of view – a 10–24mm zoom would be broadly comparable on a camera with a 1.5x crop factor. Most camera brands have a dedicated lens range for cropped type SLRs, such as Canon's EF-S lens range and Nikon's DX lens range.

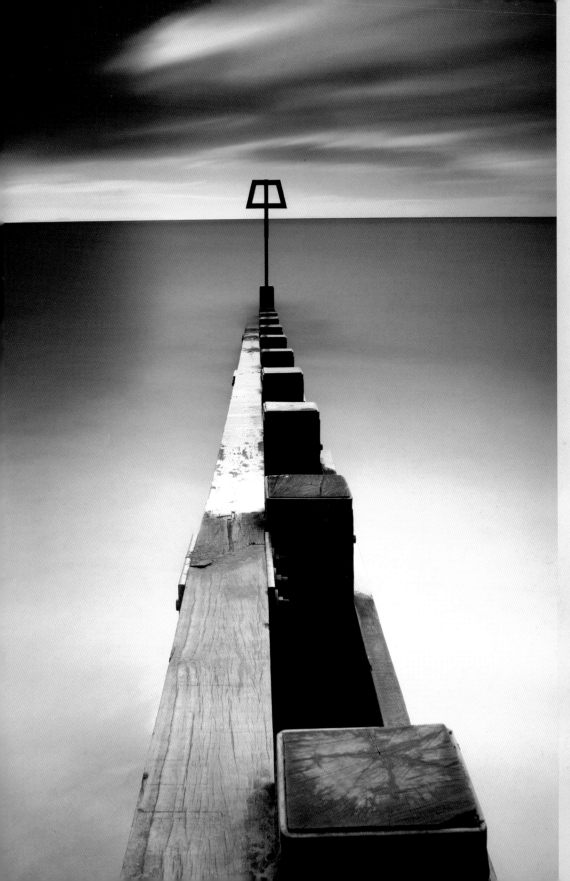

WIDE-ANGLE LENS
Lens choice is a key consideration, as it will greatly influence how you frame and capture your subject. This image, which was taken directly along the length of a groyne, is a good example of how wide-angle lenses accentuate the size of foreground objects, whilst making everything else appear much further away.

STANDARD LENSES

A 'standard' lens is one that has a focal length that approximately matches the diagonal measurement of the sensor. On a full-frame digital SLR this is 43mm, although a focal length of 50mm has been largely accepted as 'standard'. This lens type produces a field of view that is not dissimilar to the human eye, displaying minimal distortion and providing a natural looking perspective.

Because they produce images that appear so 'normal', standard lenses are often overlooked in preference of wider, more dynamic focal lengths. However, they remain a good lens choice for landscape photography, being sufficiently wide to capture large views, yet possessing a narrow enough angle of view to allow you to record simple, precise compositions.

A standard lens is particularly suited to views where you want to place the emphasis on background elements, or when you simply wish to guard against foreground objects dominating your composition. Prime standard lenses are typically fast, compact and optically superb. They also tend to be relatively inexpensive, making them a worthwhile addition to your kit bag.

STANDARD FOCAL LENGTH
Although often overlooked in favour of wide-angles, a standard focal length – in the region of 50mm (or its equivalent) – is an excellent lens choice for many landscapes. In this instance, I didn't want to 'push' the little lighthouse further away from my chosen foreground by using a wide-angle lens: I wanted to capture the view with minimal distortion.

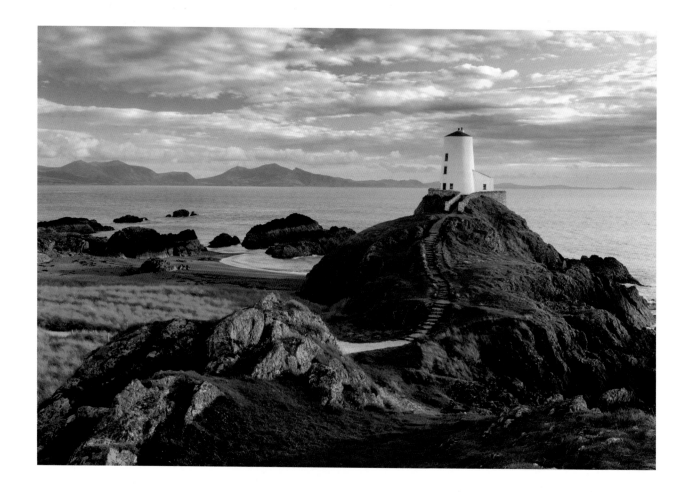

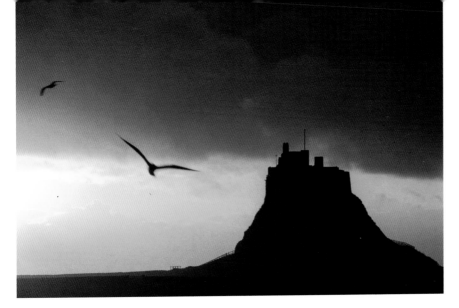

SIMPLICITY WORKS
You can easily overlook longer focal lengths when shooting scenery, but it is possible to capture eye-catching results using a telephoto. They allow you to place emphasis on a single, select element and produce wonderfully simple compositions free of distraction. In this instance, a telephoto was the ideal choice for isolating the castle against the colourful, dramatic dawn sky.

TELEPHOTO LENSES

Focal lengths longer than 50mm are considered telephoto. Using longer focal lengths magnifies the subject, making them appear larger in the frame than would be possible using a wide-angle or standard lens from the same distance. The relationship is geometric: assuming the same subject-to-camera distance, doubling the lens's focal length will double the size of the subject within the frame.

One of the key characteristics of longer focal lengths is the way they appear to foreshorten perspective. Because of the longer working distance they make objects within the landscape appear closer to one another than they actually are. This is a lens trait that photographers can take advantage of creatively when deciding what type of composition will suit the landscape best.

Short to medium telephoto lengths – in the region of 70–200mm – are generally the most suited to landscape photography, as they are ideal for isolating details and key elements within the landscape – a skeletal tree, church tower or building, for example. Telephoto focal lengths are also a good choice when shooting subjects in mist or fog, as they exaggerate the conditions.

WHAT IS ANGLE OF VIEW?

'Angle of view' is a measurement in degrees of the amount of a scene that can be captured by a given focal length – usually a diagonal measurement across the image area. Lenses with a short focal length (28mm, for example) have a wide angle of view, while longer focal lengths (such as 150mm) have a much narrower angle of view. This means a 50mm lens on a full-frame SLR has an angle of view of approximately 46 degrees, while a 24mm lens on the same camera would have a much wider, 84-degree angle of view. Put simply, the wider the angle of view, the more of the subject you can include within the frame.

ZOOM LENS
A 70–200mm zoom lens (or its equivalent) is perfect for picking out details in the landscape.

PRIME VS ZOOM

As you will already be aware, there are two types of lens – prime lenses and zoom lenses. Prime lenses have a specific focal length that cannot be altered, while a zoom lens covers a range of focal lengths; both have advantages and drawbacks for landscape photography.

Prime lenses tend to have the edge in terms of optical quality due to their simpler construction, and they also have a fast maximum aperture, providing a brighter viewfinder image in low light. Some photographers favour prime lenses, claiming that they make you think more carefully about where and how you position yourself.

However, this means you have to work harder when using prime lenses, as you can't simply remain in one position and zoom in and out to alter the composition. Because of this, many photographers prefer zoom lenses due to their enhanced versatility. Zooms reduce the frequency with which you have to physically change lenses and conserve space in your camera bag too. More importantly, they allow you to be more spontaneous when taking photos. The ability to quickly adjust the focal length allows very precise framing and encourages creative and experimental compositions. One of the disadvantages of zoom lenses is that they do not have detailed depth-of-field scales marked on the lens barrel, making it trickier to set the hyperfocal distance (see page 42).

TILT AND SHIFT LENSES

Tilt and shift (or 'perspective control') lenses are a specialist lens type that offers a number of benefits to landscape photographers (also see pages 82–5). With conventional optics, the axis of the lens is mounted in a fixed position, perpendicular to the sensor plane. As a result, if you point your camera up or down, a degree of subject distortion – known as 'convergence' – will occur. The design also means that the focal plane is often different to the object plane, so depth of field is more limited.

Tilt and shift lenses are designed to overcome these issues by allowing you to alter the plane of focus to control depth of field and correct converging verticals. The tilt and shift principal involves two different types of movements – rotation of the lens (tilt) and movement of the lens parallel to the image plane (shift). Tilting the lens controls the orientation of the plane of focus and, as a result, the area of the final image that appears sharp. Shift is used to control perspective, eliminating the convergence of parallel lines. A tilt and shift lens is also well suited to creating seamless stitched panoramic images. The advantage of using a tilt and shift design (opposed to a conventional lens) is that you don't have to move the optical centre of the camera lens to adjust the framing. As a result, you can avoid the problem of parallax error with foreground subjects.

TILT AND SHIFT
Canon and Nikon both have tilt and shift lenses in their respective ranges, although the specialist nature of the lens makes it an expensive proposition compared to a 'normal' lens of the same focal length.

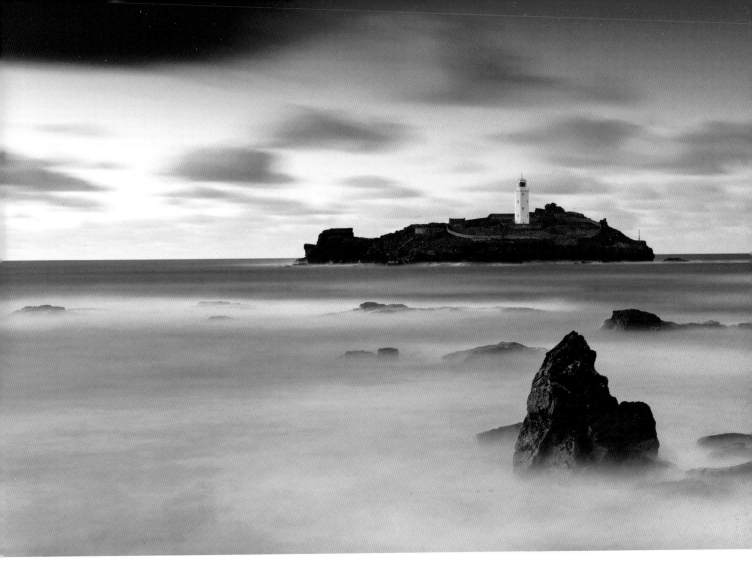

CAMERA SUPPORTS

In this age of in-camera and lens-based image stabilization, newcomers to photography can wrongly assume that camera supports are redundant today. However, a good quality tripod isn't a luxury for landscape photography – it's an essential tool for the job. Not only will a tripod eliminate the risk of 'camera shake', but it is also a key compositional aid. Nothing will improve your photography as dramatically as using a tripod, so your choice of legs and head is an important one.

STABILITY

A sturdy tripod is essential for keeping your camera stable and safe in windy conditions. I took this photo as the day neared its end; the light levels were low, so the exposure was naturally long. Thanks to the stability and weight of my tripod I was able to capture a bitingly sharp result, despite the conditions.

TRIPOD

It is true that a tripod can be heavy and awkward to carry, but it is false economy to invest in a good camera and then shoot handheld. Equally, you will be wasting your money if you buy a lightweight or flimsy tripod – it simply won't withstand the challenges of working outdoors in all types of weather. Creative landscape photographers will regularly want to employ slow shutter speeds, whether that's because they are working with small apertures, shooting in low light or as a result of using filters. In situations like this it is impossible to capture bitingly sharp results without the aid of good, supportive legs.

Although primarily designed for stability, a tripod will aid your photography in other ways too. Crucially, using a support slows down the picture-taking process, allowing your eye to wander around the frame for longer. This means you tend to think more about your composition and viewpoint and are far more likely to adjust or fine-tune your framing than when you shoot hand-held. With your camera in a fixed position, it is also far easier to place your focus precisely and it is easier to align graduated filters as well.

When investing in a new tripod, your budget, the weight you can comfortably carry and your height will determine which model is right for you. Leading brands, such as Giottos, Gitzo, Manfrotto and Really Right Stuff, produce a wide range of models and designs. It is better to buy your tripod legs and head separately, rather than purchasing a one-piece tripod, as you can then choose your ideal combination.

Tripod legs can vary greatly in price, but if your budget allows, carbon fibre legs are the best option, as they are lighter and more comfortable to carry than aluminium legs. Look for a design that will allow you to easily select a low shooting angle for when you wish to achieve a dynamic perspective, but also consider height: buy a support that will extend to a height you will be comfortable using, without having to extend the tripod's centre column.

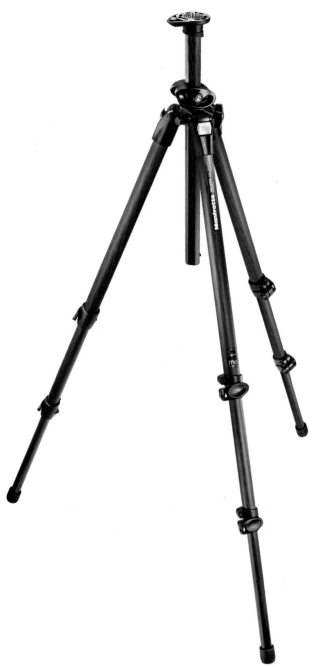

TRIPOD LEGS
Top-of-the-range carbon fibre tripod legs are costly, but you don't have to invest huge sums in order to buy a good support for your camera. The weight, versatility and affordable price of Manfrotto's 190 and 055 ranges make them a favourite among landscape photographers. To maximize stability, avoid raising the tripod's centre column when possible and – if your tripod has a hook – hang your camera bag from it in blowy weather.

TRIPOD HEADS

Your choice of tripod head is arguably even more important than the legs you buy: the wrong design will only frustrate and slow you down, while the right one will allow you to frame your subject freely and intuitively. There is such a wide range of designs available that the choice can seem daunting at first, but most are simply a variation on a pan-and-tilt or a ball-and-socket design.

Ball-and-socket heads allow you to smoothly rotate the camera around a sphere, and then lock it into position. They are easy to operate, with the most sophisticated designs offering tension / friction control, precision panning and a large locking knob for smooth, precise control. Pistol grip versions are also available.

However, while some photographers like ball-and-socket designs, others find them fiddly and frustrating – it is simply a matter of taste. The alternative is a pan-and-tilt design, which offers three separate axes of movement; left-right tilt, forward-back tilt and horizontal panning. The best versions are geared, which although more costly, allow you to make very fine adjustments to composition. This is a great type of head for shooting static subjects, and is highly recommended for landscapes.

As with your tripod legs, it is a good idea to try a variety of designs in a shop before making your final decision. Regardless of type, be sure to select a head with a load capacity that will adequately support your heaviest camera and lens combination.

L BRACKET
Many tripod heads are designed with a quick release plate, which you screw onto the camera – via the tripod bush – so you can quickly attach and remove the camera. A variation of this is an L-Bracket, which allows you to quickly switch from horizontal to vertical orientation without recomposing your shot.

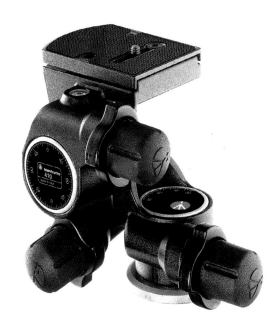

GEARED HEAD
It is impossible to say which is the best tripod head to buy, as every photographer's requirements and taste is different. However, geared heads – such as the Manfrotto 410 Junior – are particularly suited to shooting landscapes, as they allow you to make very fine adjustments to your composition.

FILTERS

While it is true that the effect of most filters can be replicated in post processing, the majority of photographers – your authors included – still favour in-camera filtration. There is something hugely satisfying about achieving the result or effect you want in-camera, without needing to spend extra time on a computer. Somehow, it feels more 'real' and authentic getting it right in the field, and filters allow photographers to do exactly that. They can be employed creatively or for correction and continue to play an integral role in the art of landscape photography.

FILTER HOLDERS
The Lee Filters holder for 100mm filters is a particularly good design as it is customizable, so you can add or remove filter slots (up to a maximum of four).

FILTER SYSTEMS

There are two types of filter – called 'slot-in' and 'screw-in'. Screw-in versions attach directly to the front of the lens via its filter thread, while square or rectangular slot-in filters attach via a dedicated holder. A filter holder allows you to easily combine filters and is an essential investment if you are using graduated ND filters, as it allows you to adjust the filter's alignment.

There are a number of different holders available, from manufacturers such as Cokin, Hitech, Kood and Lee Filters. These vary in size, but the most popular among enthusiasts are the 84/85mm and 100mm filter systems. If your budget allows, we recommend you opt for the larger system. This is because smaller holders are prone to vignetting (darkening of the corner's of the frame), especially when attached to wide-angle lenses.

There are also a number of specialized holders available. Lee Filters produce a smaller Seven5 filter system, for example, which is designed for using with compact system cameras. The same company also produces a larger 150mm system, designed to work in combination with super-wide-angle lenses, such as Nikon's 14–24mm wide-angle zoom.

TIP: Your camera's 'through the lens' (TTL) metering will automatically compensate for most filters, but with extreme ND filters the exposure may exceed the camera's longest automatic shutter speed (usually 30 seconds). You then need to switch to Bulb (B) mode and calculate the exposure time manually. Charts and phone apps (such as ND Calc) are available to help.

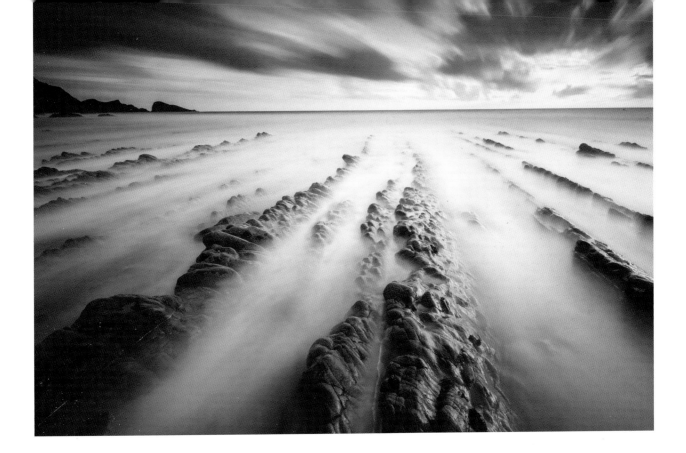

NEUTRAL DENSITY FILTERS

Solid neutral density (ND) filters are designed to absorb light, so you can set artificially slow shutter speeds. This is a highly creative filter type, as reducing the amount of light entering the camera allows you to artistically blur subject movement, such as moving clouds, swaying crops or water. This can add a feeling of motion and flow to images, or be used to generate foreground interest or a powerful lead-in.

ND filters are available as both slot-in and screw-in filters, and are produced in a range of densities, which is usually measured in stops: the greater the density, the more light the filter absorbs. Arguably, 3- and 4-stop ND filters are the most useful strengths. To give you an example of their effect on exposure, if the original recommended shutter speed is, say, 1/4 sec., the exposure time will be lengthened to 1/2 sec. if you used a 1-stop ND; 1 second with a 2-stop ND; or 2 seconds if a 3-stop ND filter is attached.

Extreme ND filters (with a strength of up to 13-stops) are also available. The most popular extreme ND filter is Lee Filters' Big Stopper, which has a density of 10-stops. It is often possible to make

LONG EXPOSURE

You either love the 'blurry water' effect or you hate it. Personally, I love it and the impression of motion can be a very powerful visual and compositional tool. In this instance, I wanted to blur the water rushing up and between the large fins of rock. This helps highlight the shape of the rock and also simplifies the composition overall. I always carry a couple of ND filters in my kit bag – both 3- and 10-stop versions – and for this image I used a 10-stop extreme ND filter to increase the exposure time to 1 minute. I also attached a 2-stop graduated ND to 'hold back' the sky.

exposures last several minutes using one of these filters, which can render drifting clouds as brushstrokes and make rough, choppy water appear flat and ethereal. These filters can also help emphasize a subject's shape and form and add mood and interest to a scene that may otherwise seem ordinary. However, as an extreme ND filter's density is so great, you can hardly see through them, so it is important to compose and focus your shot prior to attaching the filter.

GRADUATED ND FILTERS

One of the biggest problems facing landscape photographers in the field is the contrast between bright sky and darker foreground. The difference in brightness can be high, and if it extends beyond the sensor's dynamic range (its ability to capture shadow and highlight detail simultaneously) the resulting image will be poorly exposed: if you expose for the landscape, the sky will be overexposed; expose correctly for the sky and the foreground will appear too dark. Of course, you could resolve this by altering your viewpoint so you are shooting toward a less bright part of the sky, but changing your composition is hardly a satisfactory option. Instead, you need to be able to manage the contrast.

One solution is to make two exposures, one exposed correctly for the land and one for the sky. You can then blend them together during processing to form one correctly exposed final image. If you enjoy processing, this is a perfectly good option, but if you want to minimize the time you spend on your computer, graduated neutral density (ND) filters are a better option. Graduated ND filters are half clear and half coated with a neutral density coating, with a gradual transition between the two areas. They work in a similar way to solid neutral density filters, but are designed to block light from part of the image, rather than all of it. They are brilliantly simple to apply. With your filter holder attached, slide the graduated ND filter in from the top and – while looking through the viewfinder, or Live View – align the filter's transitional zone with the horizon. By using a filter of an appropriate density, you can balance the contrast and bring the entire scene within the sensor's dynamic range, ensuring that detail is retained in both the shadow and highlight areas.

As with plain ND filters, graduated ND filters are available in different strengths (typically 1, 2 and 3 stops) and you can also buy soft- or hard-edged filters. Soft grads have a feathered edge that provides a gentle transition from clear to maximum density. They are best suited to views with an interrupted or uneven horizon, such as mountain peaks. Conversely, hard grads are designed so that the transition from clear to full strength is more abrupt. As a result, they can be aligned with far greater precision, but are much less forgiving should you position the filter incorrectly.

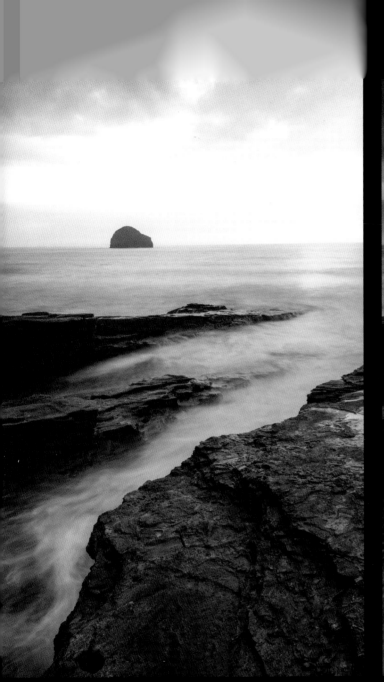

Without graduated filter

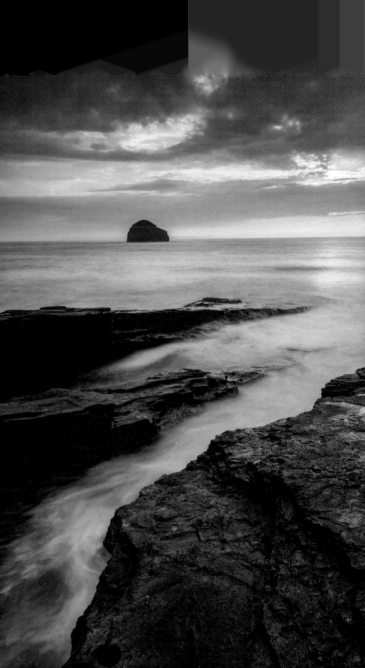

With 2-stop ND graduated filter

GRADUATED ND COMPARISON

For coastal images like this, a hard-edged grad is almost always the best choice. The difference in brightness between the sky and land can be several stops when shooting towards a bright sky, so grads are particularly useful around sunrise and sunset. This comparison helps illustrate the difference that a graduated ND filter can make to a shot

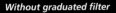

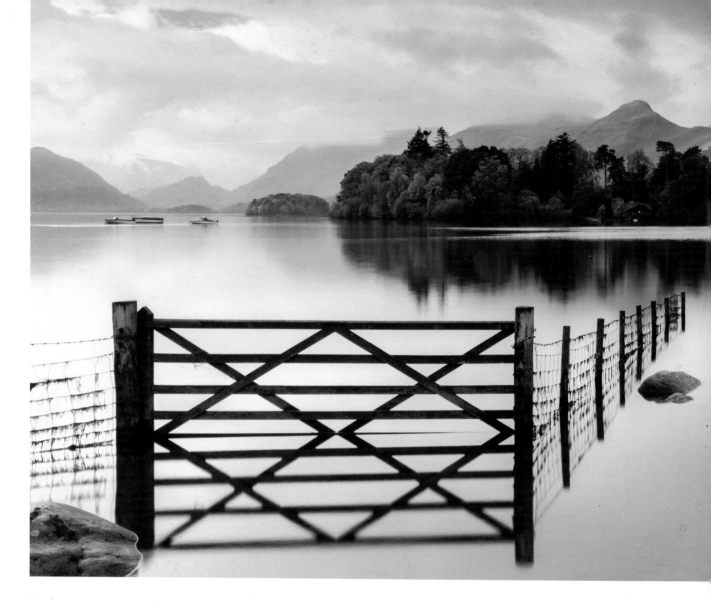

REFLECTIONS
A polarizing filter can not only be employed to eliminate reflections, but also capable of enhancing them. Mirror-like reflections can prove a great compositional aid, creating a feeling of symmetry. A polarizing filter also has a filter factor of up to 2 stops, meaning that exposure times are lengthened.

POLARIZING FILTERS

A polarizing filter is designed to reduce glare and reflections and restore natural colour saturation. It is best known for the effect it can have on clear, blue skies and foliage and is undoubtedly one of the most useful filter types. Its effect is also impossible to mimic during processing.

A polarizing filter works by blocking polarized light. It is constructed by sandwiching a thin foil of polarized material between two pieces of optical glass. By rotating the front of the filter, you can adjust the amount of polarized light passing through it, and by doing so you will see reflections come and go and the

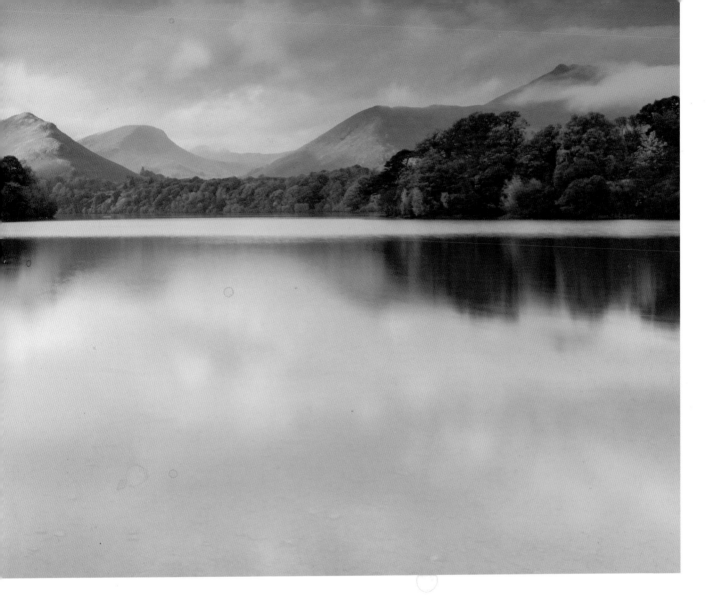

intensity of colours strengthen and fade – simply rotate the filter until you achieve the effect you desire. A polarizing filter gives its most pronounced effect when used at a 90-degree angle to the sun, but beware of over-polarization, when blue skies appear artificially dark. You should also be careful when using a polarizing filter with a wide-angle lens, as the effect can appear uneven across the sky.

There are two types of polarizer – linear and circular. This has nothing to do with the filter's shape, but to the way in which it polarizes light. Circular polarizers are designed for use with modern AF cameras, so this is this type that you should opt for.

POLARIZING FILTER

Lee Filters' filter holder allows you to add a polarizing filter ring, which enables you to attach a 105mm polarizing filter directly to the front of the system.

OTHER ESSENTIALS

Aside from cameras, lenses, supports and filters, there are a handful of other accessories (not to mention camera functions) that will assist you when capturing your landscape images. Some aid image sharpness, while others are framing devices, but anything that helps you maximize image quality or compose more precisely is worth knowing about. Here we highlight these camera-related 'essentials'.

REMOTE TRIGGER

Physically depressing the shutter-release button can generate a small degree of camera vibration, even when you are using a tripod. Although the effect is minimal, it can grow more obvious when the image is enlarged. To maximize image sharpness it is therefore a good idea to trigger the shutter remotely, either by using a remote release cord or a wireless/infrared trigger.

A remote cord attaches to the camera via its remote release terminal. Basic models are designed with a simple trigger button at the end of a cable, while more sophisticated devices are equipped with such things as an interval timer, back-lit control panel and timer. Remote devices also allow you to lock open the camera's shutter in Bulb mode, enabling you to capture long exposures in low light or when using ND filters.

HOTSHOE SPIRIT LEVEL

It is usually important to keep the horizon level when framing a landscape. Although a sloping horizon can be corrected during post processing, it is always preferable to get things right in-camera. Some cameras have a virtual horizon feature, or you can buy a hotshoe-mounted spirit level. This simple accessory has a double-axis spirit level and can prove particularly useful when capturing multiple frames to create a panoramic stitch.

REMOTE DEVICE
A remote release allows you to trigger the camera's shutter remotely, without having to press any buttons that could, potentially, introduce a degree of movement. If you don't have a remote release, consider using your camera's self-timer facility instead.

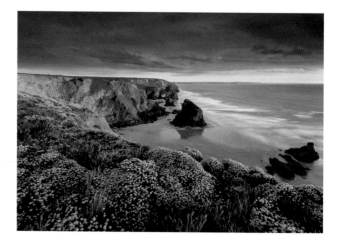

LEVELLING AID
If you are someone who struggles to keep the horizon perfectly level – as many photographers do – try using a levelling aid. In this instance I used my camera's virtual horizon function to aid me. I also released the shutter using a remote release cord and locked the mirror up to help maximize image sharpness.

FRAMING DEVICES

Some photographers find a framing device helps them pre-visualize. Basically, this is a movable frame, which you hold in front of you in order to select part of the visual field, while obscuring other parts, and the idea is that the frame helps you 'see' the best composition. The concept of visual framing is hardly a new one – artists have used them throughout history. By moving the frame closer or further away from your eye, you can alter the composition and mimic different focal lengths. You can also use an adjustable frame (or different-sized frames) to show the effect of using various aspect ratios. You can easily make your own device with two L-shaped pieces of card of the same size.

FRAMING AID
A framing device should provide some focus and clarity when you are trying to select the best possible composition. Alternatively, you can form a basic frame using your index fingers and thumbs.

IN-CAMERA FEATURES

The latest digital cameras have a wide range of useful and innovative features, some of which can greatly assist you when you compose your images.

LIVE VIEW: Live View is a great framing and focusing aid, which allows you to use your camera's rear LCD screen as a viewfinder. By viewing the subject as a two-dimensional image, Live View gives a very accurate preview of how the final composition will look.

GRID LINES: Many cameras allow you to display a 'Rule of Thirds' grid in the viewfinder and / or in Live View mode. Enabling the grid can help you compose your images, and allow you to carefully place key subject matter on 'power points' – the point where the grid lines intersect.

VIRTUAL HORIZON: A virtual horizon is basically an in-camera level. When enabled, a graphic is displayed on the camera's monitor, which will verify when the camera is level, both horizontally and vertically. This is a great way of ensuring your horizon is perfectly level.

MIRROR LOCK: By enabling this feature, you can 'lock up' your digital SLR's reflex mirror prior to making an exposure. Doing so eliminates any internal vibrations created by 'mirror slap' as the mirror flips up to allow the sensor to be exposed. When using this function, two presses of the shutter-release button are required to take a photograph: the first locks the mirror up, then the second makes the exposure.

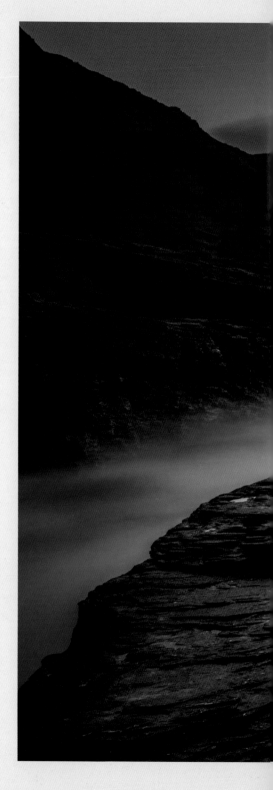

▶ CHAPTER TWO >
SHOOTING TECHNIQUE

Most photographers would describe themselves as 'creative' – artistic people who, through their camera, can allow their inventiveness to show through. However, simply being creative is not enough to guarantee that you will capture great images with your camera. In order to capture a photograph that closely resembles what you 'see' in your mind's eye will also require good shooting technique.

Some photographers enjoy and embrace the technical side of photography, while others have little interest in f/stops and ISO. However, like it or not, you must have a good technical foundation in order to realize your creative potential. If you do not properly understand such things as exposure, colour theory or how to maximize image sharpness, then you will undoubtedly end up taking more images that fail than succeed. Good technique provides you with options; it arms you with the knowledge and knowhow to maximize the creative potential of any picture-taking opportunity.

CREATIVE CONTROL
Good images are rarely the result of luck. As sophisticated as modern cameras are, they are still only tools. While today's technology certainly makes our lives as photographers easier, they cannot – and never will be able to – predict the effect we wish to achieve. It is important to retain creative control and fully understand the effect that certain shooting parameters have on the look and feel of the resulting image. Doing so will enable you to make good choices and apply the most appropriate settings. In this instance, I prioriticated a slow shutter speed in order to blur the movement of the cloud and rising tide.

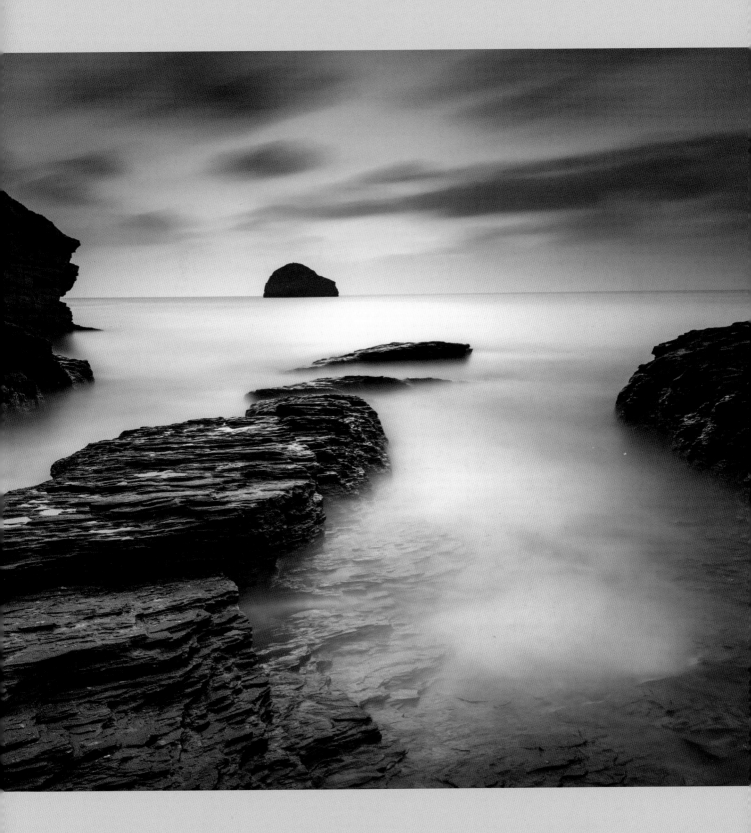

EXPOSURE

Exposure is the heartbeat of photography. Put simply, it is the process of light striking – and exposing – a photosensitive material, be it a piece of film or a digital sensor. An exposure is controlled by three variables – shutter speed, lens aperture and the photographic material's sensitivity to light (given as an ISO setting). Understanding the role and relationship of these three variables is essential if you wish to master landscape photography.

APERTURE

Aperture is the common term used for the iris diaphragm in a lens. Quite simply, this is an adjustable hole through which light can pass to expose the sensor (or film). The numbers indicating the size of the aperture are fractions, referred to as f/numbers or f/stops. Aperture settings can be slightly confusing at first, as a large aperture is represented by a small number (such as f/2.8), while a small aperture is indicated by a large number (such as f/22). When a large aperture is used, more light can pass through; when the aperture is smaller, less light passes through, however, the resulting depth of field (see page 38) is more extensive. Changes in aperture – and shutter speed – are referred to in 'stops' (hence f/stop), with one stop equal to a halving or doubling of the amount of light reaching the sensor.

SHUTTER SPEED

The shutter speed is the length of time that the camera's mechanical shutter remains open for during an exposure. If the shutter speed is too short, the image will be too dark; if it is too long, too much light will strike the sensor and the resulting image will be too light. A camera's metering system will help determine the correct shutter length depending on the aperture, ISO sensitivity and available light. While its primary function is to ensure the right amount of light is allowed to reach the sensor, the shutter length also dictates how motion (see page 106) is recorded. This is a powerful aesthetic tool; faster shutter speeds can be used to freeze motion, while slower ones will blur it.

Shutter speed has a reciprocal relationship with the aperture, meaning that a change to one will require an equal and opposite adjustment to the other if you want to maintain the same level of exposure overall.

ISO

ISO (International Standards Organization) refers to a sensor's sensitivity to light. A low number, such as ISO 100, indicates lower sensitivity, so the sensor requires a greater level of light to achieve the correct exposure. Conversely, a high ISO, such as ISO 6400, indicates high sensitivity to light, so less light is required to make an exposure. Doubling the ISO speed halves the amount of light required to produce the correct exposure, and vice versa.

With digital cameras it is possible to alter the sensor's ISO sensitivity from one frame to the next. Increasing ISO is an effective way of generating a faster shutter speed, which is useful if you wish to freeze subject movement or eliminate camera shake when shooting hand-held. However, when practical, it is best to employ low ISO settings, as image-degrading noise is more prevalent at higher ISOs.

TIP: Cameras have a choice of exposure modes, which offer varying levels of control. It is usually most important for landscape photographers to be in control of the aperture, in order to generate sufficient depth of field. Therefore, opt for either Aperture Priority (A or Av) or Manual (M) mode.

1 Exposure

-1 Exposure

0 Exposure

ADJUSTING EXPOSURE

You will often need to adjust exposure for either corrective or creative purposes. If you wish to make your images brighter, you can select a larger aperture (smaller f/number), slower shutter speed or increase the sensitivity of the ISO. To make your images darker, you could choose a smaller aperture (larger f/number), employ a faster shutter speed or reduce the ISO. In this instance, I've altered the level of exposure using photo editing software, but you can see the effect that changing the exposure can have on the look and feel of a photograph.

CORRECT EXPOSURE VS DESIRED EFFECT

Achieving the right level of exposure is easier than ever before. Firstly, cameras have highly sophisticated Through The Lens (TTL) metering systems with multi-area metering patterns that are designed to evaluate a scene's overall brightness and are rarely deceived – only predominantly light, dark or contrasty subjects are likely to cause them any problems. There is also the photograph's histogram to consult, which gives us all the information we require to properly assess exposure. The graph either reassures us that the original settings were correct, or prompts us to reshoot using different settings. Finally, digital images – particularly Raw files, which we recommend you shoot – are very flexible and tolerant to adjustment. Using image-editing software it is quick and easy to 'tweak' the brightness of a photograph. You can do this with great impunity, as long as the shadow and / or highlight areas of the original image aren't 'clipped'.

Yet while we have all of the tools required to get the exposure right, time and time again, the big question is, 'how do you define correct exposure'? It could be argued that the 'correct' exposure is the one that records the subject as our eyes saw it when we triggered the shutter: if a picture is any lighter than that it is overexposed; any darker and it is underexposed.

However, photography would be very boring if we always had to capture things completely authentically. Therefore, a far better way of defining 'correct exposure' is to simply say that it is the exposure that achieves the precise effect that you – the photographer – intended. Subsequently, the best result will not always be the one that most closely resembles how your eyes 'see'. High-key images, which are bright, full of light and comprise mostly white tones, can appear very striking, while a degree of underexposure can add drama to your photographs and make the colours deeper.

In this regard, desired effect, and how you interpret a scene is what really matters. This is why good shooting knowledge is so essential: once you fully understand the mechanics of exposure, you will be able to manipulate it in order to capture what you believe is the best possible result.

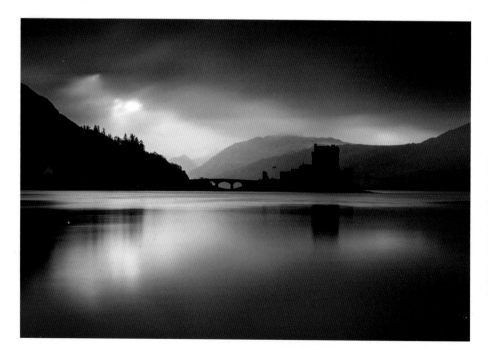

THE 'CORRECT' EXPOSURE
Due to the subjective nature of photography, defining 'correct' exposure seems like an impossible task. In truth, it is easy: the 'correct' exposure is simply the one that the photographer intended when triggering the shutter. Silhouettes (see page 124) are an excellent example of how exposure can be interpreted creatively. Effectively, contre jour images like this are the result of poor exposure – the subject is grossly underexposed, and devoid of colour and detail. However, as long as the result is the photographer's desired effect, how could anyone possibly argue that the photo was anything but correctly exposed?

HISTOGRAMS AND EXPOSING TO THE RIGHT

A histogram is a graph that shows an image's tonal distribution. The horizontal axis represents the picture's tonal range from black (0, far left) to pure white (255, far right), while the vertical axis represents how many pixels have that particular value. By correctly interpreting an image's histogram, you should never make any significant errors.

For example, a graph displaying a large number of pixels pushed-up to either edge normally indicates poor exposure. Peaks to the left may indicate underexposure; peaks to the right, overexposure. When the pixels are 'overflowing' off the edge of the graph, a histogram is said to be 'clipped', which means detail has been irretrievably lost. It is then normally best to reshoot, applying exposure compensation. There is no such thing as the perfect histogram, though – it will depend on the brightness of the subject and how you've exposed the shot.

Histograms are an essential guide for when you are 'exposing to the right' (ETTR). This is a Raw technique designed to maximize image quality. Sensors capture more tonal data and information in the brightest areas, so by intentionally exposing a scene so that the histogram is pushed as far to the right as possible (but not so far that the highlights are clipped) you will capture the maximum amount of information.

The only way to do this with any accuracy is to use the histogram as a guide. ETTR results will typically look washed-out and lack contrast, as they are effectively too light and poorly exposed. However, by adjusting the exposure, brightness and contrast during processing, the final image can be corrected and you will have a file containing maximum tonal information with the minimum amount of noise for the ISO setting. Modern photographers are not always looking to achieve the 'correct' exposure in-camera: sometimes the intention is to capture the optimum file for processing.

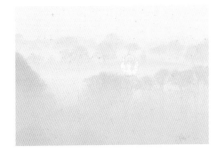

Unprocessed ETTR image

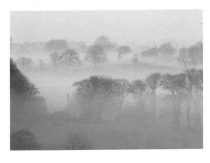

Unprocessed ETTR histogram

Processed ETTR image

Processed ETTR histogram

EXPOSING TO THE RIGHT

The idea of ETTR is to push the histogram as far to the right as possible, without clipping the highlights. Due to the linear design of sensors, doing so will capture more tonal information and the resulting image will exhibit less noise. With some scenes, you may only be able to push the exposure by a small amount – perhaps just 1/3 or 1/2 stop. However, with low contrast landscapes, such as this misty rural scene, you may be able to apply 2 or 3 stops of positive exposure compensation and capture most of the data in the right half of the histogram.

On your camera's LCD, the resulting images will appear washed out and lacking contrast (top). However, once you import the image into your Raw converter and adjust exposure and contrast, the end photograph will resemble the original scene (bottom). While the technique requires more input from the photographer, the resulting image quality will be superior.

DEPTH OF FIELD

Depth of field is the zone of acceptable sharpness within an image. Although both focal length and camera-to-subject distance also help determine depth of field, aperture size is its overriding control. By adjusting the aperture you not only alter the amount of light passing through the lens, but you also determine the level of front-to-back sharpness. Only by understanding depth of field – and the significant role it plays in photography – will you be able to capture the landscape as you envisaged.

Aperture choice is a key consideration when setting up your landscape images, so definitely not a decision you can leave to your camera. Insufficient depth of field will result in parts of the image being recorded out of focus, which – unless intentional – is likely to ruin the photograph. At large apertures – f/2.8 or f/4 – depth of field is shallow; at small apertures – f/16 or f/22 – front-to-back sharpness is extensive.

Typically, landscape photographers wish to capture images that are acceptably sharp throughout. Doing so can give photographs a lifelike quality, with an enhanced three-dimensional feel. Therefore, more often than not, your priority will be to select a small aperture to generate a large zone of sharpness. This is particularly effective combined with a short focal length, as wide-angle lenses have an inherently large depth of field compared to longer focal lengths.

A small aperture should enable you to render everything from your foreground interest to infinity acceptably sharp, but you need to select your point of focus with care. Depth of field extends from approximately one-third in front of the point you focus at, to around two-thirds beyond it. Therefore, if you focus too near or far into the frame, you risk wasting some of the available depth of field. Focusing approximately one third of the way into the frame is a rough and ready (but quite effective) way of maximizing depth of field, but a far more reliable method is to focus at the hyperfocal distance (see page 42).

While larger apertures aren't so widely used for landscape work, don't overlook using a shallow depth of field in your photography. Having a narrow zone of focus is an effective way to help your main subject, or focal point, stand out against its surroundings. Turn to page 40 to discover more about depth of field's creative potential.

VISUAL IMPACT
In order to exaggerate the size and visual impact of this little stream, I used a wide-angle lens and positioned my camera approximately 40cm from the water. To make sure that everything from the foreground boulders to the crooked cross and moorland was in focus I had to set a small aperture of f/20, and placed my focus carefully at the hyperfocal distance. By doing so, everything in the composition is bitingly sharp.

TIP: Shorter focal lengths appear to display a greater depth of field than longer lenses. As a result, wide-angle lenses are popular not only for their ability to capture large vistas, but also for the way they can help ensure full front-to-back sharpness.

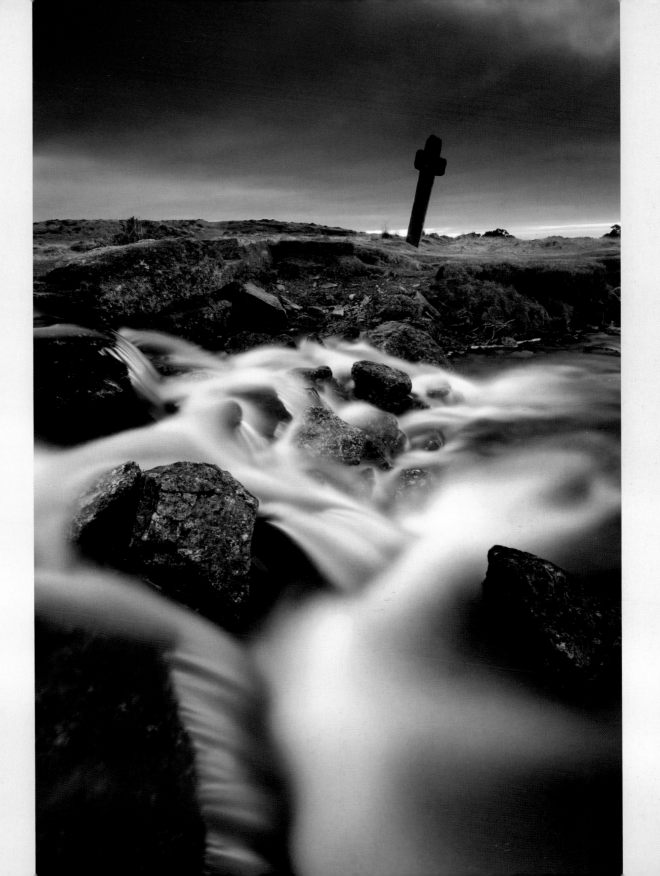

THE BEST APERTURE
It is important to select the aperture that is best suited to the subject, rather than opting for a small aperture through habit. In this instance, I set the aperture to f/4 and used a longer focal length to further reduce the depth of field.

CREATIVE USE OF DEPTH OF FIELD

While there is no 'rule' stating that landscape photographs must be sharp from foreground through to infinity, there is certainly a strong tendency for landscape images to use that approach. A broad depth of field allows you to highlight a landscape's design and complexity, enabling you to draw attention to texture, shape, form and fine detail throughout your composition to give the viewer a better understanding of the location and its setting. However, a deep depth of field will not always produce the best, or most creative result, so avoid selecting a small aperture simply through habit. Instead you need to evaluate every scene individually, and then select the aperture setting that will generate the most pleasing and appropriate depth of field.

WHAT IS THE BEST APERTURE?

There is no simple or correct answer to this – it greatly depends on the shooting situation, the result you desire and, to some extent, the camera's format. Depth of field is inversely proportional to the camera's format size. A camera with a smaller sensor will effectively provide a greater depth of field than a camera with a larger sensor if both are fitted with the same equivalent focal length lens, set at the same aperture. This means that you do not need to select such a small aperture on a crop type camera as you would on a full-frame camera in order to generate the same zone of focus.

When a large depth of field is your priority, an aperture setting in the region of f/11 or f/16 is a good starting point for SLR users. It is no coincidence that the vast majority of the images illustrating this book were captured using an f/stop in this region – it is a range that offers significant depth of field, while remaining free of diffraction (see page 46). A side effect of employing smaller

apertures is longer, corresponding shutter speeds. This can prove advantageous when you wish blur subject motion, but if you are shooting hand-held, be aware that the exposure will be slower and the risk of camera shake is enhanced.

While you will tend to employ wider apertures less frequently, don't overlook the potential of using a shallow depth of field. If you wish to generate a shallower zone of focus, it is normally best to combine a wider aperture with a longer focal length – a medium telephoto, for example. In addition to its visual attractiveness, a shallow depth of field has the ability to direct your audience to the key elements of your composition – a lone tree or building perhaps.

Using a shallow depth of field can simplify complicated scenes and promote serenity, but applied well it can also heighten the impression of depth. Photographs are two-dimensional, so we naturally rely on elements within the landscape to act as reference points. When you capture an image using a wide aperture, you can create a 'slice' of focus, with everything in front and behind it appearing soft. Doing so will create a layered effect that will give the viewer a 'three-dimensional' experience.

TIP: When assessing sharpness and depth of field on your camera's rear LCD screen, avoid viewing your images at 100%. Viewing on screen at pixel level is the equivalent of looking at a huge enlargement from close distance, so only objects on the plane of focus will appear truly sharp. Viewing at 50% gives a far better indication of how sharp the scene is.

DEPTH OF FIELD PREVIEW

To aid viewing and focusing, cameras set the lens to its widest (maximum) aperture setting to provide the brightest possible viewfinder image. Therefore, the level of depth of field you see through the viewfinder rarely represents what you will actually capture.

To help, many SLRs have a 'Preview' button to help you assess whether the selected aperture will provide sufficient depth of field or not. By pressing the button, the camera stops the lens down to the chosen f/stop, so you can see the depth of field at the aperture setting that will be used to take the photograph. Note that the viewfinder image will darken, and the smaller the aperture, the darker the preview will be. It can be worthwhile adjusting the aperture gradually, stop by stop, so that the shift in depth of field appears more obvious. If you find you require more or less depth of field, adjust the aperture accordingly.

Live View makes it easier still to preview depth of field, although it works in different ways depending on the make and model of camera. On some models, Live View always gives a true representation of depth of field at any given aperture, while on others you need to use a depth of field preview button in conjunction with Live View to properly assess depth of field. Being able to preview how depth of field falls will help ensure you place your focus correctly, and achieve just the result you desire.

HYPERFOCAL DISTANCE

Front-to-back sharpness is a prerequisite for most landscape images. A broad depth of field will help you achieve this, but where you focus within the frame is also very significant. A lens can only focus precisely at one given point – sharpness will gradually recede either side of this distance. The hyperfocal distance is the point within the scene that will maximize the available depth of field for any given aperture and focal length combination. By applying this shooting technique, you can help ensure that you don't ever waste any of the depth of field available to you.

MAXIMIZING SHARPNESS

Depth of field extends approximately one-third of the way in front of the point of focus, and two-thirds beyond it. While focusing roughly one-third into the frame is a logical approach to maximizing sharpness, it is far from precise. When your composition includes nearby foreground interest – meaning you will require extensive depth of field – it is important to calculate the hyperfocal length. When a lens is correctly focused on this point, depth of field will extend from half this distance to infinity.

This technique is not as complex as it might first sound. If you are using a prime lens, with good distance and depth-of-field scales on the lens barrel, it is in fact very easy to set: simply align the infinity mark against the aperture marking of the selected f/stop.

However, most photographers today work with zoom lenses, which have rather deficient distance scales. Therefore, photographers need to calculate and estimate the distance themselves. Thankfully, hyperfocal distance charts are readily available online and there are also smartphone apps that will calculate the hyperfocal distance if you enter the camera type, aperture setting and focal length. Frustratingly, having used a chart or app to determine the distance you should focus at, the rather perfunctory distance scales found on modern optics can make it hard to actually focus at that distance. For example, a lens might

only have 0.3m, 0.5m, 1m and infinity marked on its barrel. This is both unhelpful and infuriating should you need to focus, say, 3m away. As a result, you will often need to apply a little guesswork when adjusting focus. Typically, you will find the hyperfocal distance is relatively close-by – normally within 4–5m. Most people can judge distances fairly accurately within this range, so if the hyperfocal length is 2m, look for an object that you judge to be this distance away from the camera and focus at that point.

You can do this using autofocus, by placing the active AF sensor over the point you wish to focus on, or manually. Using Live View can be helpful, as it allows you to zoom into the image and place your focus with great precision. Having set the hyperfocal distance, don't be alarmed if you look through the viewfinder and see that only the immediate foreground appears to be in focus. This is because you are looking through the lens at its brightest, widest aperture setting. To get a true idea of depth of field, press your preview button, or assess it via Live View (see page 41).

While having to 'guestimate' the hyperfocal distance in this way isn't ideal, unless you are using prime lenses there is often no other option. However, while the method might not be 100 per cent accurate, it will prove close enough to be satisfactory. However, it is worth allowing a little margin for error by focusing slightly beyond the calculated distance.

It is good practice to apply hyperfocal focusing in order to maximize image sharpness, especially when using larger resolution sensors, which are less forgiving of poor technique. However, there is no need to apply it to views where no immediate foreground is included. While doing so wouldn't necessarily lead to bad results, it can mean that you are using depth of field where you don't need it – in the foreground – and that the background, while acceptably sharp, could actually be sharper. If the nearest object to the camera is beyond the hyperfocal distance, it is better to focus on that object instead, or just slightly beyond it.

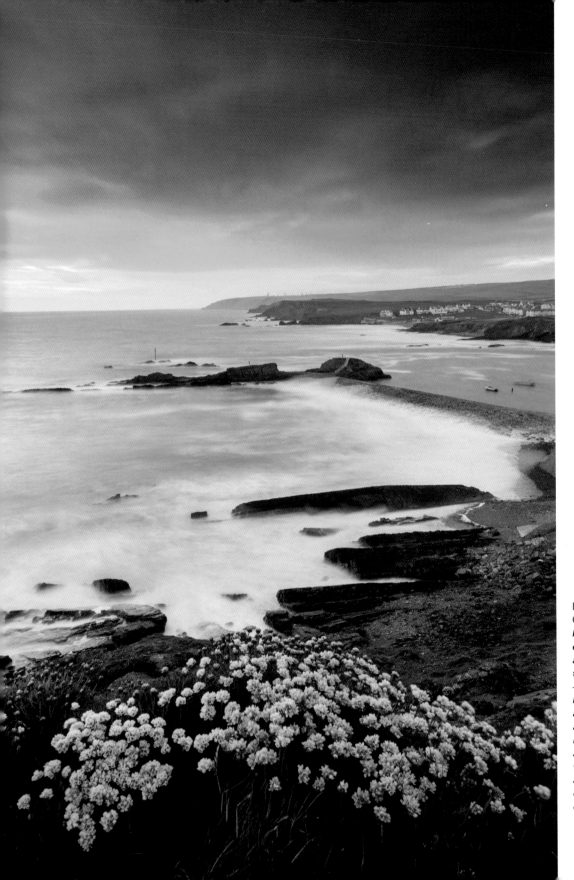

DEPTH OF FIELD CALCULATOR

In this instance, it was essential to calculate and carefully focus on the hyperfocal distance – had I failed to do so, I would not have been able to achieve both acceptable sharpness in the foreground thrift and also the distant view. Personally, I find a phone app is the most convenient type of depth of field calculator.

HYPERFOCAL DISTANCE CHARTS

Although the most convenient hyperfocal distance charts to use are those found on phone apps, we've included two charts here, which cover a range of the most popular focal lengths. You will note that there are different charts for different camera formats. This is because sensor size affects the equation used to calculate depth of field and hyperfocal distance.

You may want to copy the chart relevant to your camera type, laminate it and keep it in your camera bag so it's available when composing your landscape images. When you have focused at the predetermined distance, do not adjust the focal length or aperture until you have taken the shot, otherwise you will need to recalculate the distance. Remember, when using this technique, everything from half the hyperfocal distance to infinity should be acceptably sharp.

HYPERFOCAL DISTANCE

The wavy patterns in the sand drew me to this scene. However, in order to keep both them and the distant castle in focus, I knew I would have to place my point of focus with extreme care. I calculated the hyperfocal distance for a full-frame camera. A 32mm focal length set at f/16 resulted in a hyperfocal distance of 2.2m. I focused at a point I estimated to be this far away, knowing that everything from half that distance to infinity would be acceptably in focus.

HYPERFOCAL DISTANCE CHARTS

These charts show the hyperfocal distance for each given sensor type, focal length and aperture. After focusing at the predetermined distance, finish taking the shot before you adjust focal length or aperture. If you do make these adjustments, you will need to recalculate. Using this technique, everything from half the hyperfocal distance to infinity will be recorded in acceptably sharp focus.

HYPERFOCAL DISTANCE (ft/m) – APS-C SENSORS

	12mm	15mm	17mm	20mm	24mm	28mm	35mm	50mm
f/8	3.2/1	5/1.5	6.4/2	8.9/2.7	12.6/3.8	17/5.2	27/8.2	55/16.8
f/11	2.3/0.7	3.5/1.1	4.5/1.4	6.2/1.9	9/2.7	12/3.7	19/5.8	39/11.9
f/16	1.7/0.5	2.5/0.8	3.3/1	4.4/1.3	6.4/2	8.6/2.6	14.5/4.4	27/8.2
f/22	1.2/0.4	0.9/0.3	2.3/0.7	3.2/1	4.5/1.4	6/1.8	9.5/2.9	19.2/5.9

HYPERFOCAL DISTANCE (ft/m) – FULL-FRAME SENSORS

	16mm	20mm	24mm	28mm	35mm	50mm
f/8	3.8/1.2	5.6/1.7	8/2.4	11/3.4	17/5.2	35/10.7
f/11	2.6/0.8	3.9/1.2	5.8/1.8	7.8/2.4	12/3.7	25/7.6
f/16	1.9/0.6	2.9/0.9	4/1.2	5.5/1.7	8.5/2.6	17.5/5.3
f/22	1.4/0.4	2/0.6	2.9/0.9	3.9/1.2	6/1.8	12.5/3.8

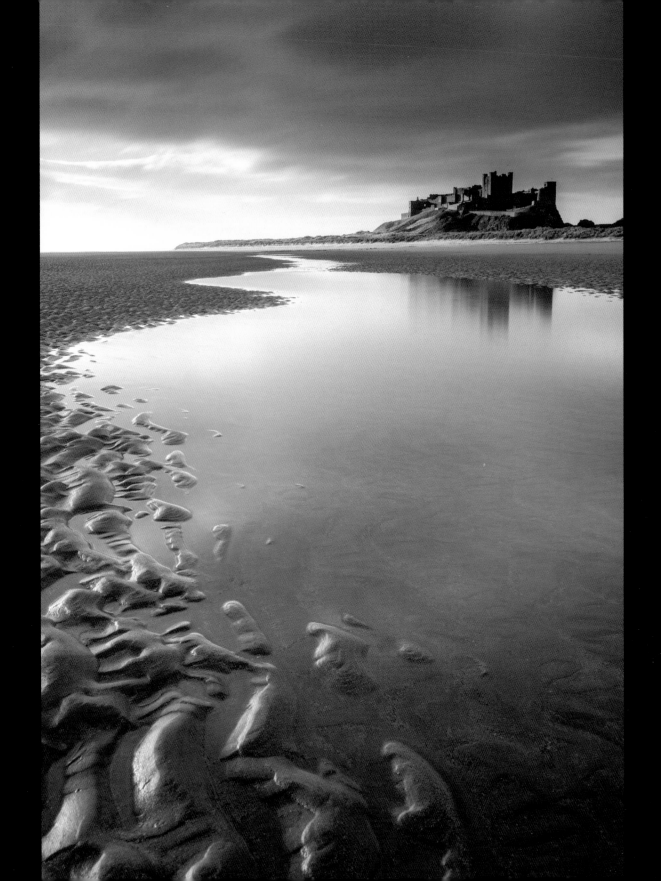

DIFFRACTION

You might now understandably think that you simply need to select the smallest available aperture and focus at the hyperfocal distance in order to guarantee front-to-back sharpness. However, it's not quite that straightforward. As your demands as a landscape photographer grow you will become more discerning. Capturing images that are simply 'in focus' won't be sufficient – you will desire critical sharpness, which is essential when you wish to make quality enlargements of your photographs. The problem here is that while small apertures generate more depth of field, they do not produce the sharpest results, due to an optical effect known as diffraction.

When image-forming light passes through the aperture, the light striking the edges of the diaphragm blades scatters, or 'diffracts', which softens image quality. At wider aperture settings the amount of diffracted light is proportionally quite small, but as the aperture is stopped down (reduced in size), the amount of diffracted light increases. Therefore, despite depth of field increasing, image sharpness actually decreases.

So, continuing on the theme of image sharpness, it is good practice to avoid your lens's smallest f/stops. Instead, try to rely on its optimum apertures, which are the f/numbers that suffer least from the effect. The precise settings can vary, depending on the quality of the lens, but the more circular the aperture (determined by the number of aperture blades), the less light will be scattered. The aperture blades employed in high quality optics tend to be more 'rounded', which also reduces diffraction.

The only way to know how your lenses perform is to do your own tests. We recommend you shoot a series of images, taken at different aperture settings, and enlarge a small segment of each in order to compare them. As a general guideline, users of cropped type SLRs should try to avoid f/numbers smaller than f/11, and full-frame users should go no smaller than f/16. An aperture in this region should still provide sufficient depth of field for the majority of viewpoints – particularly if you are hyperfocal focusing – while keeping diffraction under control.

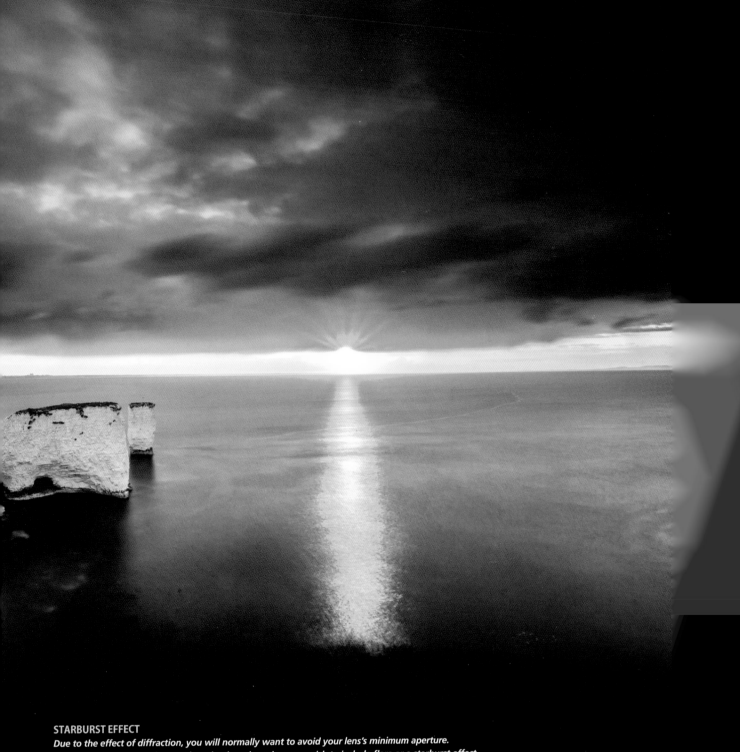

STARBURST EFFECT

Due to the effect of diffraction, you will normally want to avoid your lens's minimum aperture.
There are always exceptions to the rule, though – when you wish to include flare or a starburst effect
in-camera, for example. Diffraction will cause a point source of light to become a starburst shape
when it strikes the sensor. In the right situation, this can add interest and draw attention to the light
source. For this shot, I set the aperture to f/22 to create a starburst effect around the rising sun.

COLOUR THEORY

Colour is an important factor in the vast majority of landscape images. When you are deliberating over how best to compose your shot, the influence of colour shouldn't be overlooked. Colours can be harmonious or conflicting; warm or cold; saturated or muted; calming or unsettling. They will help determine a photograph's mood, impact and – crucially – your audience's emotional response to it. Obviously, as photographers we have no influence over the colours found within the landscape, but we can choose what we do and do not include within the frame.

EMOTIONAL IMPACT

How you employ and combine colours will help determine the look and impact of your photographs. Therefore, it is important to understand the visual and emotional effect of colour. In order to do this, a little knowledge of colour theory is useful.

Different hues can imply different moods and evoke contrasting reactions. For example, red can signify danger, warmth or excitement, while blue is considered tranquil, calming or cold. Green is another calming shade, which often implies freshness, vibrancy and vitality, while yellow is a powerful colour that demands attention; it is often considered happy and uplifting.

Some colours always stand out more than others, and are said to carry more 'visual weight'. For example, even a tiny splash of red can dominate an entire composition, creating a key focal point, or directing the viewer's eye to the subject. If you include a foreground element that is red within your composition – a poppy in a field of barley, for example – it will help create a greater perception of depth.

Red, yellow and orange are all considered 'advancing colours' that will shout out far louder than neighbouring shades, while green, blue and purple are regarded as 'receding colours' that will normally fall away into the background. To fully understand the relationship between colours, it can be useful to look at a colour wheel.

COLOUR WHEEL

A colour wheel is designed to show the relationship between primary, secondary and tertiary colours. Put simply, colours next to each other are 'harmonious', while colours opposite one another are 'complementary'.

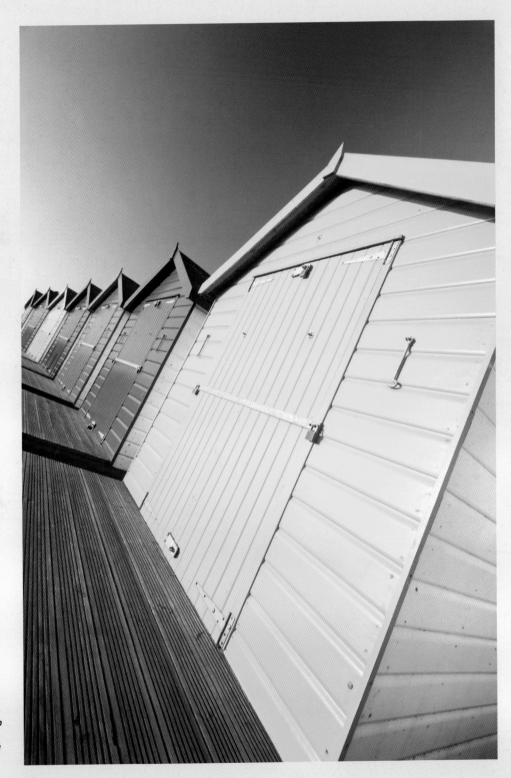

COLOUR DOMINANCE
Although yellow and blue
(complementary colours)
dominate this quirky
viewpoint of a row of beach
huts, our eye still gets drawn
to the red hut further along:
such is the dominance of red
as an 'advancing' colour.

THE INFLUENCE OF COLOUR

How you should or shouldn't employ, combine or contrast colours is tricky, if not impossible, to answer. Much will depend on the result you wish to achieve. There are no definitive rules on working with colour, but a little forethought about colour impact and harmony can prove hugely beneficial.

Your use of colour can be striking or subtle. Saturated colours can certainly make for powerful, dynamic results, but in order to produce saturated images you need to do more than simply adjust the colour saturation slider during processing. If you wish to capture images boasting strong, intense, but natural colours, you need to do so at the picture-taking stage by shooting at the right time of day; early morning and late evening, when the sun is low, produce more intense colours than at any other time of the day.

The light's direction is another consideration. Front light, rather than side lighting, will lead to stronger colour reproduction and using a polarizing filter (see page 28) will also improve saturation. Some of the most intense, natural colour can be found looking toward the sunrise and sunset, so timing and location is also a factor. However, while strong, vibrant colours are seductive and often very appealing to landscape photographers, they are not always desirable. Subtle, muted, pastel tones can prove just as effective, with subdued colours creating a calming, tranquil atmosphere. Weather conditions can play a key role here as well: mist and fog will desaturate the

landscape, and often add a cool, blue hue that you can enhance further through creative use of white balance. A juxtaposition of harmonious colours might not have the same sudden impact as strong, contrasting shades of colour, but they will generate a natural sense of balance and order, and generate results that will look pleasing to the eye.

It is even possible to create successful compositions using just a single colour, or shades of one colour. For example, during the 'blue hour' – the twilight hours when the landscape is flooded with cool, overcast light – your photographs will often be dominated by varying shades of blue. Rather than reduce the image's impact, using a single overriding hue can actually enhance it.

Certain lighting conditions, such as strong backlighting, can create an almost monochromatic look, with washed out colours. Again, applied to the right scene this can produce beautiful results. Removing colour altogether can also help produce dramatic, striking and elegantly simple results (see page 122).

DIFFUSED DETAIL

Photographers often try to maximize the colour in their images, but a more restrained outlook can often prove to be just as effective. Fog and mist desaturate the landscape, producing muted shades and diffused detail in images. Before the sun has risen, mist can add a natural, cool bluish tone to images that is hugely appealing.

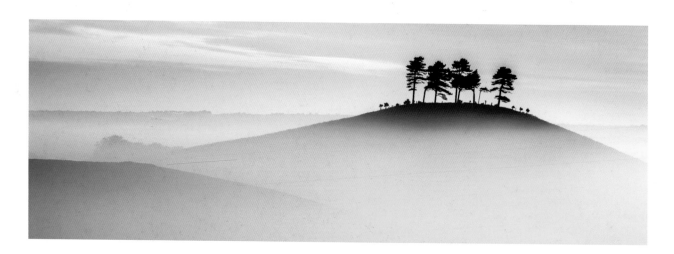

WHITE BALANCE

Every light source has a different colour temperature, which is measured on the Kelvin scale ('degrees Kelvin' or 'K'). Light is considered to be 'neutral' at 5,500K, which is approximately the colour temperature of daylight at mid-day with a clear sky. Lower colour temperatures appear warmer (more orange), while higher temperatures appear cooler (more blue).

In landscape photography the colour temperature is generally lower at sunrise and sunset and higher in overcast and shady conditions, and at higher altitudes, but it changes throughout the day. Our eyes do a very good job of compensating automatically for these changes, while a similar role is performed by a digital camera's automatic white balance option, designed to neutralize colour casts produced by different temperatures of light – just like the human eye. Most cameras also have a number of preset white balance settings, designed to mimic common lighting conditions – Daylight, Cloudy and Shade. By matching the preset to the light you are photographing under, you can achieve neutral-looking results.

However, white balance can have a dramatic effect on the look, feel and mood of an image. Auto white balance is typically very reliable, but it can inadvertently neutralize the warmth of early morning or late evening light, for example, or reduce the coolness of images captured at twilight. The most aesthetically pleasing result is not always be the one that is 'technically' correct.

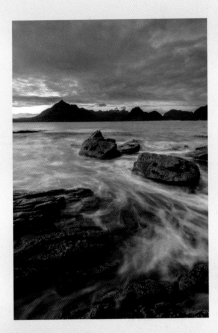
Daylight

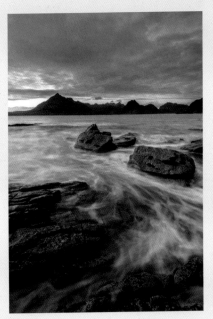
Cloudy

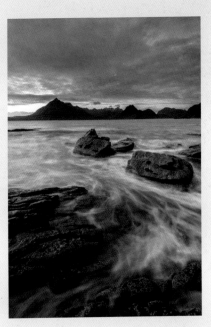
Shade

CREATIVE WHITE BALANCE
Although designed for correction, white balance can also be employed creatively. This comparison illustrates how different white balance settings can affect the mood and look of an image.

► CHAPTER THREE > **BALANCE**

It's now time to progress from raw technique to the aesthetic side of landscape photography. The concept of balance is central to composition. Perhaps the most fundamental decision we make when composing a photograph is how we balance the different elements in a scene to achieve a harmonious composition, or how we do the opposite to create discord. The start of the process is often to choose a focal point for the composition and then decide where in the scene we want to place this point of interest for maximum effect. This chapter will look at the principles behind visual balance and different ways of organizing elements within the frame to help achieve this, such as the 'rule of thirds' and the 'Golden Section'. It's worth bearing in mind, however, that many successful compositions do not conform to these traditional proportions, so while they should always be considered, it's sometimes good to just trust your instincts.

VISUAL BALANCE
Centring the main focal point often results in a rather static composition, so the choice in this instance was whether to place the castle to the left or right of centre. In some ways, placing it at the left was the more logical choice, because of the visual movement down the right hand slope of the hill. However, placing it on the right enabled me to include the rising sun as a counterpoint to the main point of interest.

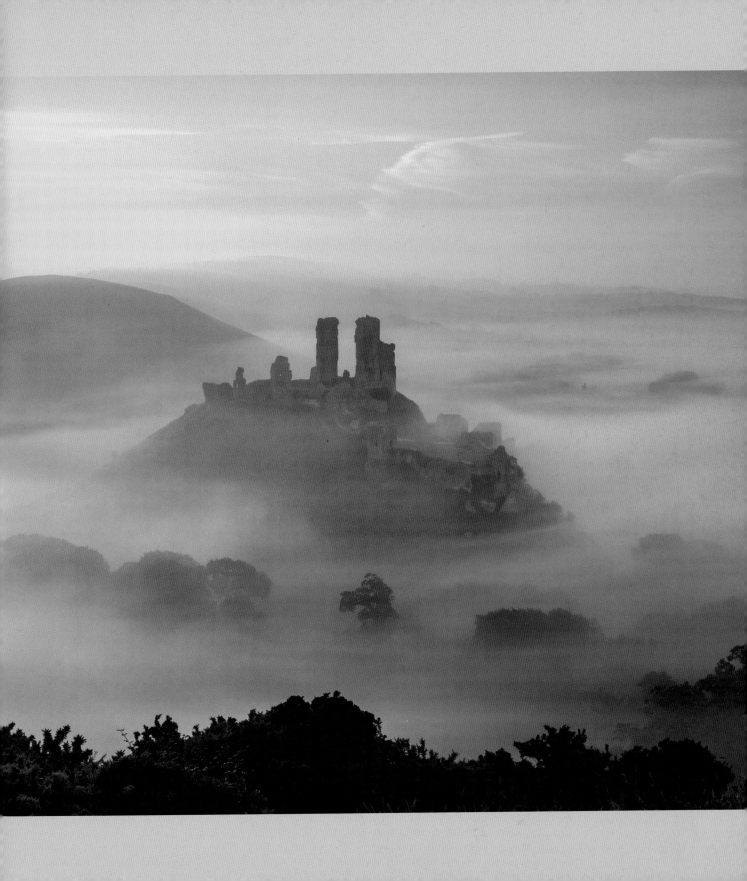

VISUAL BALANCE

For some people, balance equates with symmetry, but this is only one of several ways of achieving balance in a composition. Visual balance is in many ways comparable to physical balance, and making this comparison can help us to understand how it works.

If we place two objects of equal weight on a seesaw they will need to be equidistant from the fulcrum in order to achieve balance. If we translate this to visual balance, then we have symmetry, often thought of as being harmonious, but somewhat static. If we take two objects of different weights, the lighter object will need to be further away from the fulcrum in order to balance them. In visual terms, this would create an asymmetric balance, which would normally be perceived as being more dynamic.

This is, of course, a simplification. In reality, visual balance is more complicated than this, but the basic principle is true. Clearly, in a photograph we can't consider the physical weight of focal points, so what contributes to 'visual weight'? Visual weight could be defined as the 'strength of visual impact' and the factors that create this include size, colour (and its relationship to the surrounding areas), brightness, contrast, texture, shape and inherent interest. Much of this is rather subjective, but there are some basic principles that seem fairly consistent (see box, right).

The goal of most compositions is to achieve harmony and balance, in which no one part of the composition seems significantly 'heavier' than another; paying attention to the guidelines in the box can go some way towards helping us achieve this. Of course, harmony is not the only way to achieve a successful composition; done properly, discord and 'dynamic tension' can be effective.

PRINCIPLES OF BALANCE

- A small object further away from the 'visual fulcrum' will balance a large object closer to it.
- A seemingly lighter shape further away from the fulcrum will balance a heavier object closer to it.
- A small area of high contrast will balance a larger area of low contrast.
- The eye is drawn to bright, saturated colours, so a small area of bright colour can balance a larger area of neutral or less saturated colour.
- Small, complex shapes can balance large, simple shapes; for example a small, busy area can balance a large, uncluttered area.
- Complex, high contrast texture on a small object can balance a large object with smooth texture.
- Objects towards the top of the frame have more visual weight than those near the centre. The top edge of the frame can therefore be a good place for a counterpoint that has less visual impact than a point of interest closer to the frame's centre.

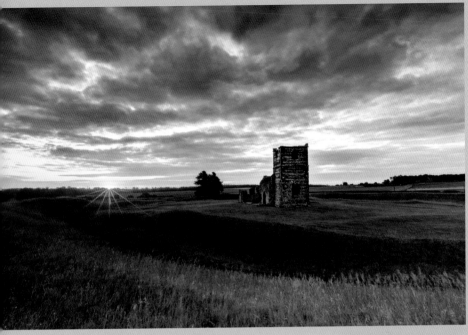

USING IMPLIED MOVEMENT FOR BALANCE

The two main points of interest on the image below are the distant islands on the horizon, and the elliptical boulder at the bottom right hand corner. At first sight, the placement might seem counter-intuitive, as the boulder is large, bright and textured, arguably carrying more visual weight than the islands, yet is placed further from the centre. However, the shape of the boulder generates movement within the frame, pointing inwards and directing the eye to the islands, which form the main focal point. Thus, the boulder, despite being larger and brighter, plays the supporting role in this composition.

BALANCING CONTRASTING POINTS

There are two clear points of interest balancing each other in the picture above – the ruined church and the rising sun – which contrast in several ways: size, brightness / contrast, simplicity / complexity of shape and texture. The church is larger, simpler in shape and has more complex texture, whereas the sun is higher contrast and a more complex shape. It seemed natural to place the larger shape closer to the centre of the frame and have the sun further from it. However, because of its brightness and shape the sun has a lot of visual weight, so it is better for it not to be too close to the edge or top of the frame.

Clearly, as we are dealing with the natural world the placement of objects such as the sun can be a matter of chance, although some control is provided by changes in viewpoint. Careful planning, which means researching locations, working out possible compositions in advance and calculating the position of sunrise is therefore necessary.

Because of the extreme contrast range in this scene, two exposures were made. The highlights were then blended into the main picture using layer masks in Photoshop. A small aperture was set to encourage the 'starburst' effect on the bright light source.

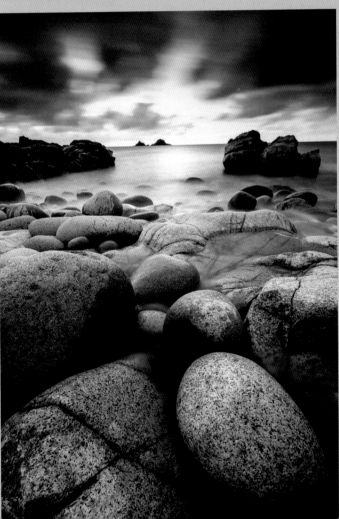

PLACING THE MAIN SUBJECT

A landscape photograph may not have a single, obvious subject in the conventional sense. It may well be that the view itself becomes the subject, but most successful compositions contain a strong point of interest or 'focal point', such as a tree, dominant hill or building. Placing the main focal point centrally in the frame usually results in a rather static composition, as the eye tends to go straight to the subject and is not encouraged to travel around the frame. Simply placing the focal point off-centre will immediately create more interest and dynamism, although there are exceptions

to this – certain scenes lend themselves very much to symmetry, for example (see page 66). Having decided to place the subject off-centre, the question is where exactly to place it. Obvious positions are on an intersection of thirds (see page 58) or an intersection in a golden section grid (see page 60), but there are many other options. An interesting exercise is to find a single object, surrounded by a large amount of negative space, and experiment with placing it in different parts of the frame. What at first sight would seem to be a fairly straightforward experiment can prove surprisingly complex, as there are many options, not only regarding where to place the subject, but also how large in the frame it should be.

Creating a bold composition, with the subject in the corner or at the edge of the frame can create an interesting result, as the natural tendency is for the eye to seek out a counterpoint in another part of the frame to create balance. If there is no other object in the frame, then the negative space itself becomes the counterpoint, creating a sense of isolation and perhaps unease. This works well if the space has some intrinsic interest – a textured sky, for example – but is an approach that should be taken with some caution. Bold, unconventional placement only really works well if it done with good reason.

A sense of movement also has an influence on the placement of the subject. If the subject is moving – or movement is implied – then it seems most natural to have the subject moving or pointing into the frame rather than out of it. In these situations, placing the subject too close to the centre, or even adhering too strictly to the rule of thirds or golden section can also be a mistake, as it can leave wasted space away from the direction of movement. Instead, the most natural place for the subject is further towards the frame edge.

A SINGLE SUBJECT
Deciding on the placement of a single subject can be a remarkably complex process, as there are numerous options for what is a fairly simple end result. In this case, positioning the post towards the left edge of the frame seemed to suit the scene, as it is counterbalanced by the large expanse of soft, textured sky. The post itself is straight, but its reflection in the sea and wet sand is angled into the frame; further encouragement for placing the subject close to the edge. A long exposure simplifies the scene further by smoothing out the texture of the water.

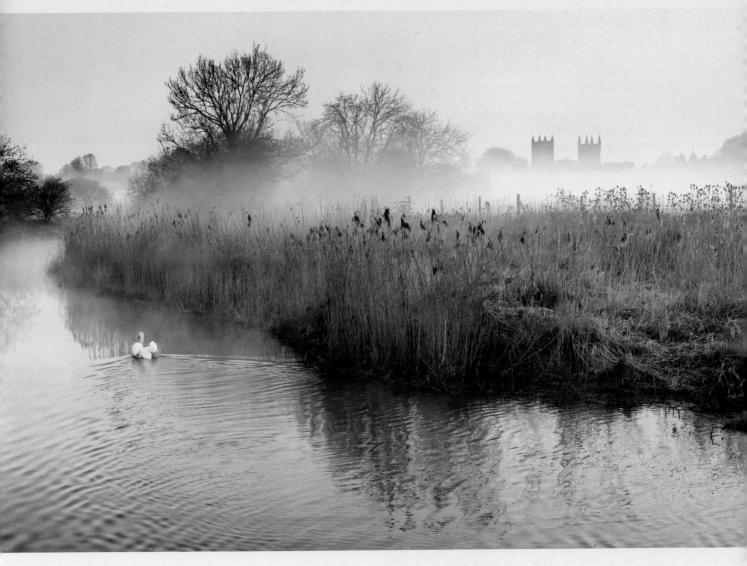

PLACING A MOVING SUBJECT

When this swan started approaching from downriver, my initial thought was that the ideal position for it would be moving into the composition from the bottom right hand corner. However, it failed to follow the course I'd hoped, so I pressed the shutter when it was swimming towards the left hand edge of the frame, just past one of the divisions of thirds. On reflection, this works better than the position I had hoped for: if the swan were at the bottom right quarter of the frame, the composition would be biased too heavily to the right side of the frame. As it is, the other focal point – the church – is a good counterbalance, creating a sense of harmony.

57

THE RULE OF THIRDS

Anyone who has been involved in photography for even a short time will have come across the rule of thirds. It is a simple way of dividing the frame and then using this division to arrange the elements in the composition in a balanced and harmonious way.

Part of its appeal is that it is simple to apply: imagine a grid overlaying your viewfinder, dividing it into thirds, horizontally and vertically. You can then use this grid to arrange the different components in the scene, usually starting with the horizon, which would typically be placed either on the top or bottom third line, depending how much interest there is in the sky. Once this decision has been made, you can move on to the other points of interest. If you are including a clear focal point in the composition, and have decided to place it off-centre, then the rule of thirds provides a useful guideline in that the intersections of the horizontal and vertical dividing lines are powerful places for points of interest.

The rule of thirds is derived from the theory of the 'Golden Section' in art and architecture (see page 60), and is a tried and tested way of achieving a balanced composition. However, the fact that it is so well known and well established brings with it both strong advantages and disadvantages. Perhaps the strongest point in its favour is that, quite simply, it works. After all, if it didn't, it wouldn't be such a strongly established principle.

On the other hand, it does attract a fair bit of criticism from experienced photographers, who dismiss it as clichéd and formulaic. To some extent, this is a valid point of view, as anything that is so widely practised is in danger of becoming hackneyed. Certainly, if a photographer only ever based compositions around the rule of thirds, their work would look formulaic.

However, it would of course be foolish to completely reject a compositional tool that works, so while it makes sense to avoid applying the rule to every image you take, even for the experienced photographer it provides a useful starting point when working out how to organize the main points of interest in the frame. For less experienced photographers it can provide a reliable framework when getting to grips with the art of composition, perhaps before moving on to more nuanced ways of structuring an image.

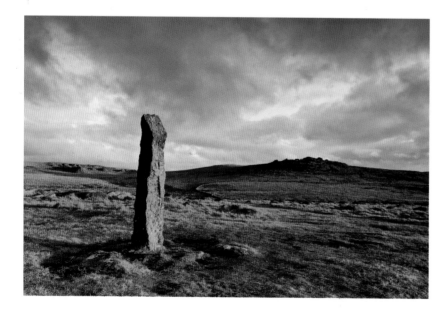

THE RULE OF THIRDS
With few elements in the composition of this image, the main choices were where to place the foreground and background focal points (the standing stone and the granite tor on the hill top in the background). I decided to place them on a dividing line of the rule of thirds grid, resulting in a pleasing sense of balance and harmony.

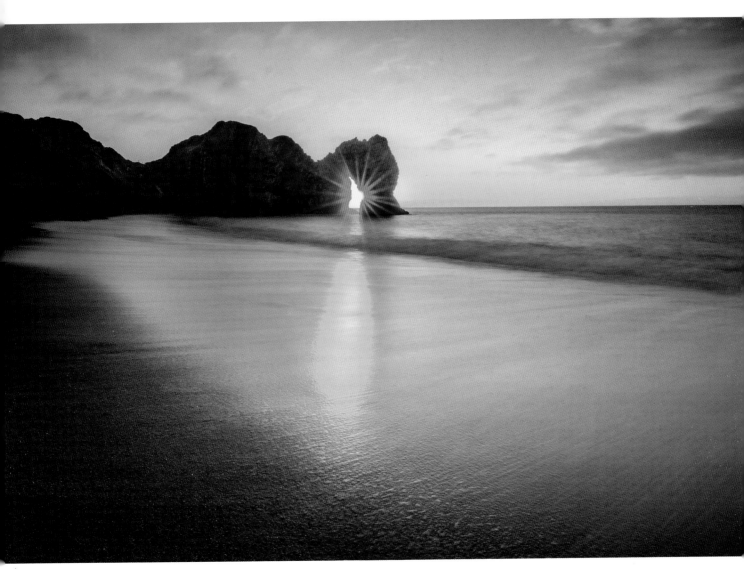

BREAKING THE RULE OF THIRDS

Not all scenes will fit neatly into a rule of thirds grid, or any other formal division of the frame. In this shot, the main focal point of the image is the sun, seen rising through the rock arch, which has been rendered as a starburst through the deliberate use of a small aperture.

Convention would have this point placed on an intersection of thirds, but there were other considerations when it came to composing this image. The arch, sky and the wave breaking on the shore are all key elements that need to be balanced. Placing

the sun on the left third would have resulted in too little of the arch appearing in the frame and too much empty space at the right of it. If it had been positioned on the right third, there would be too much dark cliff at the left, too much empty beach and too little focus on the wave in the foreground. Therefore, in order to balance these features the only sensible option was to place the sun fairly centrally in the frame. With the clouds fanning out to the corners there is a certain symmetry to the top section of the frame, so this works quite well.

TIP: With modern digital SLRs and CSCs (compact system cameras) there is no need to 'imagine' a rule of thirds grid in the viewfinder, as most have an option that will overlay this (and other grids) in the viewfinder or on the live view screen.

THE GOLDEN SECTION

The rule of thirds (see page 58) is probably the best-known way of dividing up the frame to achieve balance, but it is in fact derived from a more complex ratio, which dates back to the ancient Greeks, and was popularized in art during the Renaissance – the Golden Ratio. The Golden Ratio is inherently harmonious, occurring frequently in the natural world, and people of all cultural backgrounds tend to find attractive images and objects that conform to the proportion. It is less widely known than the rule of thirds and probably less well understood, but should (in theory at least) provide an even more harmonious division. After all, the rule of thirds is merely a simplified version of it.

The Golden Ratio works like this: if you divide a line into two parts so that the proportional relationship between the smaller part and the longer part is the same as the proportional relationship between the longer part and the whole length, then you have divided the line according to the Golden Ratio. Expressed mathematically, this proportion is approximately 1:1.618 – the smaller and longer parts differ in length by a ratio of 1:1.618, as do the longer part and the whole line. This ratio can be used to divide the image frame. If you divide the frame into two rectangles, so that the ratio of the small rectangle to the large one is the same as that of the large one to the whole frame, you create a 'Golden Section'. This can be subdivided according to the same ratio, and the result is a grid that looks something like a 'squashed' rule of thirds grid. As with the rule of thirds, the intersections of the horizontal and vertical lines are powerful places to position focal points.

The Golden Section is popular among artists, many of whom will actually sketch the grid onto the canvas before they start painting, but it's a little harder for photographers to apply. Firstly, the proportions are not as easy to visualize as a rule of thirds grid. More importantly, even if you own a camera that allows you to superimpose a Golden Section grid on the viewfinder, you can only work with what is in front of you: few scenes lend themselves perfectly to a Golden Section arrangement.

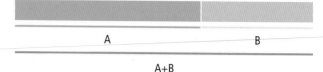

$$\frac{A}{B} = \frac{A+B}{A} = 1.618 = \Phi$$

THE GOLDEN RATIO
The proportional relationship between a and b is the same as between a and a+b – a ratio of 1:1.618.

THE GOLDEN SECTION GRID
The image frame can be divided up according to the Golden Ratio to create a grid similar to the rule of thirds grid, with focal points being placed on the intersections of horizontal and vertical lines.

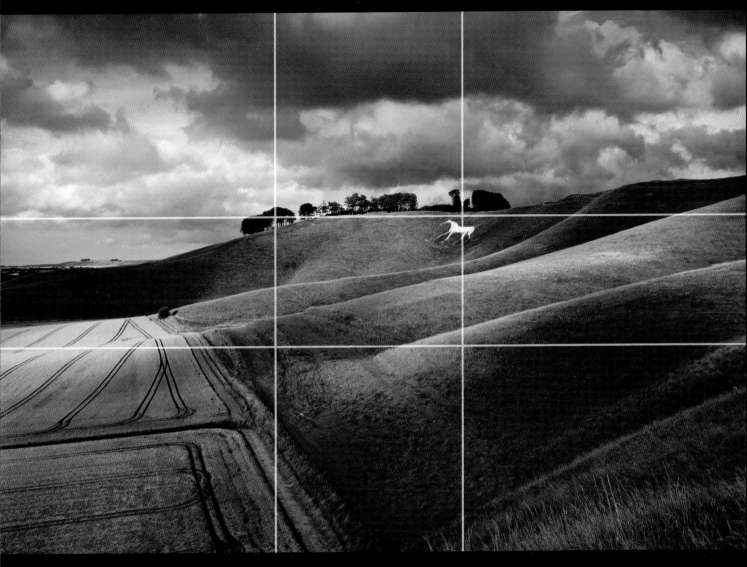

GOLDEN SECTION IN PRACTICE

The key elements in this image are arranged according to the Golden Section. The division of land and sky is close to the upper horizontal dividing line and the white horse, spot-lit by the low sun, is almost exactly on an intersection of horizontal and vertical lines. This was not a conscious decision at the time of shooting, but was framed intuitively; it just looked 'right' in the viewfinder.

However, being precise is not crucial; a composition can be based loosely around the Golden Section and still be successful. Alternatively, it can partly conform to the proportions. To a degree we have control over where we place the focal points in an image, and placing a focal point on an intersection of Golden Section lines can create harmony, even if everything else in the composition does not fit exactly.

In many respects, it is probably best to treat the Golden Section as an analytical tool. This is partly because of the difficulty involved in applying it consciously in the field and also because deliberately imposing it on a scene can result in 'forced' or contrived compositions. Looking at a variety of images and seeing to what extent they adhere to the proportions will naturally lead to a greater familiarity with the proportions, with the likelihood that they will be applied instinctively when composing images.

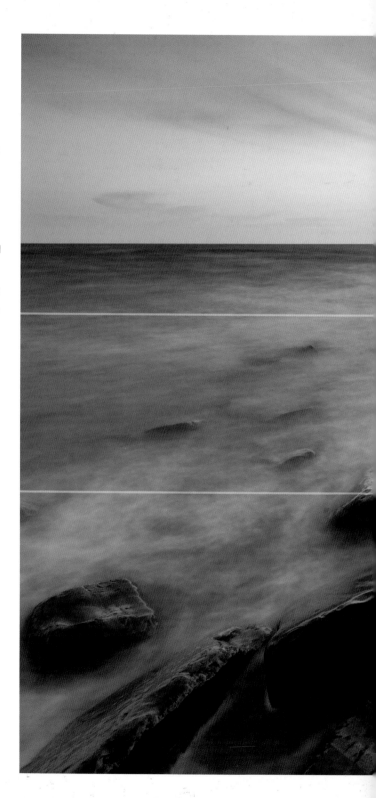

FIT THE GOLDEN SECTION
While photographers can never have the same amount of control as painters do over where to place elements in the frame, careful selection of the viewpoint can have some influence. Through careful positioning of my tripod I was able to place two key components – the end of the headland and the end of the triangular group of rocks – very close to the vertical grid lines. The group of rocks at the bottom left of the frame also fall neatly into one of the sections of the grid, all of which makes for a harmonious arrangement.

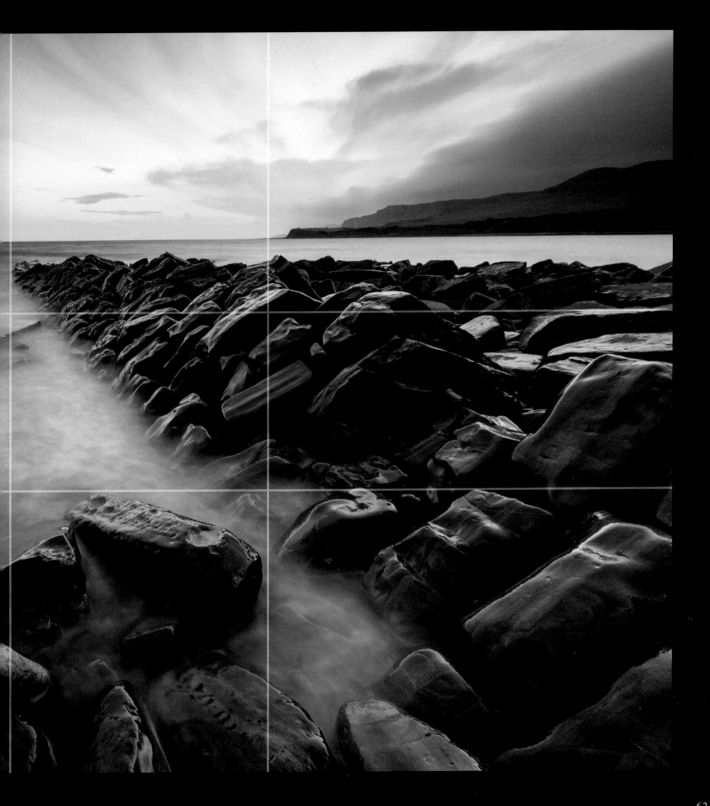

ALTERNATIVE METHODS FOR ORGANIZING THE FRAME

There are many valid possibilities for arranging the elements in a composition beyond the rule of thirds and the Golden Section. Two particularly interesting divisions, however, are closely related to The Golden Ratio.

THE FIBONACCI SEQUENCE

In the Fibonacci sequence you start with two numbers, 0 and 1. Each subsequent number is the sum of the previous two, creating the sequence 0, 1, 1, 2, 3, 5, 8, 13 and so on. The Fibonacci sequence is closely connected to the Golden Ratio, in that the ratio between any two consecutive numbers in the sequence is very close to the Golden Ratio (for example, the ratio of 34 to 55 is 1:1.6176). In fact, if you express the Golden Ratio as rational numbers, the closest approximations are the numbers in the Fibonacci sequence.

It is possible to use the Fibonacci sequence to create an image frame, as in the illustration shown here. This is very close to the 3:2 proportions of many digital SLR formats, making the grid very useful for modern photographers when it comes to placing the elements in a scene. It is claimed that the Fibonacci sequence occurs throughout nature, which is why compositions based around it are inherently

pleasing. However, there are those who argue that the frequency of its appearance in the natural world is somewhat overstated. In any case, the internal logic of a Fibonacci grid makes for an interesting and harmonious arrangement.

THE FIBONACCI SPIRAL

If you use arcs to connect the opposite corners of the squares in a Fibonacci grid, you get a Fibonacci spiral, as illustrated here. It is also possible to create a spiral based around the Golden Ratio. Although this is slightly different from the Fibonacci spiral, the two are so similar as to be the same for all practical purposes. Again, this is a shape that appears in nature (although perhaps not as often as is claimed) and is an excellent way of organizing a composition, particularly one that is based around arcs and curves.

THE GOLDEN SPIRAL IN PRACTICE
The 'visual flow' of this image correlates very closely to the Golden Spiral. The eye enters the image from the left and sweeps down around the bottom of the rock pool. It then explores the waves at the right hand side of the frame, before spiralling around to the background focal point – the sun rising over the ocean. Of course, the framing was intuitive and wasn't planned around a Golden Spiral, but familiarity with the proportions helps make this sort of composition an instinctive choice.

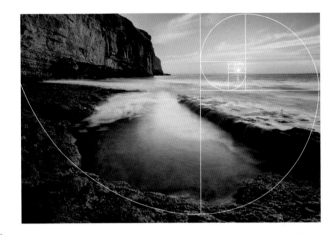

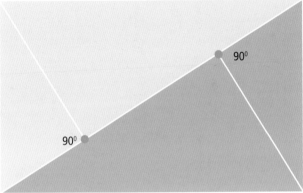

THE GOLDEN TRIANGLE

The Golden Triangle is also related closely to the Golden Ratio. Here you draw a line from the bottom corner of the frame to the top. Lines are then drawn perpendicular to this line, into the other corners. As a result, the frame is divided into two small and two large triangles. The result is a frame division that works particularly well if there are strong diagonal lines in the composition.

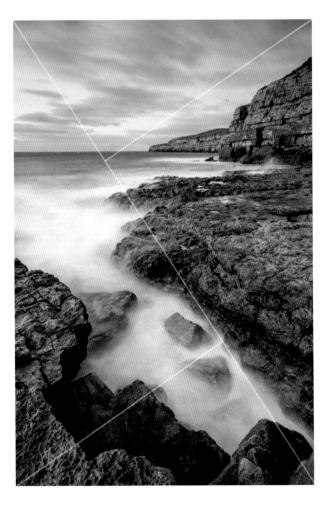

A GOLDEN TRIANGLE GRID
Golden Triangle grids work well when there are strong diagonal lines in a composition. In this image, the main diagonals of the channel and the cliffs broadly follow the diagonal lines of a Golden Triangle grid.

SYMMETRY

Beginners in landscape photography (and photography in general) are usually advised to avoid centring the main subject as this can lead to dull, static images. However, symmetry is common in the 'real world', both in nature and in man-made objects, so it would be a shame to ignore the compositional opportunities presented by this type of balance.

Symmetry occurs when objects on one side of any imaginary line are mirrored on the other side of the line. This line is often referred to as the plane of symmetry. The human plane of symmetry is vertical. As a result, we get a better feeling of balance from images with a vertical plane of symmetry. That said, certain subjects (such as reflections in lakes) clearly lend themselves to symmetry based around a horizontal plane. In minimalist images (see page 166) placing a single subject dead centre can work well, especially when the image frame is square. Scenes with strong converging lines (see page 94) are also very suited to symmetrical compositions, especially if the lines converge on a single, strong subject.

When composing symmetrical images, precision is vital. If the plane of symmetry is not properly centred, it will be immediately obvious and discordant; there is no room for even the slightest error. Furthermore, as well as the balance either side of the plane of symmetry, we need to consider how the rest of the composition is balanced. With a vertical line of symmetry, most images will appear better balanced and more 'stable' if there is greater visual weight at the bottom of the frame.

As well as horizontal and vertical symmetry, we can also find radial symmetry, where elements are arranged regularly around a central axis. There are many examples of radial symmetry in the natural world: the arrangement of petals on a flower, starfish and sea anemones to name a few. It is far less common in the landscape, but is worth looking out for, especially when framing detail shots and 'miniature landscapes'.

PLACING THE HORIZON

Positioning the horizon so it runs across the centre of the frame goes against the traditional guidelines of composition, such as the rule of thirds and the Golden Section. There are, however, occasions when it is perfectly natural to centre it. One obvious example is when symmetry occurs along a horizontal axis, as it does with reflections in water.

It is also worth considering the psychological impact of a centred horizon, as it can suggest stillness and tranquillity. If there are other elements in the scene that convey this atmosphere, such as the weather conditions, then a central horizon is a good option.

When placing the horizon, you also need to consider the overall balance of the composition and take a good look around the frame to ensure the other components are balanced. Sometimes this will only happen when the horizon is centred, and this will be the best way to achieve overall balance within the image.

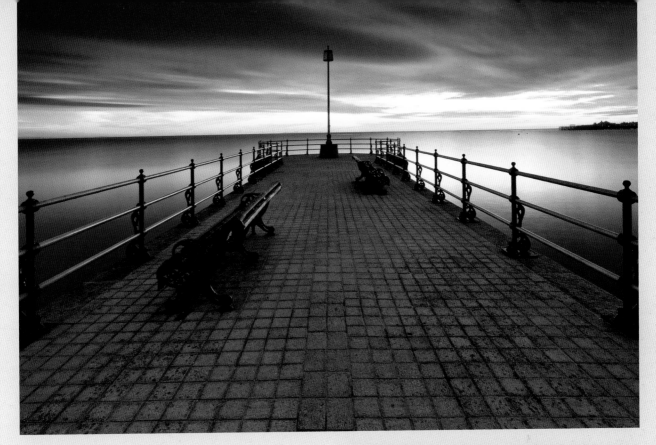

NEAR SYMMETRY

The strong converging lines leading towards a central pole made a symmetrical composition the natural choice for this image. As with all images of this nature, it was important to be as accurate as possible with the framing. Using the grid lines on the camera's LCD screen as a guide, I ensured that the pole was centred and that there was an equal amount of space between the railing posts and the left and right frame edges.

Other points had to be considered regarding the overall balance of the shot. Rather than centring the horizon, I placed it in the upper part of the frame, so that the pier would add weight at the bottom of the image, creating stability in the composition. The scene, of course, is not completely symmetrical (one bench is further away from the camera than the other), but this slight asymmetry works well, especially as the distant pier on the horizon provides a counterbalance to the nearest bench.

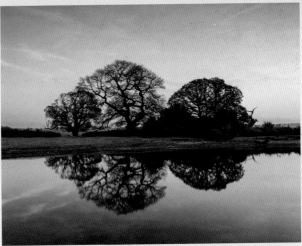

REFLECTIONS

Reflections in lakes and ponds lend themselves well to a symmetrical composition. This image is not truly symmetrical, however, as there is not an equal amount of space above the trees tops and below their reflection. This was deliberate; I wanted to place a little more emphasis on the sky and the pre-dawn glow on the clouds, and liked the way the wispy clouds were drifting into the top corners of the frame.

THE RULE OF ODDS

The rule of odds is so straightforward that it's surprising that it's not discussed more often in relation to photographic composition. Quite simply, it states that odd numbers in a composition tend to be more pleasing than even numbers. Of course, like all compositional 'rules', it is not an absolute and there are plenty of examples of successful images that ignore it. However, it's worth spending a little time examining the psychology behind it and considering why it might be effective and when it is worth applying.

The rule of odds works because of the brain's habit of trying to find shapes and patterns. One thing it will attempt to do is to pair up objects. This is obviously not possible with an odd number, which keeps the eyes moving around the image, resulting in a more dynamic composition.

There's a little bit more to it than odds and evens, though, as certain numbers work better than others. Arranging objects in threes works especially well, as in its quest to find shapes, the brain will usually join the points to make a triangle. Triangles are particularly useful shapes in composition, as they invite the viewer into the picture, encouraging the eye to explore and move around the frame.

Depending on the arrangement, symmetry can also play a role in the pleasing nature of odd-numbered objects. A central point with evenly spaced objects around it creates a symmetrical balance, and for this reason, framing a focal point with an even number of objects can provide a satisfying balance.

Once the number of objects becomes too great the eye will stop trying to arrange them into a single shape and will start to perceive groups, patterns or lines. At this point odd numbers start to lose their significance and it becomes more important to look at the overall shape or arrangement of objects than the number. The rule of odds can be useful, but it's advisable not to get obsessed by it. Unlike painters, who can add whatever number of objects they want to a composition, photographers have to work with what is there in front of them, which may be an even number. The fundamental difference between composition in painting and photography is that painting is an additive process, whereas photography is subtractive: we start with everything that is in front of us and then, via lens choice and viewpoint, try to exclude what doesn't benefit the composition. While it may be possible to frame a shot to crop out unwanted objects and follow the rule of odds, doing so might upset the balance in other ways. Therefore it is generally better to prioritize the arrangement of the elements in the frame, even if this means ignoring the rule of odds.

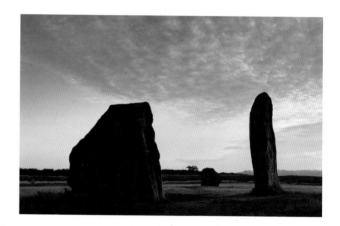

THREE – THE MAGIC NUMBER
Three is something of a 'magic number' in composition. In this instance, having two larger objects closer to the camera suggests a base for the triangle at the bottom of the frame. This helps to create greater visual stability, which is necessary with the strong sky above the stones. To see how important it is to have three standing stones rather than two, try covering the stone in the background and see how much weaker the composition becomes.

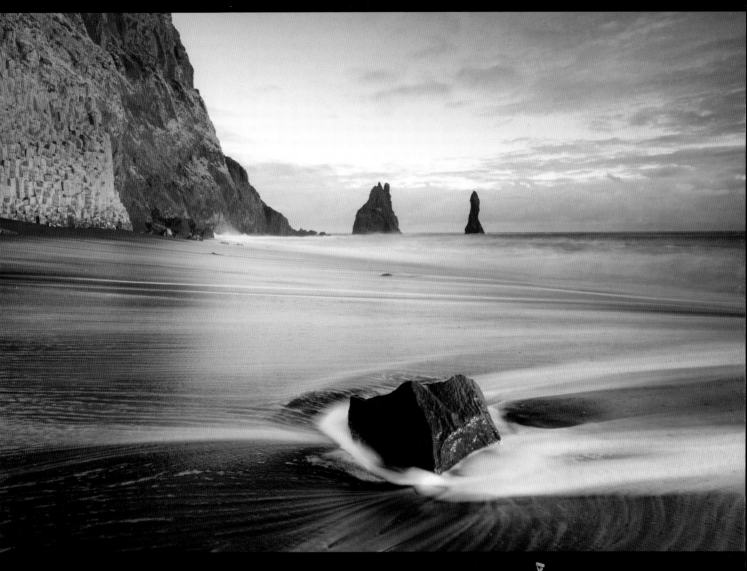

BREAKING THE RULE?

The rule of odds is not one that can be adhered to particularly strictly, as so much is out of the photographer's control – other than framing to exclude or include certain elements – and therefore is not worth obsessing about. In this instance, there were only two rock stacks in the scene, but it would have been ridiculous to have therefore decided not to take a shot. To balance the two stacks, I included a rock in the foreground, with a wave washing around it, which forms an implied triangle.

CAMERA ORIENTATION

The vast majority of photographs are taken with the camera in a horizontal or 'landscape' orientation. The reasons for this are simple: first, the field of human vision is horizontal and so this way of framing a shot accords with our view of the world; second, most cameras are designed to be held and operated in landscape orientation (and in some cases are actually quite awkward and uncomfortable to use in 'portrait' orientation). Of course, as landscape photographers, our cameras will nearly always be tripod-mounted, so this last point should be less of an issue.

If you only ever shoot in landscape orientation, not only will your pictures become predictable and lack variety, but also you will not always capture the scene in the most effective way – when emphasis needs to be placed on foreground interest, for example. However, as with all aspects of composition, turning your camera on its side shouldn't be something you do just for the sake of it. It needs to be a considered decision, and there are many factors that will influence whether a composition works better in landscape or portrait format.

In general, a landscape format works best with a horizontal subject; when there are strong horizontal lines in the composition; or when there is horizontal movement (real or implied) in the frame. As most landscape images feature a dominant horizontal line in the form of the horizon, this is another reason why the majority are framed horizontally. Landscape orientation also works best if you are trying to suggest a sense of isolation and space in a composition by placing a small subject in a large area of negative space.

Unsurprisingly, portrait format is more suited to vertically oriented subjects or focal points, such as trees, tall buildings and the like, or when there is a predominance of strong vertical lines in the composition. However, vertical lines rarely exist in isolation, and are often balanced in a scene by horizontal lines. In these instances, landscape orientation can still provide a better balance.

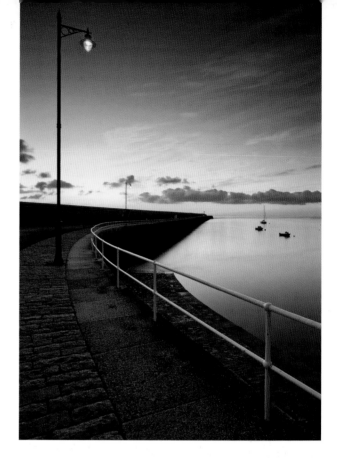

VERTICAL MOVEMENT
This scene was a natural candidate for using a portrait orientation. With the strong vertical line of the main focal point, combined with the leading lines creating vertical movement through the frame, it is hard to imagine it otherwise.

Using a portrait format works particularly well when there are acute diagonal lines in the scene, as this orientation places emphasis on these lines, creating a more dynamic composition. It is also the simplest way of emphasizing a strong sky. If vertical movement is present (or implied) in the scene, then portrait orientation would again be the natural choice.

Of course, if you are in any doubt about whether to compose a shot vertically or horizontally, the obvious thing to do is to shoot both options. This is also a good habit to get into if you are working professionally, as it gives options to picture editors and designers. I have often found that when I've submitted portrait and landscape versions of the same shot, the one that is chosen is not necessarily the one that is stronger pictorially; from the designer's point of view, the best composition is the one that fits the available space.

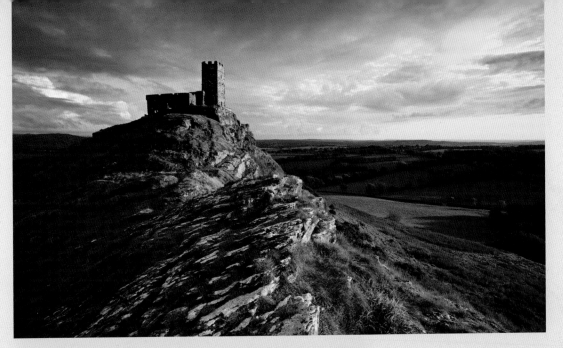

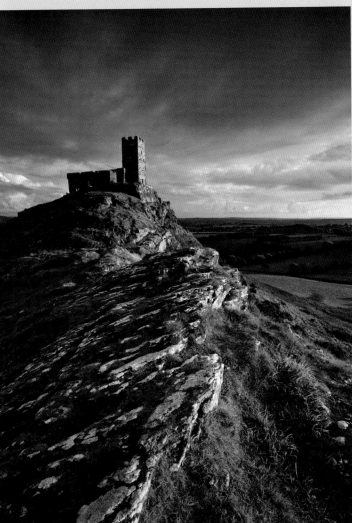

LANDSCAPE OR PORTRAIT?

My natural instinct when first viewing this scene was to frame the image vertically. I was influenced by the strong leading line entering the frame from near the bottom left corner, implying vertical movement, as well as the strong vertical line of the side-lit church tower (the main subject). There was also a desire to make the most of the dramatic, stormy sky. As the light was so good, I decided to make sure that all options were covered, so experimented with different compositions, including one in landscape format.

On reviewing the images, I decided that the horizontal version had more appeal. Apart from the fact that the warmer light is slightly more attractive, there are some important compositional features that contribute to its success. Firstly, the shape of the hill is revealed better in the horizontal frame; the slope down to the bottom right corner is satisfying, and is cut off in portrait format. More importantly, there is a much better feeling of space in the landscape format composition. The vertical shot feels rather cramped, whereas the horizontal version emphasises the space around the church, showing it more fully in its dramatic location and creating a stronger feeling of isolation.

▶ CHAPTER FOUR >
DEPTH AND PERSPECTIVE

One of the fundamental challenges involved in being a photographer is overcoming the fact that a photograph is a two-dimensional representation of the three-dimensional world: badly composed images can appear, quite literally, 'flat'. However, our brain has to recreate three dimensions from the two-dimensional image projected onto the eye's retina, so it is capable of doing the same thing when we view a photograph. If we have a basic understanding of how the human brain interprets perspective, then we can use this knowledge to help us exploit these visual clues in our photographs. In doing so, it will make it easier for the viewer to perceive three dimensions on a flat print or computer monitor. In this chapter we will look at the different ways that we perceive depth, as well as how viewpoint and lens choice can influence how we perceive scale and depth in an image.

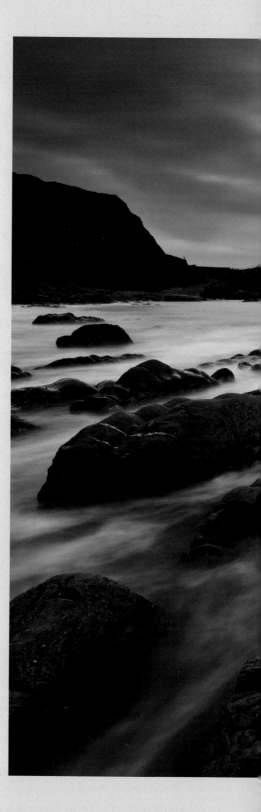

A SENSE OF DEPTH

The impression of depth in this image is created in various ways. The most powerful of these is linear perspective, with the strong lines in the image converging towards a clear vanishing point on the horizon, marked by the distinctive shape of a rock stack. This has been exaggerated by getting in close to the nearest objects in the foreground with an extreme wide-angle focal length. The feeling of depth is also enhanced by the light-to-dark contrast, with lighter tones standing out from the dark shapes in the background, and also by the sense of movement created by the waves.

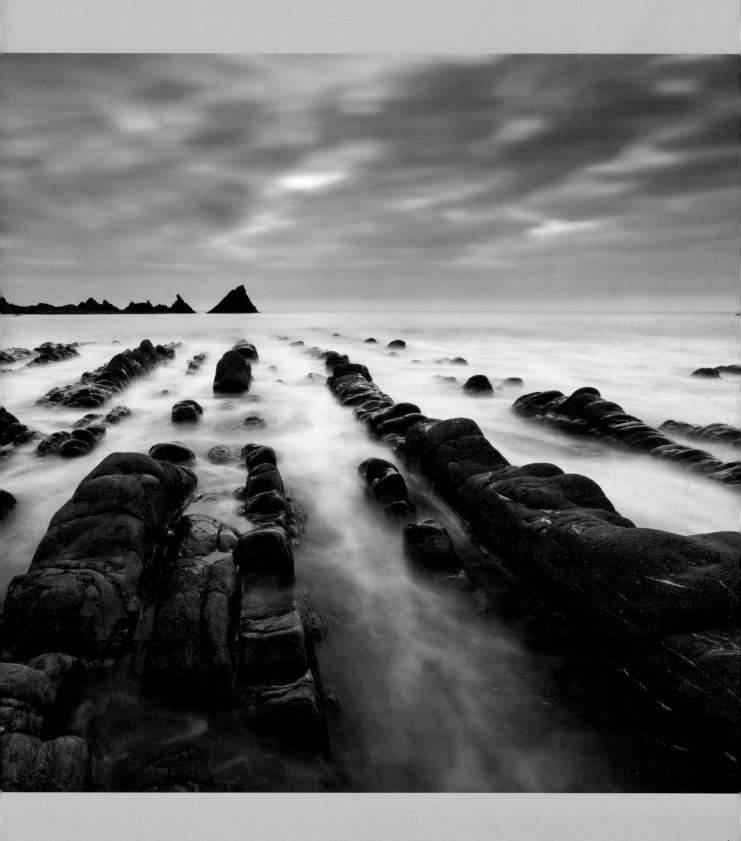

LINEAR PERSPECTIVE

Linear perspective is how the human eye judges distance, based on the way in which elements in a scene apparently diminish in size the further they are from us, and the angles at which lines and planes seem to converge. Although lines that are parallel, such as railway tracks or the sides of bridges, will appear to converge when viewing them, we understand that they are in fact parallel.

Linear perspective is enhanced by the perception of diminishing size (objects appear smaller the further away they are), so that if you have a number of similar objects going away from the camera, such as a line of trees, a strong impression of depth is created. Closely related to this is the fact that the closer we are to objects, the greater the distance between them appears to be. For example, if there are two trees, one 10 metres behind the other, and we stand one metre in front of the first one, the gap between them will seem quite significant. However, if we view the same trees from 100 metres away they will appear much closer together.

We can use this effect to exaggerate linear perspective in a photograph. By getting close to the nearest object in a scene and using a wide-angle lens, the apparent distance between foreground and distant objects will be greater than if we shoot the same scene from further away with a telephoto focal length. Using a wide-angle in this way creates a strong illusion of depth, and gives rise to the notion that wide-angle lenses exaggerate perspective, while telephoto lenses compress perspective. This is, however, untrue: changing focal length simply changes the magnification of objects in the frame. It is the lens-to-subject distance that determines the perceived relationship between the objects and thus the apparent perspective, but in order to shoot a subject from closer in or further away we need to change magnification, which means changing focal length.

Camera height also has an effect on linear perspective, as the lower the camera, the greater the degree of convergence. Therefore, the temptation is often to try and create a dramatic perspective by attempting a 'worm's eye' view of a scene. However, this can be counter-productive as it can introduce problems with the amount of separation between elements in a composition. The converging lines of linear perspective can be used to imply movement into the frame, so linear perspective can be enhanced by this feeling of movement: a figure coming in from a corner or the flow of a river or a receding wave, for example, as in the picture on page 73.

Closely related to linear perspective is 'texture gradient'. Most planes and surfaces, such as fields, oceans and roads, have texture. As their surface gets further away from us, the texture appears to become finer and smoother, providing a further depth cue. This often combines with converging lines and planes to create a strong impression of depth.

WIDE-ANGLE PERSPECTIVE

There is strong linear perspective in this view of the end of a pier, created by two sets of converging lines – the railings and the bolt holes at the side of the plaques. The diminishing size of the plaques creates a strong sense of depth, enhanced by the extremely low camera angle. There is also a texture gradient, in both the planks, which become smoother the further they go into the distance, and the railings, whose pattern slowly takes on the appearance of fine mesh.

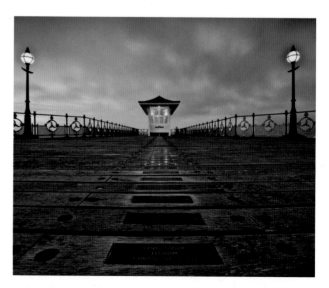

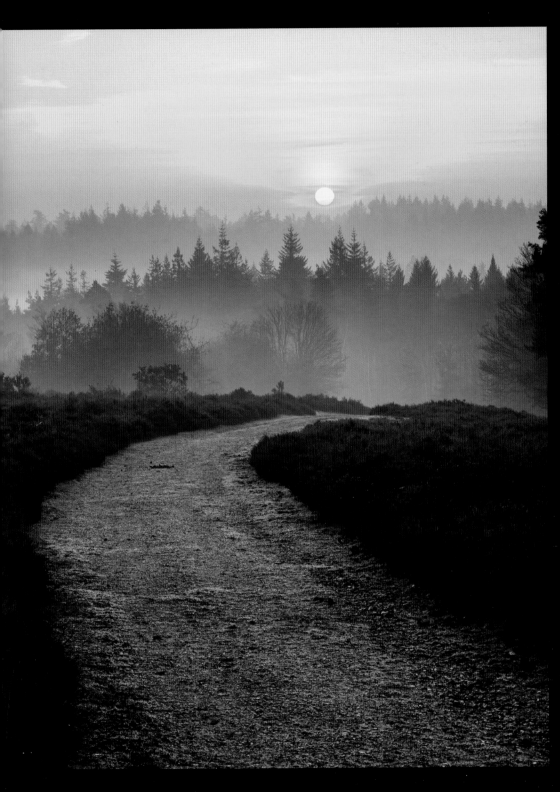

TELEPHOTO COMPRESSION

Although there are elements of linear perspective in this shot, with the converging lines of the path leading into the middle distance, the overall impression is that it is 'flatter' than the previous shot. This is largely because of the three layers of trees in the background. Although they form distinct planes, we get the impression there is very little distance between them. There is also very little apparent space between the trees and the foreground plane. This is because they have been photographed at a distance with a telephoto focal length. The choice of a longer-than-standard focal length has also magnified the sun, making it loom large in the frame, which also creates the impression of the background being closer than it is.

THE VANISHING POINT

Following on from linear perspective is the concept of the vanishing point – the point at which parallel lines appear to converge. With the camera level, horizontal lines will meet on the horizon and vertical lines (if the camera is tilted upwards) will meet at a point in the sky, possibly outside the image frame. Because of the traditions of western art, most of us are familiar with vanishing point perspective and it is a powerful way of conveying depth in two dimensions.

There are many examples of lines in the landscape that can be used to create vanishing points: roads, paths, rivers, bridges, hedges and plough lines in a field to name just a few. Compositions can be based around a single vanishing point or can include several, and work well with either symmetrical framing or when based on the rule of thirds or Golden Section grids. However, while vanishing points can be useful for creating dynamic compositions, if they simply lead the eye to a point on the horizon, the composition may not maintain the viewer's interest. It can be useful, therefore, to have a strong focal point at, or slightly in front of, the vanishing point.

Wide-angle lenses can enhance linear perspective and this is particularly true with vanishing point perspective, as they allow you to include more of the lines in the foreground, as well as suggesting greater distance between the foreground and the vanishing point. Wide-angle distortion can also exaggerate the angles, further emphasizing the feeling of depth.

Lines don't have to be complete for the effect to work, either, as the eye will usually continue to follow the lines to the vanishing point. Nor do you always need physical lines; strong implied lines, such as a row of trees, can also work in creating a distinct vanishing point.

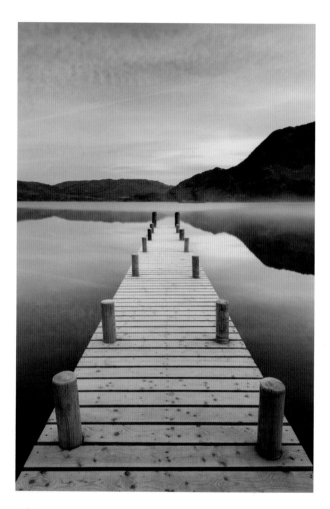

FINDING A VANISHING POINT
As well as roads and paths, bridges, jetties and piers make excellent subjects for vanishing point studies. In this case, the lines are not complete to the vanishing point, but from a compositional point of view it is preferable to have some separation between the end of the jetty and the reflected mountains. There is no obvious single subject at the vanishing point, but there is plenty of interest on the distant shoreline to keep the viewer engaged and prevent the eye from wandering out of the frame. The symmetrical composition also helps: placing the vanishing point at the centre of the shoreline discourages the eye from moving out of the frame.

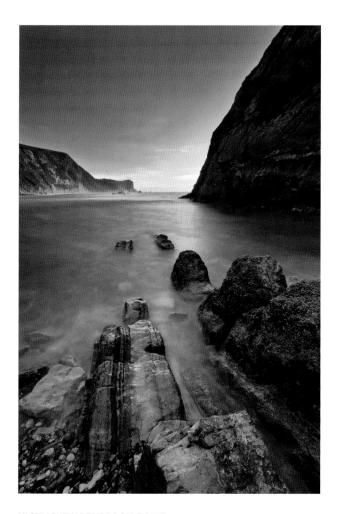

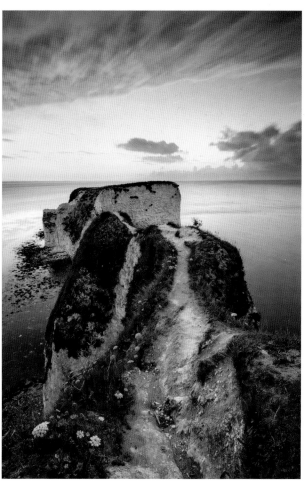

HIGHLIGHTING THE FOCAL POINT

In this shot, the converging lines are less strong. They are broken and finish somewhat short of the vanishing point, but there is a strong focal point in the distance, with the headland lit by the rising sun. Using an extreme wide-angle lens and a low viewpoint has focused attention on the lines in the immediate foreground, strengthening their visual impact. The eye is therefore quite happy to follow through to the vanishing point and focal point on the horizon. The focal point is further highlighted by the triangular shape of the dark cliff at the right of the frame, which acts as a strong 'pointer'.

CONVERGING LINES

Both the cliff top and the narrow path provide converging lines in this image. The eye tends to follow the cliff top round to the right, rather than the converging lines towards the horizon, but the effect is powerful: a path leading to a sheer drop above the ocean suggests a 'vanishing point' of another kind.

FOREGROUND INTEREST

A lot of space gets devoted to the subject of foreground interest in books and magazine articles on landscape photography. Understandably so, because the foreground is an important part of composition: a good foreground can be one of the most effective tools in our attempt to create the illusion of depth on a flat surface.

The usual advice given is to 'get in close to a strong foreground element with a wide-angle lens to add depth and perspective'. This seemingly straightforward piece of advice works well, because this technique enhances linear perspective, as well as providing an entry point into the composition for the eye. However, like all compositional guidelines, it needs to be applied with a certain amount of consideration.

It is a technique that was made popular by large format photographers such as Joe Cornish, who exploited the movements of their cameras to generate extreme depth of field and get in close to objects so they loomed large in the foreground. Done well,

the results are eye-catching, with a real sense of drama, so it is a look that has been copied extensively – so much so that the 'big foreground' landscape has more or less become a formal style.

Of course, the danger is that if this approach is followed too often, the results become predictable and hackneyed. Furthermore, it is not as simple as it first seems. To apply it well takes skill and attention to detail: it's not just a case of finding the nearest big rock and using it to fill the lower third of the frame. A successful foreground has to complement the background while the foreground, middle distance and background need to create a cohesive whole.

When choosing a foreground focal point you need to pay attention to the shape, size, angle, tone and texture of the object, as well as any movement (actual or implied) in the frame. Bear in mind that rectangular shapes tend to block the view, whereas triangles encourage us to look into the picture. Foreground objects

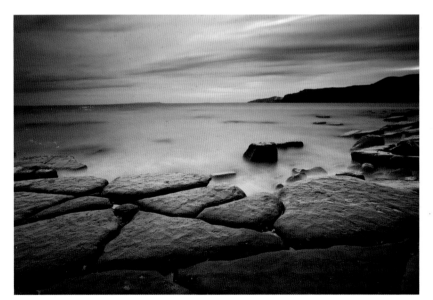

LOW VIEWPOINT
A low viewpoint places emphasis on the foreground, but can compress the middle distance and reduce the separation between key elements. In this case, getting down low causes none of these problems and was necessary to reduce the impact of a large expanse of emptiness in the middle distance. With the camera close to the foreground interest, linear perspective is enhanced and importance is given to the texture and pattern in the foreground, which helps lead the eye into the picture.

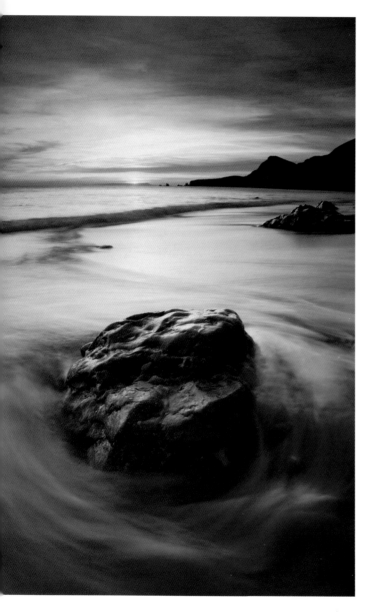

work well if there is some tonal contrast with their surroundings, and if they are angled so as to subtly lead into the frame and highlight the background focal point. Objects that partially frame the view are useful, as they help to direct attention into the image, especially when there is a strong sky above.

Lines in the foreground can be particularly powerful, as they can guide the eye and imply depth at the same time. Camera height is also important. The temptation is often to get down low, as this places more emphasis on the foreground, but it increases the danger of making the foreground too dominant and removing the separation between elements in the middle distance. Therefore, it is important to remember that small changes of viewpoint can have a big impact on how a foreground is conveyed in a picture: experiment with variations in camera height and distance from the subject until you find the best balance.

THE 'BIG ROCK' FOREGROUND
Rocks and boulders are a favourite foreground subject, especially for coastal shots, but it is necessary to give some thought as to how you compose a 'big rock' shot. In this case, without the water washing around the base of the rock, it would just be a dark mass in the foreground, lacking tonal separation from its surroundings. However, timing the shot so that a wave was washing back around the rock improves the foreground in three important ways: it provides tonal variation; it provides contrasting texture; and the flow of the water helps to compensate for the rather square rock, a shape that tends to block, rather than invite the viewer into the picture.

FOREGROUND OBSESSION

It is easy to become obsessed by foreground interest. This is partly because it is an easy compositional trick to get to grips with and partly because the results can appear quite eye-catching when done well.

However, it is a technique that is also easy to misapply. A foreground element that doesn't complement the background adds nothing to a composition and, at worst, a poor foreground can dominate an image, diverting attention from the view beyond. There also seems to be an obsession with the 'big' foreground – getting in as close as possible to an object and filling the frame with it, often to the detriment of the rest of the image. It is always worth reminding yourself that foregrounds don't have to be big to be effective, and that in the right circumstances it is not a crime to leave the foreground empty – there are many other ways of conveying depth and directing the eye into an image.

Certain images are better with less, rather than more foreground. Panoramic images are perhaps the most obvious example, as the eye will tend to scan across the frame, rather than look into it from foreground to background. A sense of depth is still important in panoramic images, but is perhaps better achieved using other techniques. In scenes where there is little of interest in the foreground, it is often better not to include it at all: if there is a strong sky, a better option is to place emphasis here by tilting the camera up.

Foregrounds don't necessarily need to have an object in them in order to contribute to the composition. Negative space can be powerful, and in cases where there is appealing texture or a strong reflection it can actually be counterproductive to include a foreground object, as this will break up the interest. The main thing is not to feel obliged to place a focal point in the immediate foreground.

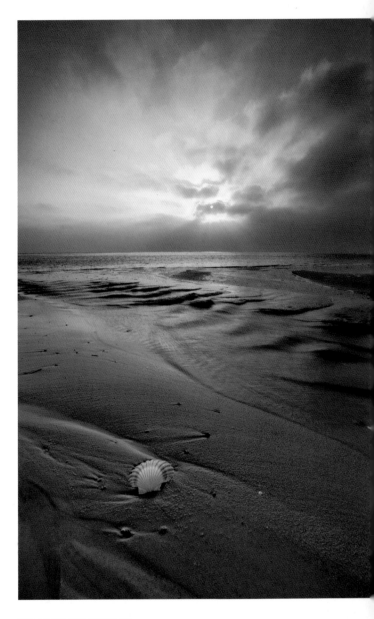

THE SMALL FOREGROUND
It is sometimes tempting to assume that foreground interest has to be big in order to be effective, but in this instance the foreground focal point is relatively small in the frame. However, without it, the eye wanders aimlessly around the foreground, without really settling and without paying much attention to the background focal point. As well as helping to provide a sense of scale and depth in the image, the shell also subtly directs the eye – the ridges on its surface guide our attention to the background focal point, the 'dark sun' rising through the clouds. The shell also ties together the background and foreground, by echoing the colours and tones present in the sky.

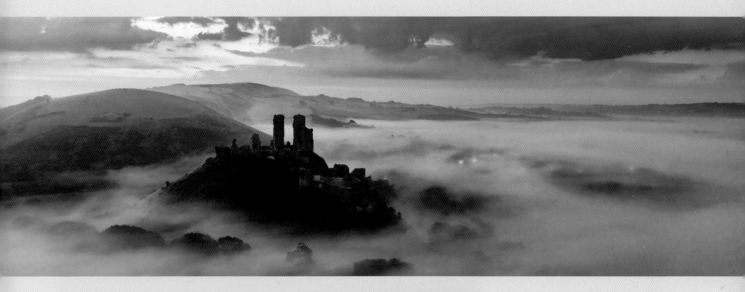

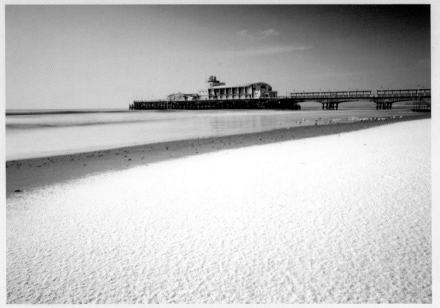

CONVEYING DEPTH

We tend to scan across panoramic images, rather than look from front to back, so need to arrange the composition with this in mind. Having a clear focal point is particularly important, but the letterbox format doesn't lend itself to having large objects close to the camera. Instead, depth needs to be conveyed using other means. In this case, a high viewpoint revealed the planes in the scene, and the mist lying in the valley helped to define them. The impression of depth is there, even with the 3:1 aspect ratio.

EMPTY FOREGROUND

Not all foregrounds have to have an object or focal point. Here, I wanted to emphasize the snow on the beach – an unusual sight on the south coast of England. It might have been possible to hunt out a rock to use as foreground interest, but this would have broken up the expanse of snow, weakening the main point of the shot, so I opted to leave the foreground empty. A sense of depth is still conveyed in the image, though, even without a focal point in the foreground. The distinct layers in the image – snow, sand and sea – lead the eye through to the pier in the background, and the texture in the snow also helps to convey depth, as the texture becomes smoother further into the composition.

TILT AND SHIFT

Large format cameras allow you to use camera movements that can help you gain extensive depth of field and get in close to foreground subjects in order to create the impression of depth. To make use of the same perspective technique, users of smaller format cameras need to shoot using small apertures and the hyperfocal distance.

There are, however, a couple of disadvantages to using a small aperture and hyperfocal focusing, compared to using camera movements. For a start, the use of a small aperture has an adverse effect on image sharpness, due to diffraction (see page 46). Also, while subjects at the extremes of the depth of field will be 'acceptably sharp', this is not the same as being truly sharp, as only objects on the plane of focus are truly sharp. There is an alternative option for photographers using smaller formats, though: tilt and shift lenses (see page 20) that replicate the movements of large format cameras.

With a 'normal' lens, the plane of focus is parallel to the sensor or film plane and perpendicular to the lens axis. If the subject plane is parallel to the plane of focus, then the whole subject can be placed in focus, but if it isn't then it is only truly in focus where the two planes intersect.

With tilt and shift lenses (called tilt-shift lenses), however, it is possible to use the Scheimpflug Principle (see box) to tilt the plane of focus and place it along (or at least closer to) the subject plane. In the case of most landscapes, the plane of focus needs be placed on, or near to, the ground stretching out in front of the camera. When a lens is tilted, a wedge-shaped depth of field is created, whose width increases further from the camera. By adjusting the tilt and focus of the lens it is possible to 'customize' the location of the depth of field to suit the subject.

THE SCHEIMPFLUG PRINCIPLE

A basic understanding of the Scheimpflug Principle, named after its discoverer, Theodor Scheimpflug (1865-1911), will help when it comes to using tilt-shift lenses accurately. Put simply, if you tilt the lens, so that imaginary lines drawn through the film/sensor plane (A), the lens plane (B) and the subject plane (C) meet at a single point, then everything along the subject plane (C) will be in focus.

WITHOUT SCHEIMPFLUG

WITH SCHEIMPFLUG

TILT-SHIFT LENSES IN USE

Although they have highly useful qualities, tilt-shift lenses can be somewhat frustrating to use compared to using similar movements with large format cameras (at least when using the tilt function). In some situations, just a fraction of a degree of tilt can make a significant difference, but it is very difficult to adjust a lens by less than half a degree with any accuracy. The easiest mistake to make is setting too much tilt.

When calculating the amount of tilt necessary, you need to know the perpendicular distance from the lens axis to where we want to place the intersection of planes: the smaller the distance, the greater the amount of tilt needed, and vice-versa. In real world use, rather than measuring the distance, estimating it and then fine-tuning by eye is probably the easiest way to go about things. There are excellent depth of field calculators for tilt-shift lenses online. Having estimated the distance and set the required amount of tilt, you can check the near and far points of focus using your camera's depth of field preview, and fine tune tilt and focus as required. This is most easily done by zooming in to a Live View image, rather than trying to assess the effect through the viewfinder.

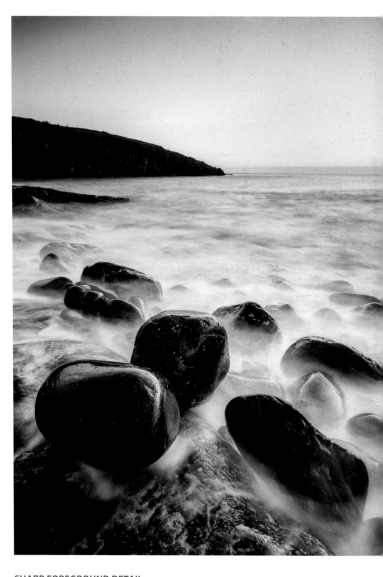

SHARP FOREGROUND DETAIL
Tilt-shift lenses allow you to get in close to foreground interest, while still keeping it sharp, in order to create an impression of depth and perspective in a photograph.

FRONT-TO-BACK SHARPNESS

With tilt-shift lenses it is possible to keep the whole scene sharp, from the immediate foreground, through to infinity, while shooting at or near to the lens's optimum aperture setting. This makes it possible to get close to foreground interest and exploit linear perspective to suggest depth in a photograph, without having to compromise optical performance. These comparison shots show the difference between shooting at f/8 with no tilt (focusing at the hyperfocal distance), and at the same aperture with tilt applied.

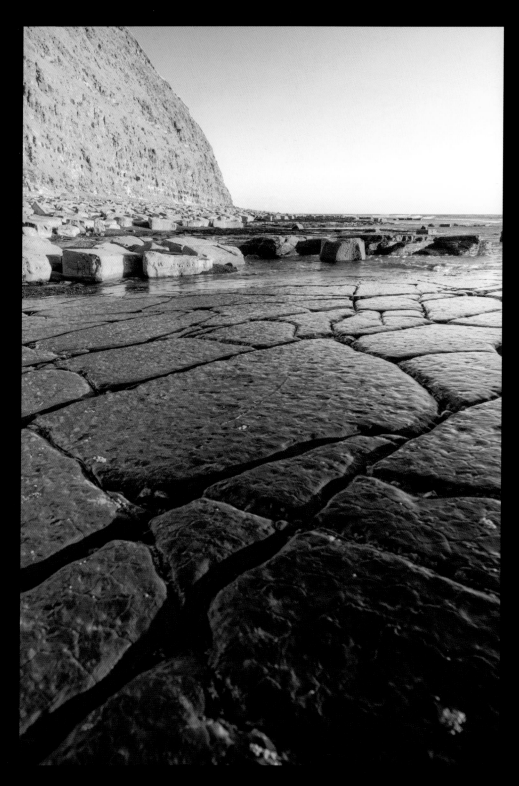

Shooting at f/8, without tilt

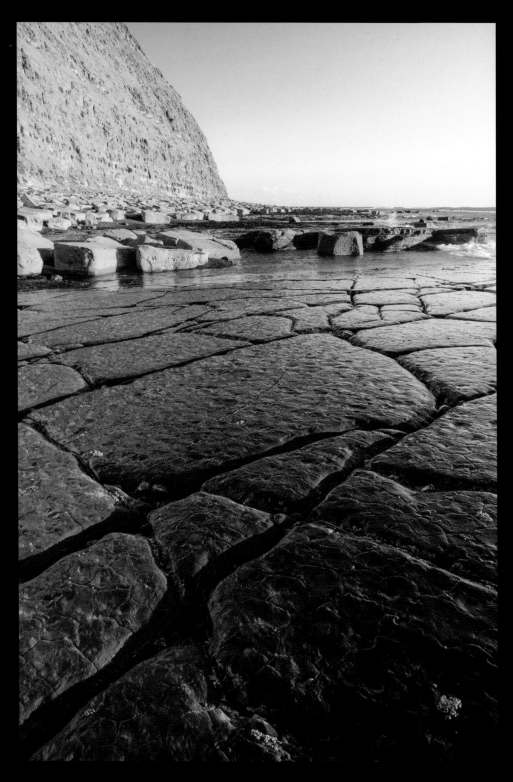

Shooting at the same
aperture, tilt applied

LIGHT IN DEFINING DEPTH

Linear perspective, foreground interest, relative size, texture gradient and so on, all provide useful clues to help us perceive depth in photographs, but their effects can be strengthened by shooting in appropriate lighting and atmospheric conditions. In isolation, light is not necessarily a strong indicator of depth, but when combined with other perspective cues, a powerful impression of depth can be created.

LIGHT

With flat, diffused lighting there are no shadows, so the form and volume of objects is hard to determine, making the scene appear rather two-dimensional. Strong, directional light, however, casts shadows that reveal texture and form, making objects appear more three-dimensional. In a landscape, the distance between shadows can help to suggest depth as well. Strong backlighting can also work to convey depth by casting shadows in front of a subject; these shadows can create converging lines that lead into the frame.

AERIAL PERSPECTIVE

Although we consider the atmosphere to be invisible, this is not really true. It contains fine particles of water vapour, dust and pollution that scatter light, resulting in distant objects appearing 'hazier' – lower in contrast, brighter and with less colour saturation – than near objects. This is known as 'aerial' or 'atmospheric perspective' and it provides us with another means of suggesting depth and distance in a photograph. The effect is stronger the more distant the object is, and it can be enhanced by shooting distant scenes with telephoto lenses. Again, it is subtle when used as a perspective device on its own, but is particularly useful when photographing compositions based around layers and planes (see page 102).

COLOUR

Perspective can be intensified through the use of colour and tone. Warm tones seem to advance, whereas cool tones recede, so choosing warm colours for foreground interest – especially if there are cooler colours in the background – can increase the appearance of depth. This effect can be strengthened further by having darker tones in the foreground and lighter tones towards the horizon (something that tends to occur naturally, due to aerial perspective).

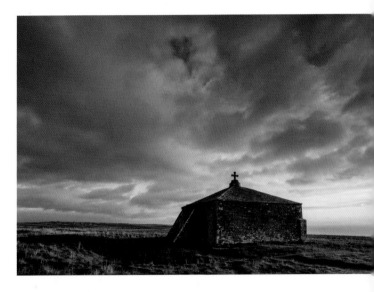

VOLUME PERSPECTIVE
Objects in photographs are given 'volume' – or a more three-dimensional look – when the light is directional. This is particularly true when photographing buildings in the landscape. In this shot of a chapel close to a cliff edge, the light is from the side and slightly in front of the building. The result is that the front of the chapel is lit and the side is in shadow, giving the structure a three-dimensional look. Depth in the composition is also suggested by the heavy sky; photographed with a wide-angle lens the clouds appear to funnel into the frame, towards the horizon.

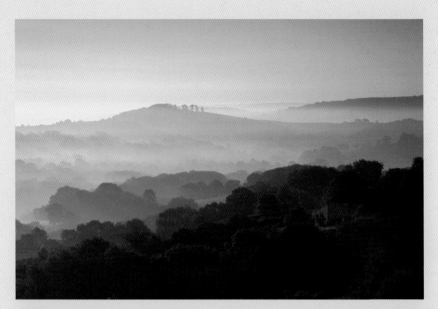

AERIAL PERSPECTIVE

In this photograph, the tones go from dark to light into the distance. Combined with atmospheric haze in the background this gives a strong feeling of depth, which is increased by the clear planes in the composition, the overlapping shapes and the strong directional lighting.

COLOUR PERSPECTIVE

The warm tones of the poppies in the foreground stand out from the green tones surrounding them, and the cooler tones on the horizon recede to subtly suggest a feeling of depth. Linear perspective is also exploited in this composition, through the use of converging lines that reach a vanishing point on the horizon.

VISUAL SEPARATION

Composition is largely about organizing the elements in the frame so that balance and harmony are achieved. Fundamental to this is making sure that each element sits in the right amount of space. Camera height plays the major role in attaining this, especially when it comes to achieving visual separation between key elements in the scene. This might sound like a basic consideration, but failing to achieve separation is a frequent error, especially among newcomers to landscape photography.

Visual separation is related to depth perception because of the two-dimensional nature of photographs; without separation it is easy for objects on different planes to merge into one another. We are all familiar with the phenomenon of a portrait photograph with a tree or pole sprouting from the subject's head. In landscape images, the result of not separating the elements sufficiently can be a lack of depth in the composition.

Camera height is so important when it comes to effective composition that it is surprising that it is not discussed more often. In fact, apart from the advice occasionally given about adding drama to a composition by shooting from a 'worm's eye' viewpoint, it rarely seems to crop up at all. However, it has a profound effect on how the planes in a photograph are shown, especially with wide-angle lenses: a high viewpoint reveals the planes and opens up the middle distance, while a low viewpoint does the opposite. With an empty middle distance, it can sometimes be useful to reduce its impact by shooting from low down, but care must be taken to ensure there is enough separation between the key points of interest in the scene; if foreground and background elements merge together, perspective effects are weakened.

Because of the popularity of the 'big rock foreground' style of landscape, many photographers are in the habit of setting the camera up very low, placing emphasis on the foreground, but in many cases, a higher viewpoint will often provide better balance and depth (if perhaps a little less drama).

Having decided on the best height to shoot from, it's worth taking a look around the frame to see if separation between any other elements can be improved – sometimes a small movement left or right can make a big difference. Of course, separation can't always be achieved, and not everything in the frame needs it. Sometimes, overlapping forms can be used to suggest depth, especially if they are similar shapes, such as a range of mountains.

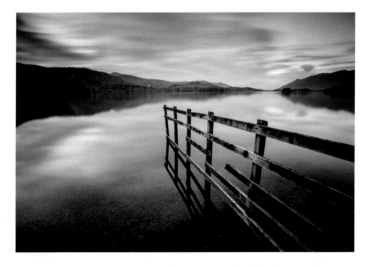

VISUAL SEPARATION

For this image, the camera height was critical: too high, and the middle distance would appear too empty, too low, and the top of the fence would merge with the reflections of the mountains in the background. There were other considerations with the placement of the fence, which is necessary to create linear perspective and lead the eye into the frame. If it was not positioned far enough into the frame it would leave too much empty space in the middle; too far into the frame and it would lead the eye out of the shot on the left hand side. I therefore chose to place it fairly centrally, rather than on a third.

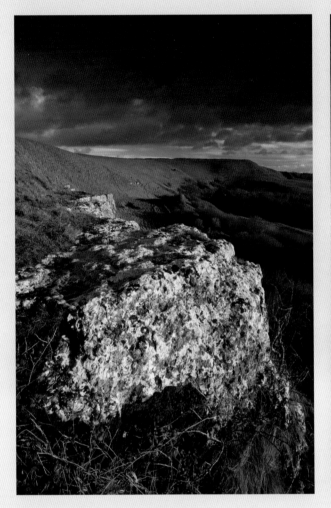

Less depth

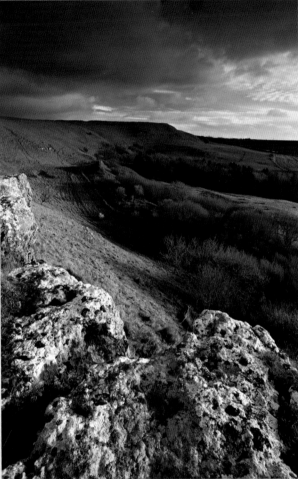

Greater depth

LOW VIEWPOINT

It is often tempting to take a low viewpoint, especially when there is interesting texture in the foreground. This isn't always the best option, though, as these two images demonstrate. In the image on the left the rock merges with the woodland in the middle distance, reducing the feeling of depth in the composition. However, moving forward half a metre and raising the tripod just a few centimetres is all that it took to improve the separation between the foreground and middle distance in the image on the right, creating a far better sense of perspective.

OTHER TIPS AND TRICKS

We have looked at the main ways of creating the illusion of depth in photographs, with linear perspective being perhaps the most powerful technique. There are, however, a few more 'tips and tricks' that are worth a mention.

CREATING A SENSE OF SCALE

It can sometimes be difficult for a photograph to convey the scale of the landscape. This can be particularly true of mountainous landscapes, where a lot of the drama depends on an understanding of the size of the peaks. Including an object of a known size, such as a tree, a building or a person, provides the viewer with a point of reference that helps them to understand the scale. If the object is at a distance, and small in the frame, the scale of the surrounding landscape will be emphasized further.

USING NATURAL FRAMES

Framing the main subject with a natural frame, such as overhanging branches, is a popular technique, but it remains a useful way of focusing attention on the subject, and keeping a composition tight. Furthermore, by directing attention within the frame and providing a separate foreground plane, it can enhance depth perception. The right frame in the foreground can also provide linear perspective.

A SENSE OF SCALE

When shooting a sweeping vista with a wide-angle lens, it can be difficult for the viewer to understand the scale involved in the scene, especially with mountainous landscapes. Placing an object of a known size in the frame, such as the hawthorn tree in this shot, gives the viewer a point of reference. It was important to have the tree clearly separated from the background, so I waited for the mist in the valley to drift into the right position behind the tree before making the exposure.

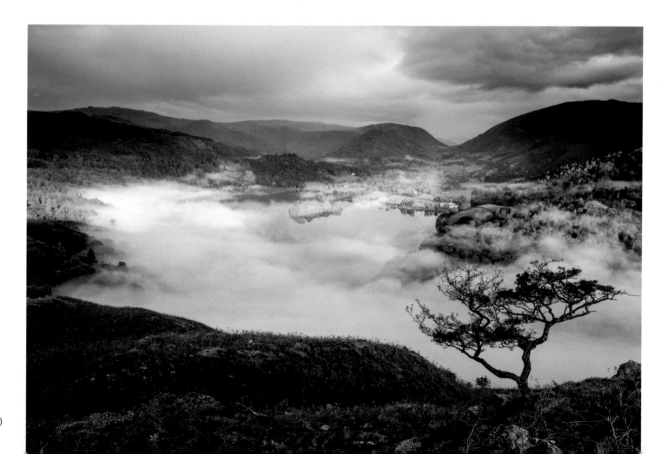

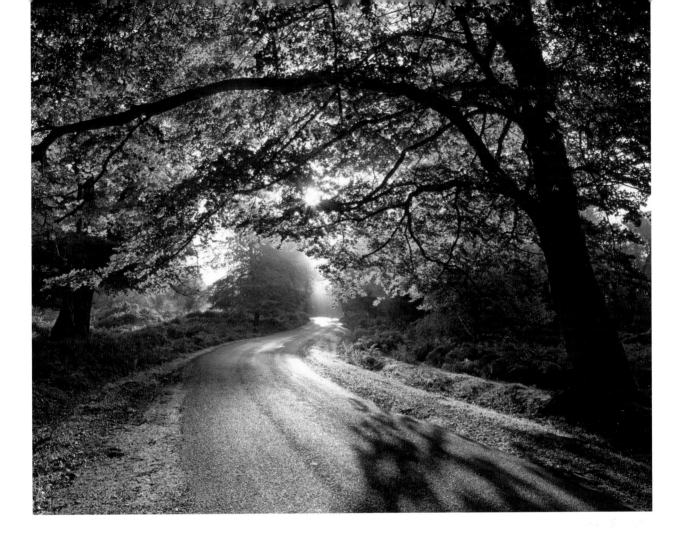

USING LIVE VIEW

Most digital SLRs now have Live View, where a real-time preview of the image is provided on the rear LCD. This has several advantages over using a traditional optical viewfinder. As well as being useful for accurate manual focusing and seeing the effects of exposure adjustments, it also allows you to see your composition as a two-dimensional image, rather than the three-dimensional view you get through the viewfinder. This allows you to judge how well your composition will convey a sense of depth in the photograph and gives you the opportunity to make adjustments and fine-tune your framing before pressing the shutter. If your camera does not have Live View, then image review allows you to make the same assessment after the fact and re-compose and re-shoot if necessary.

FRAMES WITHIN THE FRAME
The road running through the frame and the shadows in the immediate foreground creates linear perspective in this image. The overhanging branches force attention down onto the road, and also enhance the feeling of depth by creating a separate plane in the foreground. The tonal transition from a dark foreground to a light background provides a further perspective cue.

▶ CHAPTER FIVE >

THE GEOMETRY OF COMPOSITION

It may seem strange to think of geometry with regard to landscape photography – geology or geography seem much more relevant disciplines. However, geometry plays a really important part in the composition of landscape photographs. An understanding of the role of shapes and angles is fundamental to composition; after all, the basis of composing an image is creating order out of chaos, and using shapes is one of the most effective ways of doing this. Shapes, lines and angles help determine the mood of an image, influencing whether an image is perceived as dynamic or static, disturbing or restful, inviting or distancing.

The landscape's geometry can also be employed to guide the eye through the picture, highlighting key parts of the frame, yet the importance of such things is easily overlooked. In this chapter we will explore how subtle elements, such as lines, corners, shapes, layers, planes and movement can enhance your landscape images.

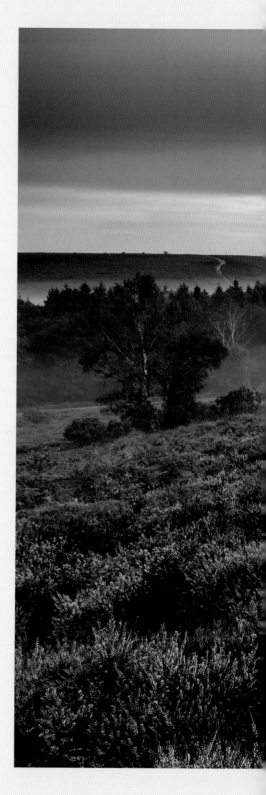

GEOMETRY IN THE LANDSCAPE
Geometry plays an integral role in the composition of this image. The path in the foreground is a strong, curving line, which pulls the eye into the heart of the picture. A combination of viewpoint and atmospheric conditions work together to define the foreground as a separate plane, and the mist suggests further planes in the middle-distance and background. The trees at either side of the path help prevent the eye from wandering out of the sides of the frame, focusing attention back into the image.

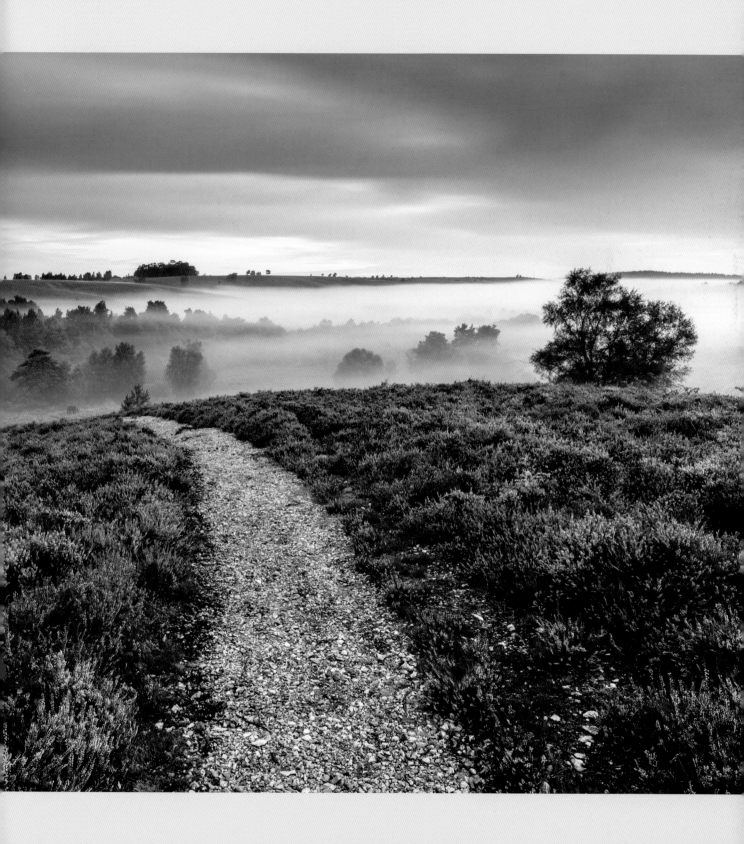

LINES

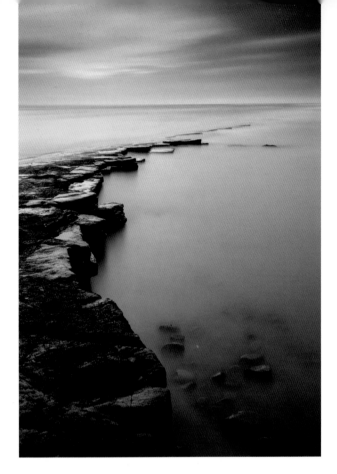

When we compose a photograph, we usually have in our mind – consciously or subconsciously – an idea of how we want the viewer to look at the image. For example, we might expect them to scan the image from left to right, or bottom to top, pausing at a particular focal point before perhaps moving on to study the details in the background.

While it's not possible to force the viewer to look at an image in a particular way, we can certainly encourage them to, and lines are powerful tools that we can employ to achieve this. The eye will seek out structure in an image and will naturally want to follow lines, particularly if they lead to obvious focal points. The good news is that lines are everywhere in the landscape. They can be man-made, such as roads, paths and hedges, or natural, such as rivers or the shoreline. Lines don't necessarily have to be 'real', either. Someone's eye line can create an implied line: if there is a person in the shot, we will tend to follow their gaze on the assumption that what they are looking at must be interesting.

To an extent, we can also create lines with our choice of equipment. The distortion of ultra wide-angle lenses in the corners and at the edges of frames can stretch objects, exaggerating angles and creating lines that perhaps the naked eye might not perceive. To make the most of this effect, you need to get in close and low to foreground objects.

There are different types of line, which create different effects and contribute in different ways to the overall mood of a composition; converging, vertical, diagonal, zig-zags, arcs, curves, S-curves and so on. Depending on the nature of the line it can inject energy into an image, or suggest feelings of tranquillity. Lines also relate to a fundamental element of composition – contrast – as it is usually contrast that defines them: contrast between light and dark, one tone and another, or different textures.

Of course, the picture frame itself consists of four lines – two horizontal and two vertical – and the way in which the lines contained within the frame interact with it and each other also

LINES AS SUBJECT
Lines rarely make good subjects on their own, often resulting in a feeling of dissatisfaction. Perhaps it because of a sense of frustration that can be caused by being guided through the picture without being taken to a focal point for the eye to rest on, but points, rather than lines, generally make better subjects for a minimalist treatment.

needs consideration, as this has a powerful impact on how the eye interprets the scene. How the lines within the frame are arranged can imply tension or harmony, can contain the eye within its boundaries or direct it outside.

While lines are one of the primary components of artistic and photographic design, it is unusual for them to actually become the subject of a composition, in the way that say, foreground interest can. Attempts to do so often result in an image that seems somehow unsatisfactory: whilst very strong supporting players, lines are rarely suited to a leading role.

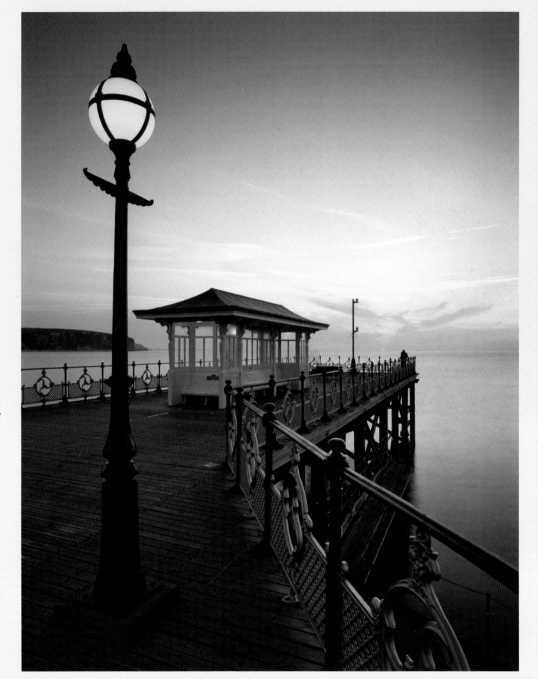

LEADING THE EYE

There are strong lines in this image, and at first glance the design is straightforward: our gaze is drawn along the railings entering the frame at the bottom right hand corner, which lead us to the figure at the end of the pier. However, there is a little more going on. First, there is the implied eye line of the man on the pier, and we follow this to the sun, watching it as it just breaks the horizon. The rising sun is a small, but powerful focal point, which is subtly highlighted by the lamppost that seems to point towards it. The viewpoint and slight wide-angle distortion has created the illusion that the bar beneath the lamp is angled downwards, creating a line towards the man watching the sunrise. Therefore, the lamppost acts not only as a framing device, but also as a 'pointer' to highlight a key focal point.

There are numerous other lines in the image – horizontal, vertical and diagonal – many of which interact, with the horizontal and vertical lines working together to create a sense of equilibrium and balance. Attention has been paid to how the lines in the composition fit together: for example, the street lamp sits perfectly between the upright railings of the pier, and where possible, the knobs on the foreground railings sit within the panels of the shelter.

TYPES OF LINE

Lines are excellent tools for guiding the eye through a picture and drawing attention to key points in the image, but they can do far more than that: they can enhance mood and atmosphere, and suggest dynamism or stability. An awareness of how this works is important, as lines can be made to work with other elements of a composition.

HORIZONTAL LINES

Horizontal lines suggest stability and tranquillity. Our eyes naturally scan horizontally and our field of vision is biased towards the horizontal, so horizontal lines in a composition complement this and seem naturally restful. Furthermore, an expansive horizontal line – the horizon – dominates most landscape scenes. Any other horizontal lines in the composition will be in harmony with the horizon, thus creating a feeling of calm.

VERTICAL LINES

The main connotations of vertical lines are growth – trees and plants grow vertically upwards, for example – or strength and power (an object fighting against the force of gravity, for example, or columns supporting a structure). If the main subject is a strong vertical, it is most natural to frame the shot vertically, although a horizontal composition can also be effective, especially if there is a horizontal line complementing the vertical. Where there is a horizontal line as well, this can create a sense of balance, suggesting support and stability. Complementary vertical and horizontal lines can work well together in compositions based around the rule of thirds or Golden Section.

DIAGONAL LINES

Diagonal lines work against the direction of the verticals and horizontals of the picture frame, introducing a slight sense of tension and dynamism into an image. Wide-angle lenses and viewpoint can be used to exaggerate and exploit diagonal lines in a composition – and even create them to some extent. As well as creating the impression of speed and movement, diagonal lines also lead the eye into a composition and imply depth and perspective. Being so dynamic, they work best when leading the eye to a focal point; otherwise the danger is that the eye is led quickly out of the frame.

Zig-zag lines are essentially diagonal lines with a change of direction. They can be very powerful and dynamic, but again are perhaps best used when guiding the eye to a strong focal point.

Converging lines are another diagonal line variant, which lead the eye quickly into the frame and often to the 'vanishing point' of the composition. Again, they should be used with caution, as it is very easy to lead the viewer straight out of the picture: having sufficient interest in key parts of the frame is important.

CURVES AND ARCS

Curves and arcs are more dynamic than horizontal lines, but gentler and more flowing than diagonals. They are excellent for taking the viewer on a smoother, more serene journey through the frame, where you would like them to be more inclined to pause and study details along the way.

Like zig-zag lines, 'S-shaped' curves are particularly strong graphic elements, which also add a sense of rhythm and movement to a composition.

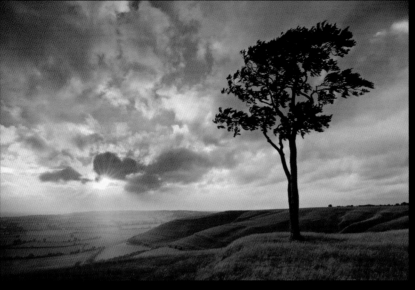

EQUILIBRIUM

The dominant line in this shot is the strong vertical of the beech tree, but as this is balanced by the obvious horizon line and the horizontal lines of the hill-tops I decided that landscape orientation would be most appropriate. This also allowed me to include the sun in the frame as a distant focal point. Geography and viewpoint determined the composition to some extent – I couldn't include both foreground and the top of the tree – so it wasn't possible to arrange the composition strictly according to the rule of thirds. However, the tree is placed close to a vertical third, and the sun is also near an intersection of thirds. The strong sky makes the low-placed horizon a justifiable compositional choice.

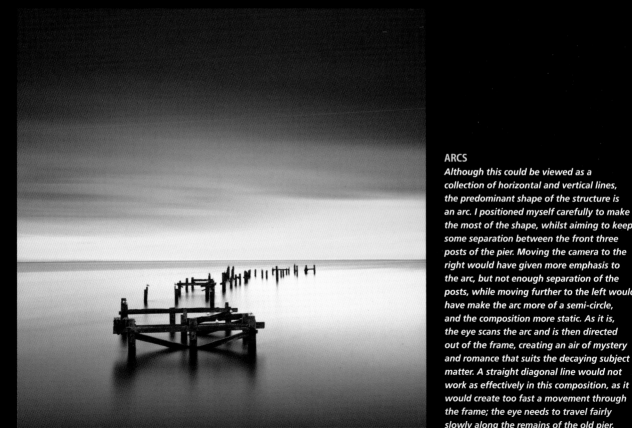

ARCS

Although this could be viewed as a collection of horizontal and vertical lines, the predominant shape of the structure is an arc. I positioned myself carefully to make the most of the shape, whilst aiming to keep some separation between the front three posts of the pier. Moving the camera to the right would have given more emphasis to the arc, but not enough separation of the posts, while moving further to the left would have make the arc more of a semi-circle, and the composition more static. As it is, the eye scans the arc and is then directed out of the frame, creating an air of mystery and romance that suits the decaying subject matter. A straight diagonal line would not work as effectively in this composition, as it would create too fast a movement through the frame; the eye needs to travel fairly slowly along the remains of the old pier.

CORNERS AND 'POINTERS'

With various 'rules' telling us to place important elements of an image on specific lines or the intersection of lines, it can be very easy to forget about other parts of the frame, including the corners. However, in a well thought out composition, all parts of the frame are important, and the corners can play a vital role in creating balance and guiding the eye.

Generally speaking, we want people to look into the picture frame, and having subtle guiding lines – or 'pointers' – at the corners of images is one way to direct attention inwards. Foreground elements such as stones, tree roots or wave patterns are easy enough to find, but it can be difficult to find pointers for the top corners of the frame. Tree branches and parts of structures can be used, but much of the time, clouds are the only option. Patience and anticipation are key here. Frame a scene with a view to how it will work when the clouds have drifted into a particular position, and then wait for that moment before pressing the shutter. Creative use of exposure can help – extending the shutter speed by using an ND filter can record cloud movement and enhance the shape of clouds as they fill the corners of the frame.

Corners also become important if you compose a scene according to the Golden Spiral, as the 'sweet spot' is close to the corner – approximately one quarter of the way in from the frame edge in both planes. In western culture, this spot towards the bottom right corner is particularly significant because we read left to right and top to bottom, so this is where our eyes pause before we turn a page. If we 'read' images in the same way that we read text, then it is a natural place to position a strong focal point.

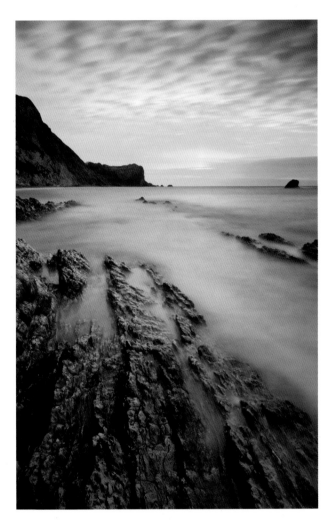

EXPOSURE TIME

The foreground interest in this shot is fairly obvious, with the rocky ledges leading in powerfully from the corners and directing attention towards the headland; the rock rising from the sea towards the right hand edge of the frame provides a counterpoint to the main focal point. Again, the sky has an important role in holding the composition together. The clouds provided plenty of interest and a useful contrast in texture to the water. The main difficulty was in determining the best length of exposure – I wanted to blur the waves washing over the rocks, to create a contrast in texture, but if the exposure was too long, the clouds would move during the exposure and the mackerel sky would lose its shape.

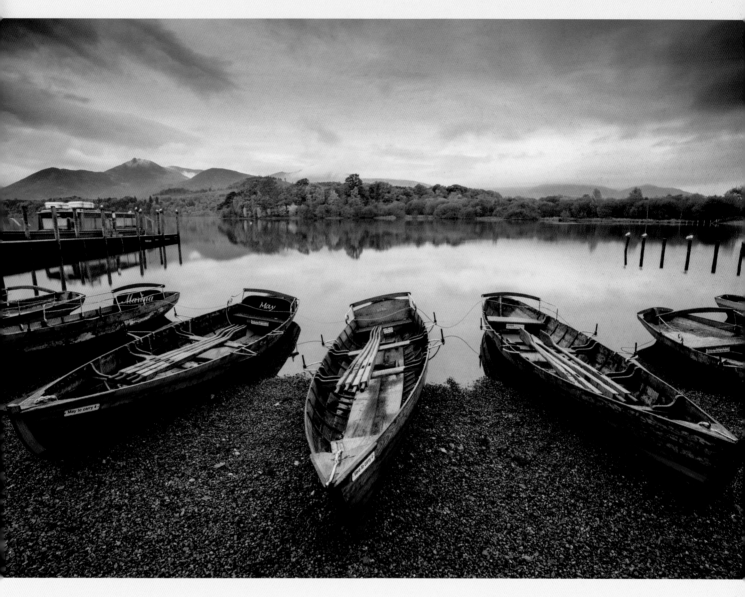

POINTING IN

The boats at the bottom of the frame provide strong lines in this image, directing the eye into the frame. These lines are mirrored by the jetty and posts behind them. The darker clouds at the top corners of the frame also push the viewer's attention inwards and towards the autumn colours on the trees and mist-shrouded mountains in the background.

SHAPES

Exploiting shapes is a fairly obvious way of imposing structure within a landscape scene. There will often be clearly identifiable shapes in the landscape, but don't restrict yourself to picking out these – also look at the relationships between different objects and how these can work together to imply shapes. As with lines, shapes can help to guide the viewer around the image, but they also have certain connotations that can influence the perceived atmosphere of a photograph.

RECTANGLES

Rectangles are rare in nature, but common in man-made objects. Therefore, you're far more likely to find yourself working with rectangles when dealing with architecture or urban landscapes. Rectangles can be useful for subdividing the frame to create a 'frame within a frame', as they echo the shape of the frame of the photograph.

Psychologically, rectangles represent solidity. They are static and unmoving, so a solid rectangle will block a view, rather than encourage the eye into the picture. You should therefore be careful of using a rectangular object in the foreground, but if you have to, try to place it at an oblique angle so that it leads the viewer into the frame. This can be very effective if you get in close and low with a wide-angle lens.

Conversely, placing a rectangle in the background – front-on to the camera – can be a useful way of stopping the eye travelling out of the frame. This can be useful for controlling the effect of powerful diagonal or converging lines.

TRIANGLES

Triangles are probably the strongest shape in composition, and are easy to find or imply: if there are three points of interest, the eye has a naturally tendency to see them as a triangle. Triangles are very dynamic and are useful for leading the eye into the picture. With the base at the bottom of the picture frame, they suggest stability; with the apex at the bottom, they imply imbalance.

Similar to a triangle is the V-shape, which can be used as a framing device at the bottom of the image. A little more subtle than a 'frame within the frame', a V-shape can help draw attention towards a focal point and create a sense of structure and organization. The effect is increased if there is a strong sky above the landscape to frame the view at the top.

CIRCLES

Circles and ovals occur relatively frequently in the natural world – in flower heads, ponds, rocks and pebbles, for example – although they are difficult to imply. They create a certain amount of movement, as the eye will travel around them, and psychologically they suggest completion. Circles also have a 'containing' effect that makes them a useful framing device. When using circles in composition, it is generally best if they are complete, although the eye will tend to complete an almost complete circle.

IMPLIED TRIANGLE
This simple, but effective, composition is based around an implied triangle. Wide-angle perspective has created converging lines from the tracks in the field, and the bottom edge of the frame makes up the base of the triangle. The bold, dynamic composition pulls the eye into the frame, but implies stability and solidity.

TRIANGULAR ARRANGEMENT

Although the foreshore is covered in round boulders, it is not circles that make up the dominant shape in this image. Instead, the water sitting in the foreground creates a triangular arrangement in the group of rocks, which results in a strong, graphic composition. The background focal point – the castle – sits inside a Golden Spiral (see page 64) and its rectangular shape prevents the eye from leaving the frame.

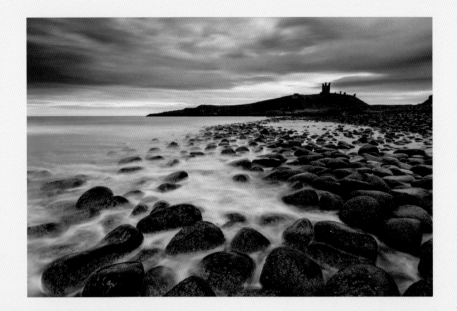

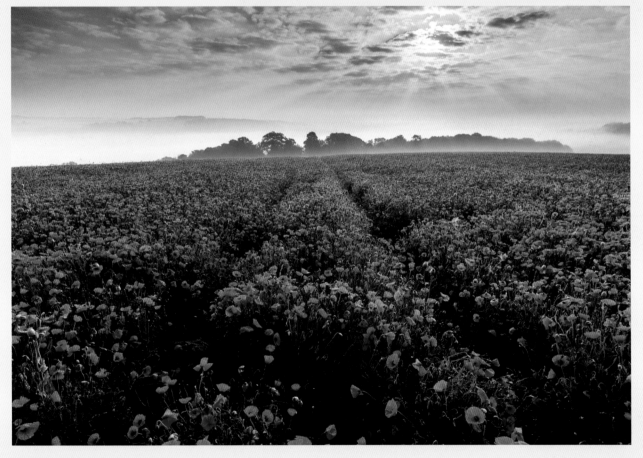

LAYERS AND PLANES

Dividing the image into separate planes, or layers, is a technique originally developed by landscape painters to create the impression of depth and direct the eye. However, this technique translates well to photography, and the effect can be enhanced by your choice of viewpoint and focal length.

Layers can be created by overlapping shapes, such as ranges of hills, or strong side lighting, which creates alternate bands of light and shade. The stronger the tonal contrast, the more clearly the planes will be separated. A dark foreground with a lighter background creates the strongest impression of depth, as we generally look at the foreground first, but the eye is then drawn to the lighter background, helping to suggest depth in the image. Aerial perspective can enhance the look and the effect is strongest in hazy, misty or foggy conditions. This is a technique that works particularly well with longer focal lengths, which exaggerate the layered effect by 'stacking' overlapping forms.

Camera height can be especially important when working with layered images as it has a major impact on the separation of the different elements in the frame (see page 88) including the planes, and this is particularly true when shooting with wide-angle lenses. A high viewpoint can open up the planes in the middle distance, potentially increasing separation, but can result in too much empty space. One way of reducing the impact of an empty middle distance is to shoot from a low viewpoint, but when doing this care needs to be taken to keep enough separation between the planes in the image.

Using the foreground as a framing device can also help to set it apart as a separate plane, and both your choice of foreground and camera height are important here. Seek out a foreground that can be used to enclose the planes beyond – V-shapes and U-shapes work well – and experiment with your camera height to see what gives the best effect, keeping an eye on the impact this has on the separation of other elements in the frame.

Layers are not always the same as planes: layers can be strips of different colour or texture, or any elements stacked on top of each other. In a more minimalist composition it could simply be the layering of land, water and sky. In a wide-angle composition, the different layers can help suggest depth, especially if there are other perspective clues, but arguably this type of layering works best in tightly framed, more abstract images.

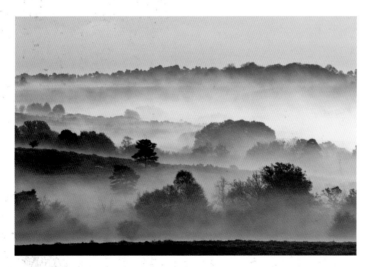

SEPARATE PLANES
The mist has helped separate the planes in this image by creating bands of light and dark, while the 200mm focal length has helped to 'stack' the layers. The strip of foreground is important in the image – try covering it with your hand to see the difference its absence makes. The mist disconnects it from the background, making it a distinctly separate plane, but the amount of foreground is also important – too much and it dominates the image, too little and it fails to register as a plane. I experimented with many slightly different crops of this image, finally settling on the version seen here.

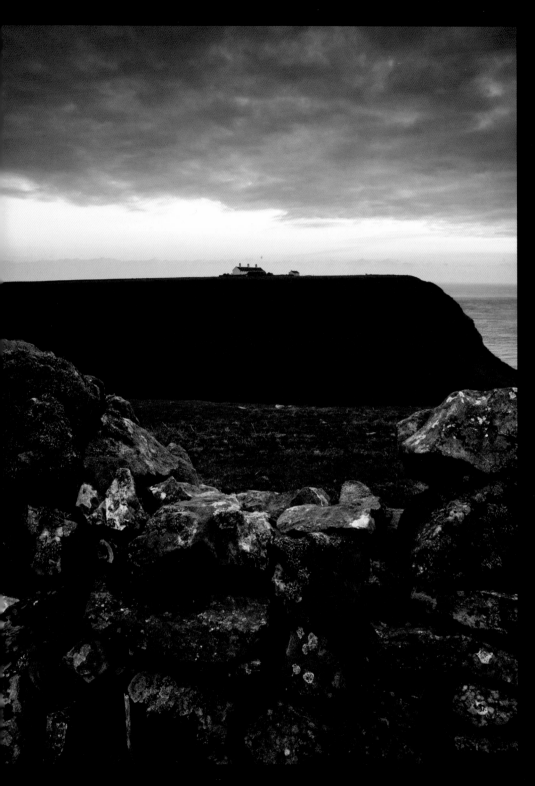

FOREGROUND PLANE

The drystone wall framing the view beyond creates a distinct plane in the foreground. The effect could have been heightened by dropping the camera down slightly lower, so that the wall rose slightly higher than the horizon, but I felt that this would not have left enough of the first field visible behind the wall. The lighting conditions have defined the planes further, with the field lit and the hill behind in shade. Further layering in the image is created by the sky, which is divided into two distinct layers; the dark, stormy clouds sitting over the lighter band on the horizon.

MOVEMENT AND FLOW

When describing composition, 'movement' does not necessarily refer to how we capture motion in a still image (although this can certainly be part of it), but rather to eye movement and how the eye explores the image. Most of the time, artists and photographers want the viewer's eye to move smoothly through the composition, without being interrupted, until it reaches a natural 'stopping point'. This is usually the main subject, or in a scenic shot where the landscape itself is the subject, the focal point. To avoid confusion, some people prefer the term 'flow', as it better describes how we would like the viewer to see our compositions.

As you've seen, geometry plays an important role in directing the eye and creating this visual flow, through the careful use and placement of lines, arcs, shapes and planes. So, which path is the best one to lead the viewer through an image? Of course, it is firstly, extremely subjective, and secondly, entirely dependent on what is in the scene in front of the camera: there is only so much that choice of viewpoint, focal length and so on can achieve. Also, if you used the same basic flow for every composition our images would soon become repetitive and predictable. There are, however, some basic principles that you can choose to follow – or ignore.

In the west, we read text from left to right and top to bottom and there is an argument that we should encourage the viewer to scan images in the same way. However, there is also a tendency to look first at the foreground of a landscape, which is usually located at the bottom of the frame, and for our eyes to then move upwards as they scan through the middle distance towards the background.

For this reason, encouraging the eye to enter the picture at the bottom left corner, and then sweep upwards and to the right, can be very effective. However, a strong composition can lead the viewer in any direction on the image, and working against such natural tendencies can create a sense of tension that can be successful in many compositions.

The judicious use of space and 'negative space' (see page 166) in the design of an image can also encourage eye movement, especially if there is actual movement shown within the frame. The eye will naturally follow the direction of the movement and travel ahead of it into any space that is there. In coastal scenes, waves are excellent for this, especially if you can catch the backwash of a wave as it sweeps back towards the sea, leading the eye into space in the middle distance.

FOLLOWING A WATER FLOW
Initially, the eye naturally follows the flow of the water in this photograph, starting at the top left corner and moving down and across, very much as we'd read a page of writing. The rocks at the bottom of the frame are important, as they prevent the eye from continuing its downward journey, and direct the viewer back into the frame. The eye then travels along the line of the waterfall to the background.

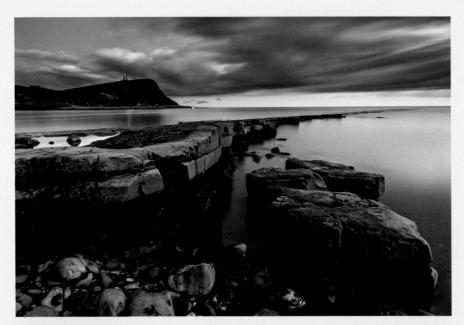

LEADING THE EYE IN

This image was framed with the intention of leading the eye in from the bottom left, following the strong curve of the rocky ledge, through the channel made by the rocks at the right. The eye follows the natural sweep of the ledge, and is then pulled back to the left side of the frame to the tower on the headland: with the bright lights shining out into the dusk it makes a powerful focal point. The lines in the cloud pattern at the top right corner also points into the frame towards the headland and tower.

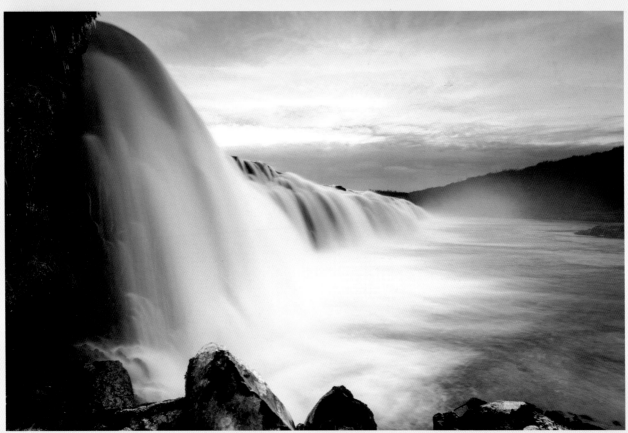

MOTION

Although a photograph is still, the landscape is a mixture of still and mobile elements. This begs the question – should you freeze movement, or blur it for creative effect? There is no simple answer to this. Your decision should be based on the circumstances and the type of result you desire. However, combined with the right viewpoint, there can be no doubt that the impression of motion can add interest, life and depth to your landscape images.

The impression of movement can prove a powerful aesthetic and compositional tool. By intentionally blurring subject motion, your images will appear less static and, potentially, more atmospheric. Of course, this relies on a degree of movement within the landscape, be it moving water, wind-blown foliage, crops or clouds.

Water is by far the most popular element to blur, and with a lengthy exposure, crashing waves or a cascading waterfall can be reduced to an ethereal milky blur. The effect is one you love or hate, but even the 'haters' can't deny that a degree of motion blur will often enhance a landscape image's impact and atmosphere. As a result, it is a popular technique among the majority of photographers.

The theory is simple: by selecting a slow shutter speed subject movement will begin to blur, creating the impression of motion in your photographs. Although water is the most obvious subject to blur, the technique can be applied to any moving element. For example, a field of swaying corn can create a rhythmic, flowing pattern in your foreground, while scudding clouds can appear like brushstrokes. Wind blown flowers, grasses and leaves can also provide interest.

Blurred elements in the foreground will have the most impact on a composition and in some situations it is even possible to use blurred movement to generate foreground interest: you can employ motion in order to 'create' lines and shapes, for example. It perhaps goes without saying that a sturdy tripod is essential

(it will ensure you don't add camera movement to that of the subject), and most likely you will also require an ND filter to artificially lengthen your exposures. However, be careful that the exposure isn't so long that important subject texture and detail becomes lost.

The exposure time is the key ingredient with this technique and the trick is to achieve enough motion that the effect looks intentional and creative: too little or too much and the shot will fail. A good starting point is an exposure time of around half a second, but the optimum shutter speed will be determined by the speed and direction of the movement and the effect you desire: to blur drifting cloud, a shutter speed exceeding 10 seconds may be required, for example. A good degree of trial and error is often needed, so don't be afraid to take a sequence of shots, using different exposure times, in order to get 'the shot'.

Timing can also be important. When photographing crops or grasses, you need to release your shutter to coincide with gusts of wind. Every frame you take will capture motion differently.

WATER BLUR

With rain clouds fast approaching, I had to work quickly when composing this image. With each incoming wave, the water rushed and swirled around the holes and crevasses in the rock, emphasizing their shape and form. To capture this effect I opted for a slow shutter speed. Initially, I chose a half second exposure, but this proved too short so I used an ND filter to artificially extend the exposure to 4 seconds. I then waited for the next large wave before triggering the shutter again – this time I achieved exactly the effect I desired.

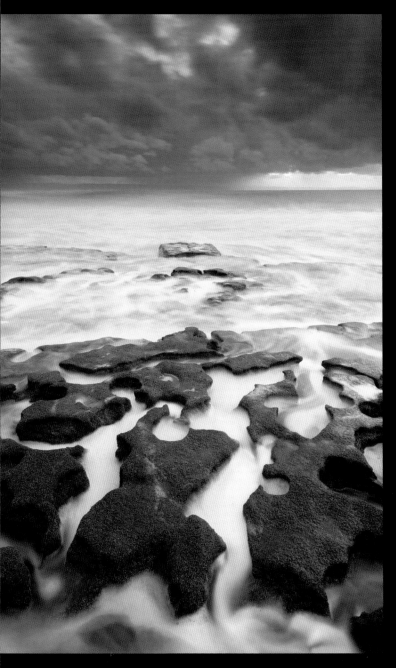

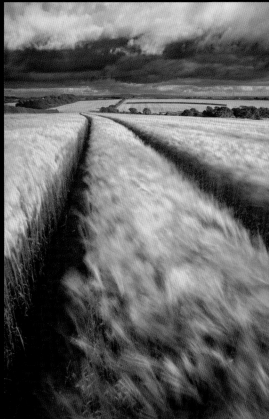

MOTION IN CROPS

Wind is an important ingredient if you wish to photograph motion in crops or foliage. Key an eye on the weather and pick a day with a predicted wind speed of at least 15–20kph (9–12mph), as this should create a good level of motion. When taking this type of shot a slow shutter speed is your priority, so select your camera's lowest ISO and a small aperture.

▶ CHAPTER SIX > **LIGHT**

Light is at the heart of landscape imagery. It is the quality of light that determines the mood of the photograph and our emotional response to it, as well as influencing the composition and helping to create a sense of depth. The meaning of 'photography' is of course 'painting with light'. A successful image is a combination of light, subject and composition.

The obvious difference between how landscape and studio photographers use light is that in the studio, the photographer is in complete control of how the subject is lit, whereas when photographing the landscape, the only control that can be applied is via filtration. However, good landscape photographers will come to understand how natural light works, what light will suit particular scenes and, to an extent, how to anticipate those conditions using tools such as maps, weather forecasts and sun compasses, or their modern equivalents – smartphone and computer apps.

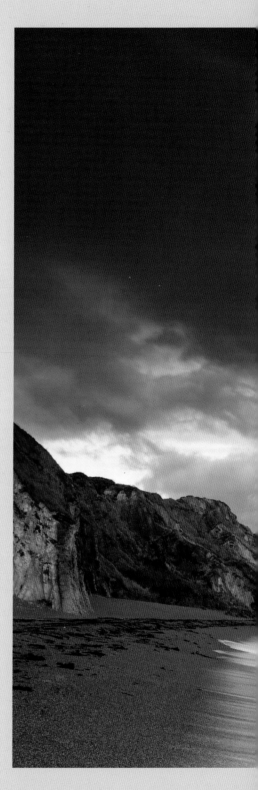

GOLDEN ARCH
Low frontal lighting has resulted in highly saturated colours, with this rock arch in Dorset, England, taking on a golden hue at the end of the day. A passing shower has created a rainbow against a backdrop of dark, stormy clouds. The picture was framed so that my shadow would not intrude into the frame, and a polarizer was used to enhance the rainbow. Foreground interest was provided by the waves washing over the foreshore and the shot was timed to catch the backwash of the wave as it pulled back out to sea.

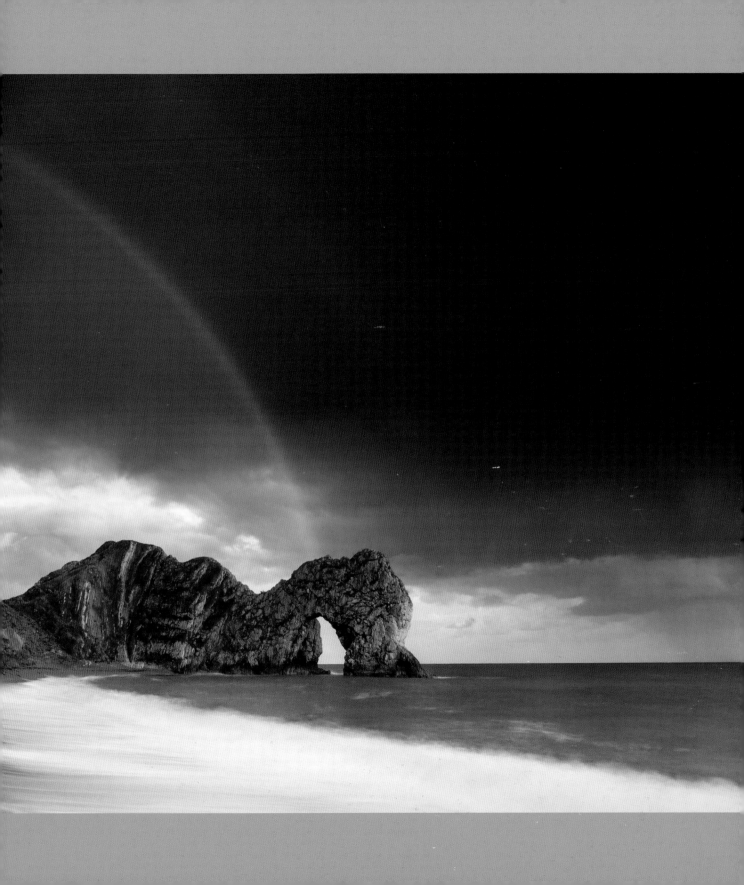

DIRECTION OF LIGHT

The direction of light – whether the subject is lit from the front, side or back – has a major impact on the look of an image. Backlighting can result in extreme contrast and silhouetted shapes, for example, whereas sidelighting can help to reveal depth, form and texture. Landscape photographers have no direct control over the lighting conditions, so it is important to understand the effect of different types of lighting, and know how you can get the most from different situations.

In theory, there is no such thing as 'the wrong light' – it's really a case of finding a subject that best suits the conditions and taking a suitable approach. That said, most photographers would agree that strong overhead light (when the sun is high in the sky), is probably the most difficult to work with.

FRONT LIGHTING

With shadows falling behind the main subject, front lighting doesn't reveal texture and shape and can make a scene appear a little 'flat'. This might not sound like the ideal conditions for landscape photography, but if the sun is low over the horizon, the result can be naturally good colour saturation. From a compositional point of view, the main problem presented by front lighting is the risk of getting your own shadow in the shot when using wide-angle lenses.

BACKLIGHTING

Backlighting can be difficult to deal with, but it can provide dramatic results, with shadows fanning out towards the camera, and emphasis placed on shape and form. Look for strong shapes to silhouette, and bold, graphic compositions. Backlit trees can look very effective, with beams of light shining through the branches. From a technical point of view, be prepared to add positive exposure compensation, as backlighting can fool in-camera exposure meters into underexposure.

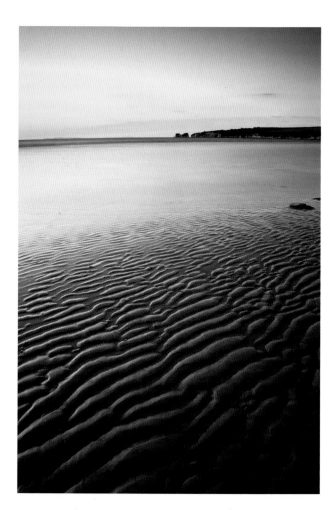

REVEALING TEXTURE
Sidelighting is excellent for highlighting texture in the landscape, as was the case here with the patterns left in the sand by the receding tide. As there was no other foreground interest it was important to make the most of this feature: the diagonal lines leading in from the bottom left corner and the texture gradient both suggest depth.

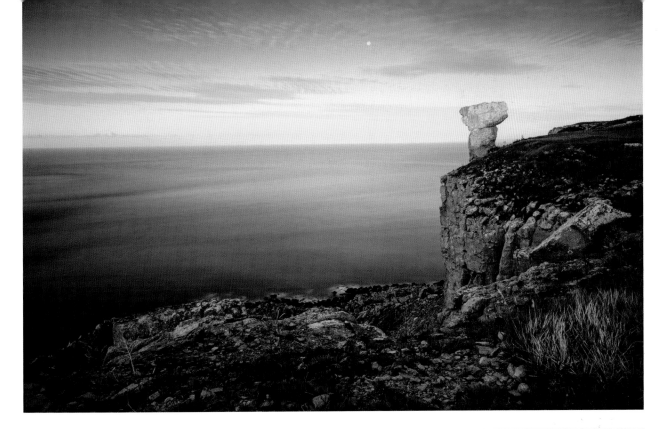

LOW FRONT LIGHTING

Front lighting can make scenes appear a little flat, as there are no visible shadows to create depth. However, low front lighting can create strong colour saturation, as it has on the anvil-shaped rock that forms the main focal point of this composition. The sunlight is also skimming the tops of the grasses in the foreground, which helps add some depth to the image. Often with front lighting, it is difficult to keep your own shadow out the foreground, but in this case the foreground was mostly in shade to start with.

SIDELIGHTING

This is the favourite type of lighting for many landscape photographers, as shadows fall across the scene to reveal texture and help suggest depth. Warm, low sidelighting from the rising or setting sun has a modelling effect on the landscape, which can be very flattering. With the right scene, sidelighting can also create a layered effect in the landscape, which greatly enhances the impression of depth. The effects of sidelighting can be enhanced by the use of a polarizing filter to boost colour saturation and increase contrast (see page 28).

LAYERED SIDELIGHTING

Sidelighting highlights shape, form and texture, and with the right landscape can create a 'layering' effect that increases the sense of depth. In this image, the light is from the side and slightly behind, catching the ridges of the hills. This has the effect of not only bringing out the texture in the scene, especially in the foreground, but also of creating alternating bands of light and dark, generating a layered look. With it, we get a feeling of depth to the composition.

QUALITY OF LIGHT

The intensity, clarity and colour temperature of light strongly influences the atmosphere of a shot. The factors that affect the quality of light are the time of day, the season and the weather. As with the direction of light there is, in theory no 'right' or 'wrong' light, but most landscape photographers would agree that the light at the beginning and end of the day is especially flattering.

DAWN AND DUSK

These are the favourite times of day for many photographers, as clouds are lit from below, which can produce colourful, dramatic skies. The light at dawn and dusk is similar, but tends to be slightly warmer at the end of the day, as there are more particles in the sky to diffuse the warm light of the sun. With clearer air, containing fewer particles, pre-dawn light tends to be cooler and bluer than post-sunset. There will often be a glow in the sky before sunrise and after sunset, so it's worth setting up well before sunrise and staying for some time after sunset.

A period of roughly 30 minutes after the sun rises and before it sets are also popular times for landscape photographers, with the low sun revealing texture and providing depth. As a result, the hours around sunrise and sunset are often referred as the 'golden hours'. When shooting in the golden hours, it's worth looking out for strong foreground interest and objects that might silhouette well. With dramatic skies, a bold composition can work well, with the horizon low in the frame. This is especially true if there is some foreground interest silhouetted against the colour. The temptation is often to shoot towards the sun at these times of day, but this only works well when the sun is very low in the sky or diffused by haze or cloud. It is also worth bearing in mind that the best colour is not always in the direction of the sunset or sunrise, so have a good look in all directions.

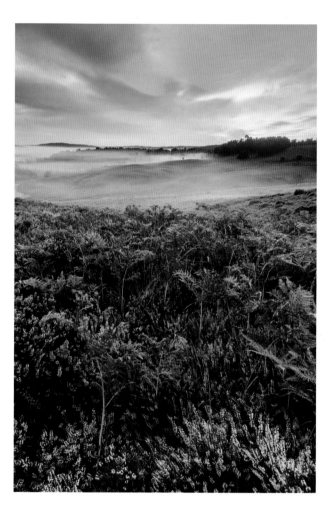

THE GOLDEN HOUR
This rural landscape was shot just as the sun reached the horizon and created a dramatic glow in the sky. That is what drew me to the scene, but I needed a strong foreground to balance the intense colours in the sky; the flowering heather, being just about at its peak, was the obvious choice. A solid mass of purple would have been somewhat overwhelming, so I looked around for something to break up the colour, settling on this clump of orange and green bracken. The orange tones of the ferns provide a nice complement to the sunrise colours in the sky, while the mist in the valley simplifies the scene in the middle distance.

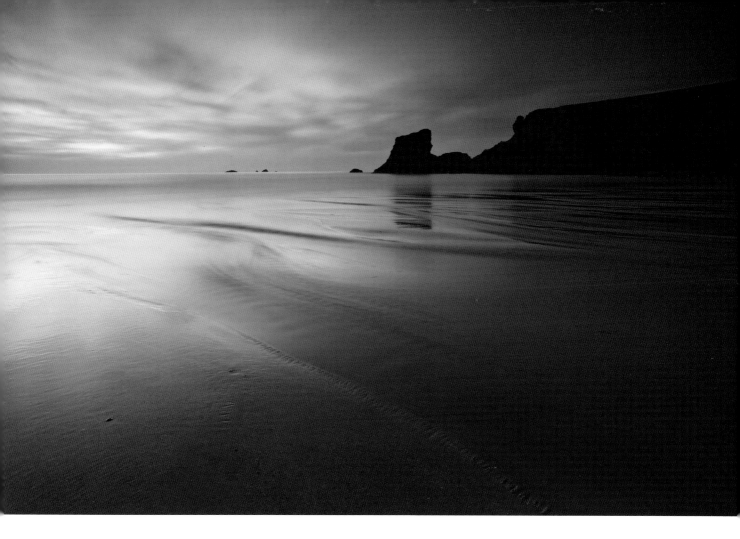

CHANGING LIGHT

The golden hours are popular for a reason. After the sun has risen, it's surprising how quickly the light becomes harsh, with little textural relief. This is not to say that landscape photography is impossible outside of the golden hours, though: bold, graphic compositions (especially those based around man-made structures) can work well in the middle of the day, especially in monochrome. If working in colour, primary colours can be quite intense, and will polarize well.

On cloudy days, the light is more diffuse, making photography in the middle of the day more possible, especially with the right subject. Woodland can benefit from these conditions, as the extremes of highlight and shadow will be reduced, but with open landscapes, black and white can again be the best choice.

THE BLUE HOUR

With modern technology it is possible to get atmospheric images in quite extreme conditions. When this photograph was taken, it was almost completely dark and practically impossible to see with the naked eye, but the camera has recorded an impressive amount of detail. This type of shot, whilst not impossible with film, is certainly extremely difficult. The composition is based primarily on shape and colour, and although there is no direct light on the landscape, what little light there is has helped to bring out texture in the foreground and middle distance. This, combined with the subtle lead-in lines created by the receding tide, has helped to create depth in the composition, even without any obvious foreground interest.
The cool light present at this time of day – long after sunset or before sunrise – has led to it being known as 'the blue hour'.

SEASONS

WINTER

It often surprises non-photographers when they learn that many landscape photographers name winter as their favourite season for photography. However, while it can be cold, wet, muddy and uncomfortable, the benefits of winter outweigh the negatives. The air is more humid and contains fewer particles, meaning that there is a greater clarity of light at this time of year. The sun stays low in the sky, meaning that directional light is available for most of the day, and bare trees mean that we can pay more attention to the shape and texture of the landscape itself. The weather can be changeable and unpredictable, the result of which can be dramatic conditions, especially at those times when one weather front is passing and another coming. Snow or frost produces interesting light, as they act like giant reflectors. They also simplify the landscape, hiding or reducing the impact of distracting elements.

SPRING

In early spring the sun remains low for a large part of the day, and the clarity of the light is still quite good. The landscape appears fresh and green, as new leaves and foliage appear, while mist is common on spring mornings after a cool, clear night. Mist adds a romantic atmosphere to scenes, and can help to simplify them. Shooting from high ground is a good approach, especially if trees and other features are visible through the mist, or the tops are rising above it. Rivers and lakes are also good places to go on a misty morning.

SUMMER

In many ways the light in summer is the least photogenic of the year. Clarity can be poor, and with the high sun creating harsh shadows, scenes can lack depth and texture. As the season progresses, the landscape looks progressively less fresh as things dry out. On the positive side, wild flowers can add colour and interest to the landscape, and if you get out early when the air is clearer and often more still, you can get good results.

AUTUMN

The quality of light in autumn – especially later in the season – is similar to spring and, like spring, it is often a season of misty mornings. The landscape appears less fresh, though, as leaves are turning colour and beginning to be shed from trees. To make the most of autumn colour, try shooting when there is low backlighting, with shadows racing towards the camera, or on a cloudy day when the light is diffused. A polarizing filter can do an excellent job of boosting colour saturation on autumn foliage, particularly with wet leaves. Showers are common, and if the weather forecast is for sunshine and showers, these are great days to head out with the camera, as the light from a clearing shower can be some of the most photogenic.

WEATHER

You will sometimes hear it said that there is no such thing as bad weather for photography, and that it is possible to create good images in all conditions. To some extent this is true, but there are some conditions that definitely make it easier to create pleasing and/or dramatic landscape photographs.

Some of the most dramatic light happens at times of transition; from one season to another, from night to day, from one weather system to another, and so on. These images can be extremely powerful, especially when combined with other transitional themes, such as the boundary between land and water. This is one of the reasons why landscape photographers favour changeable weather.

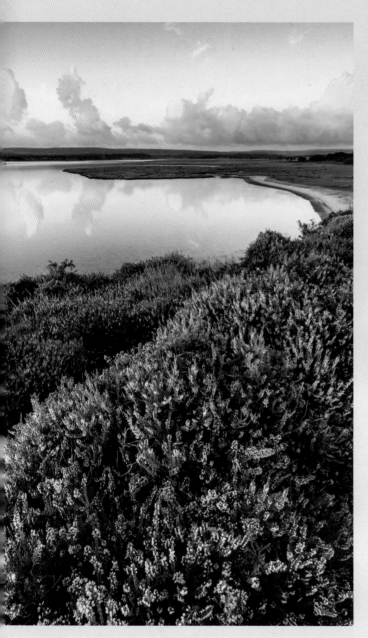

SUMMER COLOURS

The landscape doesn't always look its best in summer; foliage has lost its freshness and the light can be harsh and lack clarity. However, the colour provided by wild flowers can make up for this, especially towards the end of the season, when heather blooms, adding some much-needed vibrancy. The light is best first thing in the morning, when there is greater clarity, so an early start was needed for this shot. I knew that sidelighting would suit the scene best, as it would reveal the texture of the heather and add depth, so I looked for a composition that would work when lit from the side. As well as the texture in the foreground there are subtle lines leading into the frame, and the colour of the clouds complements the heather. The still water provides a perfect reflection of the sky, which spreads the colour a little further.

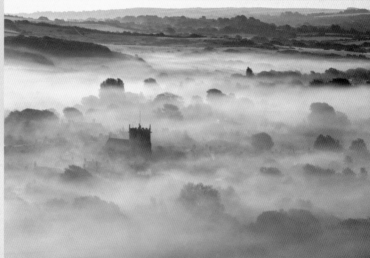

AUTUMN MIST

Misty mornings create an air of mystery and romance, as well as simplifying scenes. The most photogenic conditions are when a low-lying 'radiation fog' forms after a cool, still night, as in this shot. Although the fog was thick at ground level, I didn't have to climb too high to get above it to see the tops of the trees and the church tower rising above the mist. I composed the scene roughly according to the rule of thirds, with the church tower as the main focal point and the trees creating a layered look that stretched through to the background.

SHOOTING IN POOR LIGHT

'Poor' light does not necessarily mean low light, which is, in fact, very photogenic. Rather, it describes the quality of light: its clarity, colour temperature, intensity and 'modelling' properties. What we would consider to be poor for landscape photography might be hazy, flat, cold light that fails to highlight form and texture – the kind of light we might experience on a dull, overcast or drizzly day. While it is possible to create good images in this kind of light, strong composition now becomes an even more important element. Perhaps the only conditions when landscape photography becomes truly impossible are in very heavy rain or extreme wind.

Getting good results in adverse conditions comes down to a combination of choosing a suitable subject and taking the right approach. Compositions that rely on the interplay of light and shade to create depth and highlight texture won't work, so it's better to look for structural subjects that will work well with a bold, graphic approach. Coastal scenes are usually a good option. In particular, look for architectural features such as piers, lighthouses, groynes, harbour walls and so on, or natural features that have a strong structural feel to them, such as rock stacks. Inland, you will find that isolated trees, buildings, paths and drystone walls make good subjects.

These types of subject work well if you take a minimalist approach to composition, especially when this is combined with a long exposure that contrasts moving elements such as waves and clouds. In this instance, you will often find that compositions work better when there is more space around the subject than you might normally allow: this leaves space for the moving elements in the scene, and places attention on the texture of large areas of sky and water. Long exposures transform the look of water and textured skies, creating quite artistic effects. For this reason, extreme neutral density filters (see page 25) have become very popular as 'grey day' filters.

Minimalist long exposures often make good monochrome conversions, especially if they have been shot in flat, dull lighting conditions, as there is often little colour in the original scene to start with, and attention can be placed on shapes, tones and contrast.

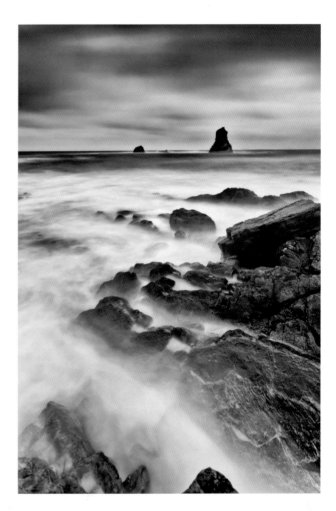

LONG EXPOSURE SEASCAPE
After an early start and a long walk in the dark, it was disappointing to be met by dull light and grey clouds. On the positive side, the sky was nicely textured and some big waves were washing around the rocks, creating the potential for capturing water movement and wave patterns. The rock stacks made a natural focal point in the background and I placed the larger one a third of the way into the frame. I didn't want the waves washing over the foreground rocks to be completely smoothed out, and felt that an exposure longer than 15–20 seconds would result in the white water losing its texture. To prevent this from happening I selected an ISO and aperture that allowed me to keep the exposure shorter than this.

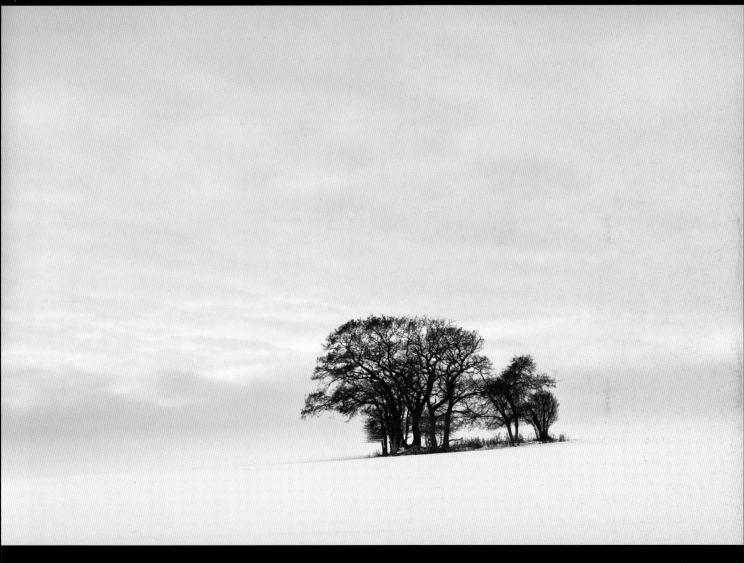

MINIMALIST SNOW SCENE

Snow isn't always naturally photogenic and looks it best on a sunny day or under a pastel pink dawn sky. Unfortunately, it's quite rare that we get to see it like this – more often than not, the sky above is flat and grey. I found myself drawn to this scene, with the small clump of trees on the brow of a hill, surrounded by fresh, unspoilt snow, but unfortunately, the sky above was grey and textureless. I framed the shot anyway, keeping the composition as simple as possible, originally with the intention of producing a high-key black and white image. A small break in the clouds drifted over the trees, however, with the result that there was just enough texture and subtle blue tone in the sky for it to work in colour. The contrasting textures of the snow

LOW-LIGHT PHOTOGRAPHY

Some of the most interesting lighting conditions occur long before sunrise and after sunset: the human eye may not be able to register colour or detail in the landscape at twilight, but digital sensors can. As camera technology has improved and the sensitivity of sensors has increased, so has the popularity of low-light photography. With the availability of clean images at high ISO settings, and without the exposure complications caused by reciprocity failure, digital photography has made low-light photography far more accessible than it was with film.

Even without direct light on the landscape, it's surprising how much modelling of shape and form occurs, but it's still worth concentrating on subjects that will reflect the colour and light in the sky – so coastal scenes, rivers, lakes and ponds are all good choices. Look for strong shapes to include as foreground interest, as these will often silhouette, and can look striking against a colourful sky.

Both pre-dawn and post-sunset are perfectly viable times for low-light images, but it's probably easier to work in the evening, as it's easier to calculate exposures in fading light than it is when it's getting brighter. Composition is also easier, as shots can be framed while it is still light enough to see properly. Remember though, a certain amount of pre-visualization is necessary, as what looks good in directional light may not work so well in twilight. The colour will usually be most intense at the point where the sun sets or rises, so plan compositions around this.

Exposure time is not really an issue, as long as you have a remote release and a sturdy tripod. Using your camera's 'Bulb' setting will allow you to lock the shutter open for as long as you need in order to get the correct exposure. However, long exposures can generate quite a bit of noise, usually in the form of 'hot' pixels that appear as bright red, green or blue dots in the image. To counter this, most cameras have a long exposure noise reduction setting, in which the camera takes a 'dark frame' of the same duration as the shot just taken, and uses the information to subtract the noise from the image. This works well, but effectively doubles the length of the exposure. For this reason, some photographers prefer to disable this feature and deal with the noise during post-processing.

If you need to reduce the exposure time for creative reasons (perhaps to reduce the amount of cloud movement, for example) then increasing ISO is an option. Camera manufacturers and some equipment reviewers make fairly extravagant claims about how high the ISO can be pushed before having a negative impact on image quality, but many modern cameras can produce acceptable images up to ISO 1600 or even ISO 3200, especially if good noise reduction software is used in post-processing. Exposing to the right (see page 37) will help keep noise levels to a minimum.

LOW-LIGHT COLOUR
Digital sensors are excellent at recording colour that the eye may not perceive. This image was taken in very low light, and while I could see the beginning of a pre-dawn glow on the horizon, the colour picked up by the camera was not all visible to the naked eye.

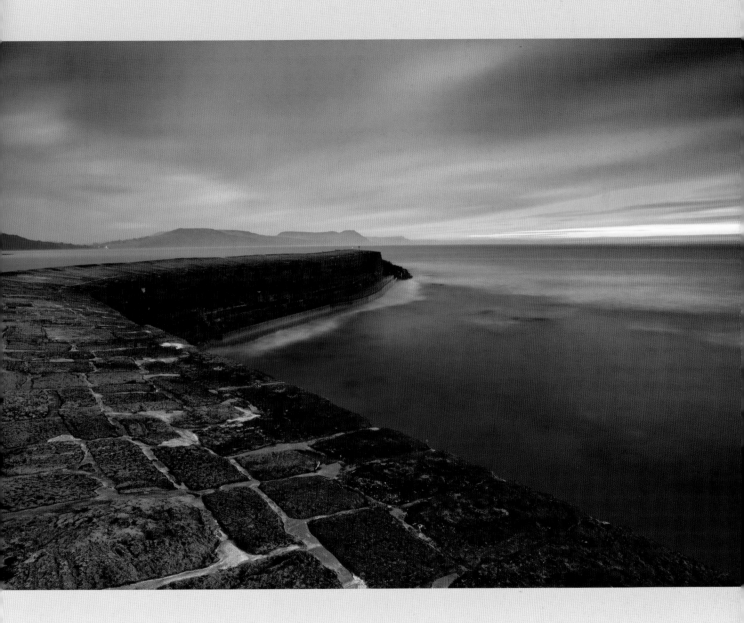

NIGHT PHOTOGRAPHY

A natural extension of low-light photography is night photography, and subjects such as the Milky Way and aurora borealis are becoming increasingly popular. Done well, the results can be stunning, but it demands excellent technique, as you will be pushing your equipment to its limits.

Perhaps the most important thing to remember is that good composition applies as much to night-time landscapes as any other – a photograph of the night sky, however dramatic, needs a well-composed landscape beneath it in order to be a successful image. Fast, wide-angle lenses, while not an absolute must, certainly make things simpler, as they make it easier to compose in darkness. Composition can still end up being a case of guesswork, though, so take a powerful torch with you to shine around the scene while framing your shot. A torch can also be shone as a source of light in the foreground, but take care not to overdo this: done subtly it can look like moonlight, but too much will appear unnatural.

Unless you are deliberately shooting star trails, exposures need to be kept reasonably short so that there is no star movement. The '300 rule' is a useful guideline for determining maximum exposure time – simply divide 300 by the focal length of your lens. For example, if shooting with a 20mm focal length, the longest exposure you can use without getting noticeable streaks is 15 seconds (300/20).

Having worked out the maximum exposure time, adjust the aperture and ISO so you can work within the limit, which usually means setting a high ISO and wide aperture. Because of the limited depth of field you will probably find that you need to focus at infinity to get the sky detail sharp, so the foreground may be out of focus. To get round this, try 'focus stacking' (page 154) or taking a second exposure with a wider aperture and blend the sky and land. If working at a particularly high ISO, a shot of the foreground at a lower ISO to blend with the sky can give good results.

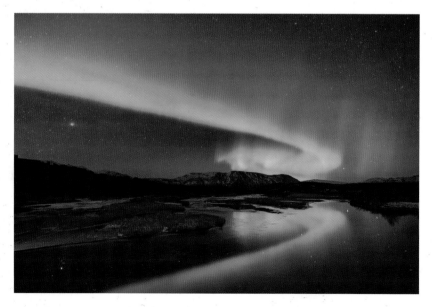

CURVED LIGHT
The aurora borealis is a spectacular sight, as seen in the image on the left, but on its own it may not make a great image. Composition is still important, although this presents obvious difficulties when working in the dark. This image was framed so that the lights curved into the frame from the left, leading to the background focal point of the mountain. The reflections in the foreground make the most of the colour.

CONVERGING LINES
With a largely featureless landscape, as seen opposite, the best option for a strong composition in this instance was to use the converging lines of the road leading to a vanishing point. The main challenge with setting this up in near darkness was to make sure the shot was framed as symmetrically as possible.

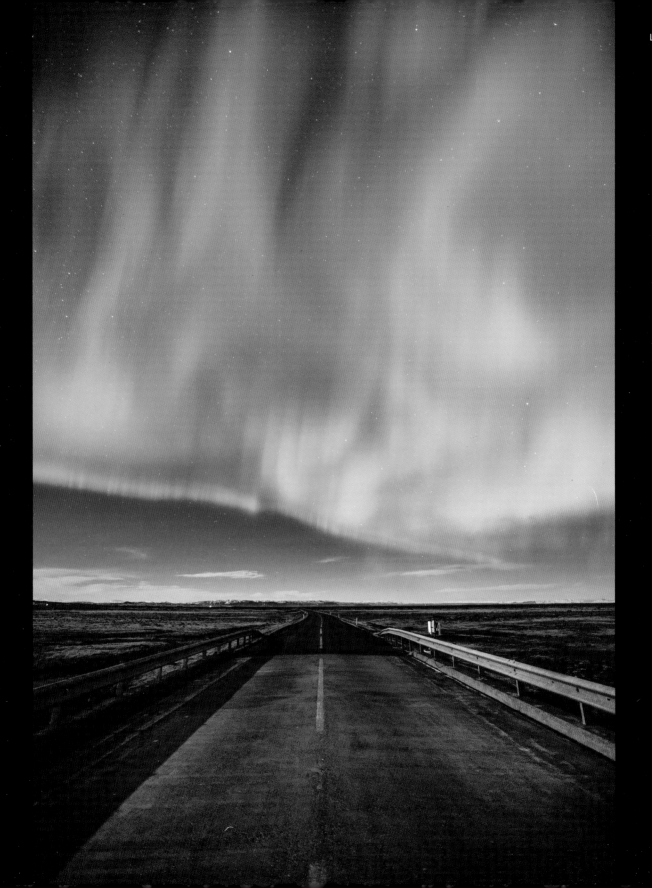

THINKING IN BLACK AND WHITE

It could be argued that the popularity – or even the existence – of black-and-white photography is very much a historical accident: if the colour process had been invented first, monochrome might never have been devised. As it is, black and white was established long before colour photography became practical, and even in the digital era it remains a popular choice – there are very few photographers who haven't taken at least a handful of monochrome images.

Part of the appeal of monochrome is that by stripping away colour the emphasis is placed on composition, form, tone and texture, allowing for a more artistic and less literal interpretation of the world. The ease with which it is now possible to create digital monochrome images, compared to the steep learning curve of the analogue process, has encouraged many more people to experiment with black and white in recent years.

However, although a basic monochrome conversion using software is a relatively straightforward undertaking (see page 160), it is still helpful for a photographer to learn the skill of 'seeing' in black and white; knowing which scenes and subjects will suit a monochrome approach and how to compose the image for maximum effect without colour.

There are many factors to consider when deciding whether a particular landscape will look good in black and white, and it's impossible to be definitive about what does and doesn't work.

Generally speaking, a strong, 'textured' sky is a good start, as this can add impact to the scene. Scenes with a full range of tones, from deep shadows to bright highlights also tend to convert well. Without colour in the scene, it can sometimes be difficult to achieve separation between key elements, so finding a viewpoint that enables this is essential, as is learning how colours translate to shades of grey – red and green can look very similar, for example.

Without colour to aid the composition, you need to pay attention to how shape, line, tonal contrast and texture work together in the frame. Graphic, structural subjects work well, such as steps, fences, paths, boats and so on. Perhaps even more importantly than with colour, keeping compositions as simple as possible, and reducing them to the essential elements, is often the way to go.

Even with practice, it's not always easy to know how well a scene is going to translate into black and white, but technology can help. Many modern cameras allow you to preview images in black and white, either on the Live View screen or in the electronic viewfinder. Even if this facility is not available to you, most cameras have a monochrome 'picture style', so you can shoot and then review the picture to see how well it works. If your camera has the facility to simulate different filter effects (red, green, orange, etc.) then experiment with these, as tones can be recorded quite differently depending on the filtration you use.

TIP: Even if you intend the final result to be in colour, it is sometimes worth setting your camera to preview the scene in monochrome, as this can help with composition. By removing the distraction of colour, your attention is forced onto the graphic elements in the scene, which can help you to produce a stronger image.

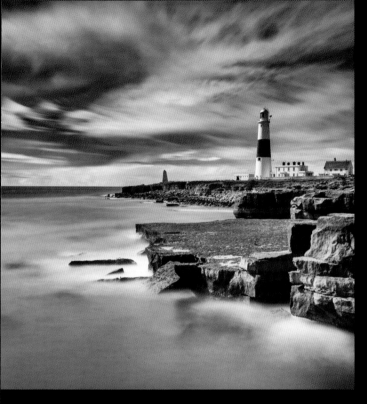

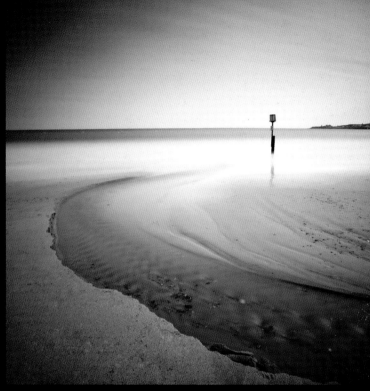

TEXTURED SKY

Monochrome can be effective in light that would normally be considered unflattering for landscape photography. There was strong directional light at the time this picture was taken, although it was on the harsh side. I chose black and white because of the strong, textured sky above the lighthouse. Subjects like this generally work well in mono, especially with plenty of space around them for moving elements such as clouds and water.

BAD WEATHER MONO

In dull weather, black and white is often the best option. For this shot, I wanted to keep the composition as simple as possible, so included just three elements in the frame: the outflow stream, the marker post and the headland in the background. The composition is based on shape, texture and contrast, with an extreme ND filter used to extend the exposure to smooth the texture of the water and simplify the scene. These filters are very popular with monochrome workers, and are often used for this purpose.

SILHOUETTES

Silhouettes are more common in photography than other art forms, largely due to the limitations of the film or sensor's dynamic range (in order to preserve the highlights in strongly backlit landscapes it is often necessary to underexpose the foreground). There are ways around this – by using ND graduated filters, for example, or blending two different exposures in post-processing – but depending on the nature of the scene, this is not always possible. In fact, it may not even be desirable, either, as silhouettes can be striking, especially against a colourful sunset or sunrise.

When considering a silhouette, it is best to look for easily identifiable shapes, such as trees, buildings and recognizable landmarks, to avoid confusing the viewer. A single, isolated subject is desirable, as again, there is less potential for confusion, and try to find objects with interesting shapes and lines, such as windswept trees. When composing a silhouette, it's worth asking yourself if somebody not present at the scene is likely to recognize what they are looking at and if not try and find something with a recognizable shape.

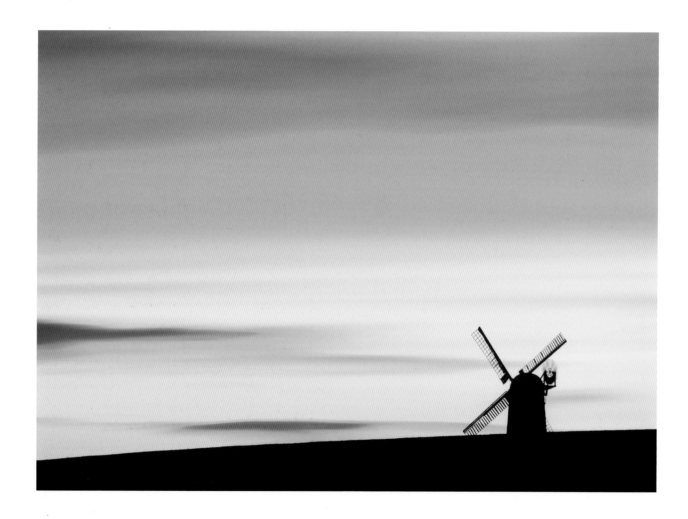

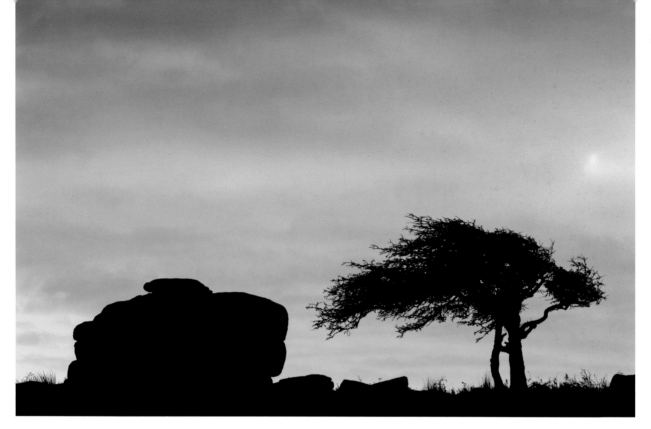

SILHOUETTED TREE

Having a recognizable shape is important with silhouetted subjects. On its own, the rock on the left would be a dark blob, and somewhat difficult to interpret. However, the windswept hawthorn on the right is instantly recognizable and gives coherence to the composition, so we understand the shape on the left must be a rock. It is, in fact, a granite tor, and those familiar with the landcape of the UK might well recognize the location as Dartmoor.

SILHOUETTED WINDMILL

With a colourful sunset sky and an uninspiring foreground, silhouetting the windmill seemed the obvious option. With so much interest in the sky it was possible to go for a bold composition and place the windmill low in the frame. The exposure was based on a spot meter reading taken from the sky, which gave a reading of around 18 seconds at f/11. I wanted a longer exposure, so the colourful clouds would streak across the frame, so fitted a 4-stop ND filter and used Bulb mode to make a 5-minute exposure.

Having chosen a suitable subject, the technique is relatively straightforward. Unlike most landscapes, where the aim is to balance the brightness difference between sky and foreground, for silhouettes you want to do the opposite. Therefore, it's best to avoid using graduated filters. The subject should be placed at a key point in the frame, such as on a third, and the horizon is best kept low in the frame. You will often find that a low viewpoint helps isolate the subject properly against the sky. There's no need to worry about distracting elements in the foreground, as it will be rendered almost completely black, with very little detail. Using manual exposure mode, take a meter reading from a bright part of the sky (but not with the sun in the frame) then recompose and take the shot.

The resulting image will have a correctly exposed sky, but the foreground and main subject will be heavily underexposed. You will certainly not get the 'perfect' histogram with this type of shot – the predominance of shadow tones will cause it to bunch up on the left, which for most images would indicate quite severe underexposure. However, in this case, the underexposure of a specific part of the scene is quite deliberate.

SPOT LIGHTING

Spot lighting is most commonly associated with the stage, being used to draw attention to a performer, but it does occur in the landscape in certain weather conditions and can be used to great effect. Appropriately enough, spot lighting in the landscape is rather theatrical and can add a sense of drama to a scene, as well as helping to increase the perception of depth.

Spot lighting works well in photography, as the eye is naturally drawn towards lighter areas of the image. Scenes that have an obvious, strong focal point work best, especially if the focal point is something structural, such as a building, a tree or distinct geological feature. In the case of buildings, they may be literally spot lit at night, and the contrast of artificial and ambient light can be very attractive. Such images are best shot in the evening, before it is completely dark, when there is still some light in the sky. At this time, the sky will be rendered a rich, dark blue and the colour of the building will depend on the type of lighting – sodium floodlights produce a warm, orange colour, for example. Your camera's automatic white balance is easily confused by this type of mixed lighting, so set the white balance to daylight or another preset value.

Under natural lighting, the chances that spot lighting will fall in exactly the right place in a scene are fairly remote, but you will increase your chances if you head out in the right weather conditions – days when sunshine and showers are predicted are ideal. Keep an eye on the movement of the clouds and try to anticipate when the sun is likely to break through – sometimes you can see a gap in the clouds moving towards the sun. When you do, set up a suitable composition and wait.

The technical difficulty here is that the camera's metering system is likely to take account of the dark areas around your subject and overexpose. Taking a spot meter reading from the spot lit area will prevent this, and as long as highlights are not clipped the exposure can be tweaked in post-processing to make the most of the lighting effect. It's important to keep an eye on the histogram and have the highlight alert set on the review screen.

This type of lighting is usually very fleeting, lasting a matter of seconds. Sometimes there is only the opportunity to expose a single frame, so anticipation is key. Be well set up in advance, with your composition fine-tuned and all cameras controls set ready to shoot.

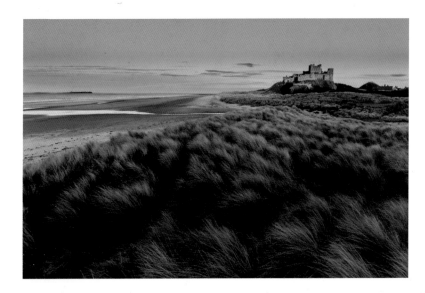

CASTLE AT SUNSET
This is a naturally beautiful view, with the grassy dunes making up the foreground and the castle overlooking the beach in the background. I found a spot where a path through the grass led into the frame, but the composition was a fairly simple matter: what it needed was the right light. I'd hoped for a dramatic sky, but there were few clouds above the castle, and a fairly thick bank of cloud behind me, blocking the sun. However, as the sun reached the horizon, it shone through a break in the clouds for a short time, casting a warm glow on the castle, while leaving most of the rest of the scene in shadow.

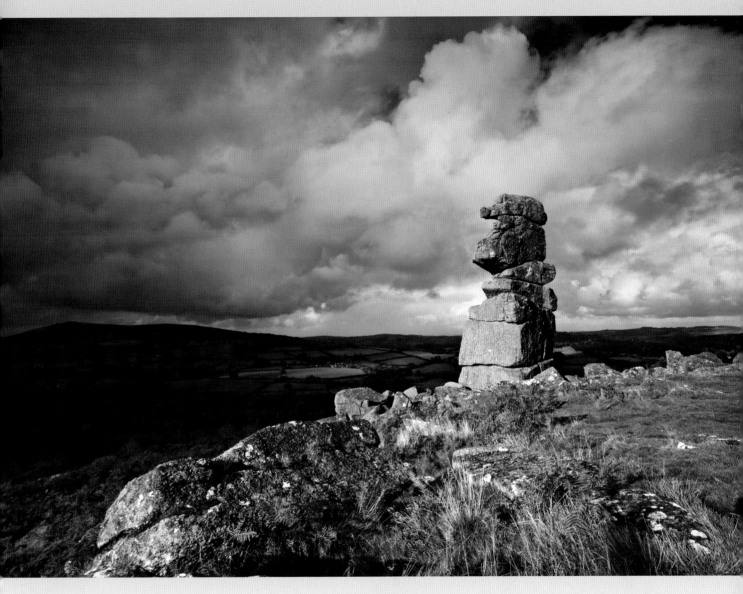

SPOTLIT ROCKS

Geological features, such as this granite tor, are well suited to spot lighting. Without it, this scene would look pleasant enough, but it would lack the drama and depth that such lighting brings. It was a day of heavy showers, interspersed with sunny spells, so I anticipated there was a chance of the rocks being spot lit when a shower passed. It was a case of setting up and then waiting to see if the anticipated light arrived. The shot was composed so that the rocks at the bottom of the frame lead in to the shot and point towards the tor. At times like this, when it is likely to rain while you're waiting for the light, a rain sleeve is a useful accessory for protecting the camera.

TYPES OF LANDSCAPE

There are many different types of landscape. In fact, you could argue that one of the biggest appeals of this 'art' is the huge diversity we encounter while out shooting. The coast, hills and mountains, woodland, lakes and moorland are among the most popular and photogenic types of landscape. In many ways, the general approach to shooting different environments can remain greatly unchanged: the core principles of composition and lighting can be applied to almost any viewpoint with success.

However, it is important to recognize that different landscape types have their own, individual qualities, which will present you with unique opportunities and challenges. Truly great images have the ability to properly communicate a location's character, mood and flavour. However, in order to do this, you first have to understand and appreciate your surroundings. You also need to know what ingredients to look for, and how best to 'tweak' your shooting technique to suit the scene. This chapter is designed to help you do exactly that.

THE ESSENCE OF A VIEW
Each type of landscape has its own individual qualities and appeal. Calm lochs and lakes can be tranquil; moorland and coastline is rugged; mountain views can be wild and dramatic. Our job, as landscape photographers, is to capture and convey the truth, essence, character and mood of the view before us – something you should be able to do by employing the skills you've gained from the previous chapters.

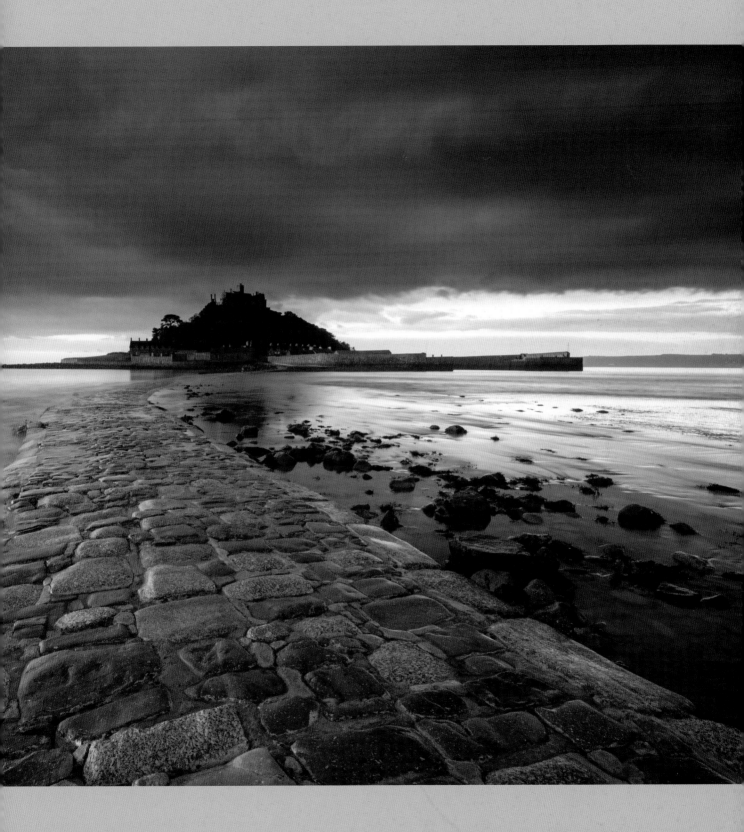

COASTAL CLIFF TOPS

For many photographers (your authors included) the coast is their favourite type of landscape. As humans, we tend to have a natural affinity with water, particularly to the sea. Throughout the seasons it is an exhilarating place to be – an ever-changing landscape, full of mood and motion. The coast can be wild and rugged, calm or tranquil, with big open spaces and great opportunities for creative thinking. The lure of shooting from sea level, close to the water's edge, is often so great that clifftop viewpoints can be overlooked. However, the elevated, far-reaching views that coastal cliff tops offer can provide some of the very best views for photography.

Shooting from coastal cliff tops is an exciting and contrasting alternative to taking photographs at sea level. There is normally safe and plentiful access to higher viewpoints, due to a good network of coast-paths. While clifftop views might involve more legwork (and often a steep climb), your reward will be breathtaking vistas along the adjacent coastline. Elevated viewpoints like this enable you to capture images with an enhanced feeling of scale and context – they are also the best option when excessive spray makes sea-level photography impractical.

When shooting from a clifftop vantage point, it is beneficial to have both wide-angle and telephoto lenses in your kit bag. A wide-angle zoom in the region of 17–35mm will typically prove an excellent choice when positioned above a vertical drop. By keeping the camera tilted slightly downward you will be able to capture the waves crashing on rocks below, together with the headland disappearing off into the horizon. A wide-angle will also allow you to exaggerate the scale and emphasis of foreground subjects. Naturally, foreground choice is important, but rocky outcrops, footpaths, walls and fences will all provide you with an entry point or 'lead-in' to your composition.

The time of year can play a pivotal role in the look of your coastal photographs. During spring and summer, headlands look lush and green, while many cliff tops are carpeted with flowers. Flora provides colour, interest and foreground matter for wider views, and clifftop views are typically at their best when wild flowers are blooming. A low and close composition – combined with a small aperture to generate sufficient depth of field – will enable you to incorporate coastal flowers into your compositions.

By contrast, during winter, an elevated clifftop viewpoint will allow you to capture fierce, angry seas and large waves crashing against headlands below. To capture this type of drama, a longer focal length is often best, as it will appear to 'stack' cliffs on top of one another. When shooting large, dramatic, crashing waves, prioritize a faster shutter speed – maybe in the region of 1/250 second. This freezes the water's motion. Alternatively, slow movement right down using an ND filter to generate an exposure of several seconds – long enough to render swirling and crashing waves as ethereal white trails in a mysterious, brooding sea.

TIP: Directional light is often important when shooting clifftop views, as it helps add contrast, definition and depth. Low morning or evening light will shape the coastline best, so consult a sun compass before planning your shoot.

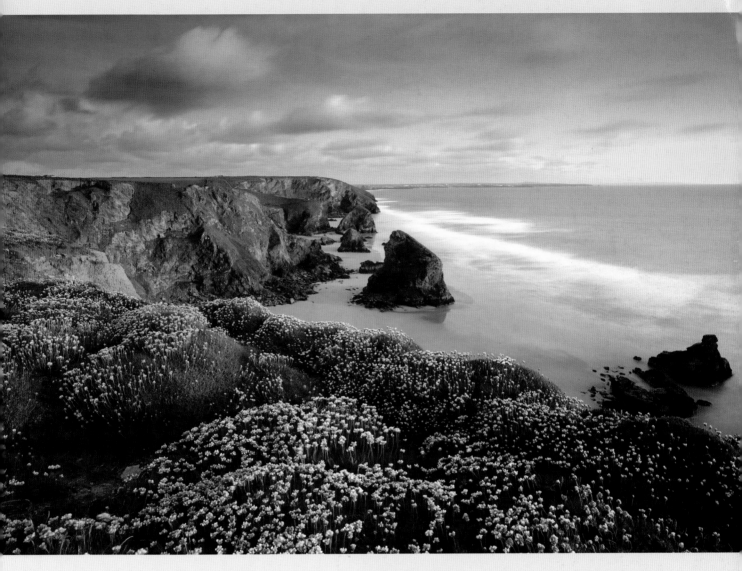

THE CLIFFTOP VIEW

When you photograph the coast, the lure of shooting from sea level is often overwhelming, but clifftop viewpoints mustn't be overlooked. They enable you to capture breathtaking and far-reaching vistas along miles of rugged coastline. Large rock stacks, breakwaters and lighthouses provide you with a focal point and scale, while seasonal changes can enhance images. Where I live, in South West England, the cliff tops are carpeted in thrift and vetch during early summer – perfect foreground interest in wider views. In this instance, soft evening light bathed the adjacent coastline and a low, close viewpoint allowed me to capture the flowers in context.

131

SHORELINE

Water can inject motion, depth, energy and life into landscape images, so the sea is understandably a favourite among photographers. In addition to the water's natural appeal, beaches are home to a wealth of photogenic subject matter, such as reflective pools, rocky outcrops, smooth boulders and wavy patterns in virgin sand. You can capture large, open views, or photograph the 'miniature' landscape by isolating key detail and interest.

PLANNING

The shoreline is a diverse and ever-changing landscape that can be interpreted in countless ways. Planning is important when photographing any type of landscape – you should always be aware of the weather, the direction of the light and the best viewpoint for any given location before visiting – but it is even more essential when shooting at sea level. The tide's height can transform a coastal scene; some locations work best at low tide, others at a mid or high tide. Ideally, visit beforehand, but if this isn't practical, do your homework online first.

A receding tide is normally preferable, as it will leave the beach clean of distracting marks and footprints. A rising tide will require you to regularly retreat and you are more likely to misjudge waves and get wet feet. Knowing tide times is also important from a safety aspect. It might sound obvious, but the coast can be a dangerous place – it is easy to get cut off by an incoming tide when you are engrossed with taking photos.

Always do a quick weather check before heading to the coast. Clear skies are usually best avoided – a degree of cloud will help add interest, depth and potentially drama to your photos. Check the wind direction and strength too. The wind is a big factor when taking photos at sea level. If the wind direction is directly from the sea, and its strength is 20mph (32kph) or more, the level of spray coating your lens will make close-to photography on the beach impossible – you will be better off staying away and looking for a clifftop viewpoint instead.

Traditionally, the most atmospheric seascapes tend to be captured using an exposure that blurs the water's movement. A sense of movement is a powerful visual tool when shooting seascapes, and smoothing out the water can create a feeling of calm.

Suitably slow shutter speeds can be generated by shooting in low light conditions and / or using ND filters. Due to the popularity of extreme ND filters, the current trend is to blur water motion almost beyond recognition with exposures that exceed 30 seconds. This technique can prove very striking, but often a shutter speed closer to 1 second is a better option. This is long enough to generate a level of subject blur, yet fast enough to retain detail and texture within the water. By triggering the shutter just as the water drags back toward the sea, you can capture the trails of water rushing around foreground objects, helping define their shape and adding interest. Getting just the right level of motion will involve a degree of trial and error, so experiment with your shutter speed and filtration.

Simplicity is often the key when shooting seascapes. There are instances when all you need to capture a compelling image is a slice of sand, sea and sky. Keep compositions clean and uncluttered. Pools, beach streams and wet sand will reflect the light and colour of the sky above, and provide you with understated foreground matter. Don't overlook manmade objects either – groynes, slipways, jetties and tide markers can all prove excellent compositional tools.

TIP: To ensure good stability when shooting on the beach, push the feet of your tripod firmly into the sand. Regularly check the front of your lens, or filters, for spray and keep a lens cloth close to hand. Clean your kit thoroughly after a visit to the beach and wash tripod legs with fresh water – salt water is corrosive.

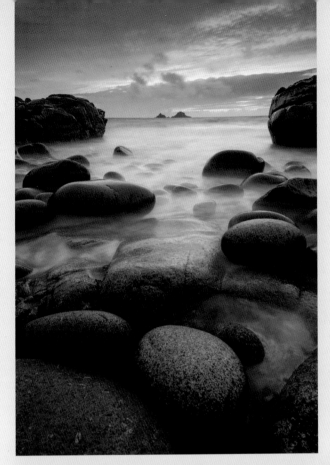

LOW VIEWPOINTS

Low viewpoints often work well for beach scenes, helping emphasize or exaggerate the shape or size of foreground rocks, pebbles or ripples in the sand. Water, wet sand and reflective rocks reflect the light above, so you can often continue shooting on the beach long after sunset, or before sunrise. Exposure times will naturally be lengthy at dawn and dusk, but this will help creatively blur the movement of the tide.

CAPTURING WATER TRAILS

Timing is important when photographing moving water. Wait for the waves to drag back towards the sea before triggering the shutter – by doing so you will capture water trails. An exposure in the region of 1 second is often ideal. Not only will the water trails define the shape of the objects they wash around, but they will also help draw the viewer's eye into the composition.

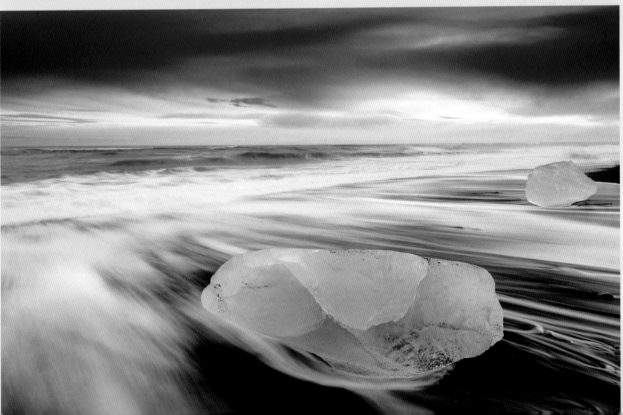

HILLS AND MOUNTAINS

Mountain peaks and large, imposing hills are among the most impressive and dramatic types of landscape you will ever photograph. Looking towards mountainous or hilly landscapes provides wonderful opportunities to capture breath-taking images, while climbing to a summit will reward you with outstanding, far-reaching views. There is no better environment for capturing images that convey a proper sense of size, isolation, wilderness or place than hills and mountains.

While the Rockies, Alps, Pyrenees and Dolomites might be among the best known and photogenic mountainous regions, there are countless more that offer equally good photo opportunities. With travel being so quick and easy today, truly remote, wild landscapes are now far more accessible to photographers. Photography workshops, led by professional guides, are an excellent and safe way to explore such areas.

Having reached your viewpoint, the key skill is to capture images that properly communicate the view's size – and convey a true feeling of awe. One compositional trick is to include elements of recognizable size within the frame, such as people, trees, a river or a building. This element only needs to be small within the frame, but including it will help provide a genuine sense of scale. Placing such elements low in the composition, with steep hills or mountains looming high above, will help generate a feeling of isolation. A vertical composition tends to further exaggerate the feeling of height, so can suit this type of environment.

The weather and lighting naturally have a significant impact on the look and mood of your images. At higher altitudes there is more UV radiation, which can result in a cool, bluish cast to images. You may need to fine-tune colour temperature – either in-camera or during processing – to neutralize this. Sidelighting will emphasize contours, texture and rugged detail.

Hills and mountains often exhibit their own peculiar weather conditions, while fog, low cloud and heavy rain can quickly affect visibility. Conditions can alter quickly, so don't give up too easily. One of the best times to visit high ground is during winter after snowfall. Snow needs to be photographed while fresh, clean and brilliant white. Look for shapes and patterns in the snow, created by fierce winds, and utilize these for foreground interest.

One final consideration is the effectiveness of using graduated ND filters to reduce the level of contrast between sky and land. Using a 'hard' grad when photographing uneven skylines, such as views of mountain peaks, will artificially darken the hilltops too. A 'soft' ND grad will help disguise the use of the filter, but exposure blending (see page 158) is usually a better option.

SAFETY

Many of the world's best viewpoints involve a long, steep climb. Appropriate clothing and footwear is essential if you intend to photograph remote areas or shoot at altitude. Capturing the best light will typically involve waiting for long periods, so if you're not warm, dry and comfortable, you are far less likely to be creative or patient. If you are walking any distance, it is best to be accompanied and tell somebody where you are heading. The weather can quickly and inexplicably change, so you need to be prepared: carry a detailed map of the area, along with a compass or navigational aid, such as a handheld GPS unit. In addition to your standard camera kit and tripod, carry a phone, head torch and high-energy snack bars.

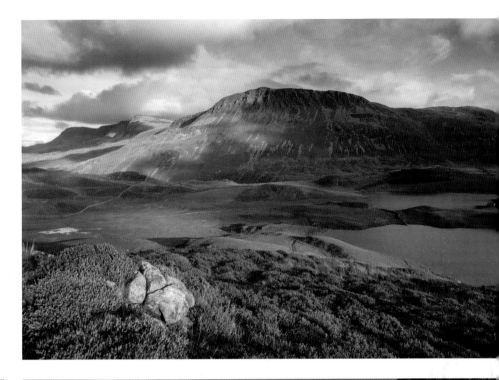

LIGHT AND DARK CONTRAST

The play of light can be magical among hills and mountains. It tends to fall less evenly, creating striking contrasts between light and dark regions, injecting depth and interest to wide-angle views. By including recognizable elements within your composition, such as walls, livestock, rivers and buildings, you can establish a feeling of scale and remoteness.

SAFETY AS A PRIORITY

After walking for over an hour in darkness, using a head torch to help guide me up the wet, muddy path, I reached this iconic viewpoint of 'The Old Man'. Warm, morning light bathed the landscape, and a light dusting of snow completed the scene. Appropriate clothing and footwear are essential to capture images like this. Invest in good outdoor clothing and always make safety your priority when photographing this type of remote landscape.

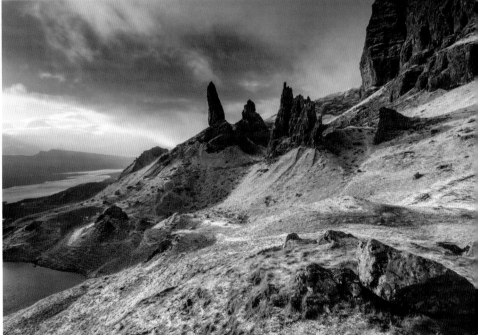

WOODLAND INTERIORS

Few types of landscape present more compositional challenges than woodland interiors. It is a truly chaotic environment, so finding compositions with balance, order and direction can prove tricky. Without forethought and care, woodland images can appear cluttered and lack focus – your choice of viewpoint and light will either make or break your photos.

The appearance of woodland interiors can vary greatly depending on the light's direction and time of year. Spring and autumn are typically the optimum time for woodland photography. During spring, leaves and foliage are fresh and vibrant, while swathes of wild flowers may carpet woodland floors, adding colour and obvious foreground interest to wider views. In autumn, foliage turns from green to a wonderful array of warm tones in one of nature's best spectacles.

Autumnal colours are typically only at their best for a short period, though, and this can vary from year to year and region to region. Therefore, it is important to plan your visit to coincide with the colours reaching their peak at the height of autumn – the window of opportunity is often short.

Regardless of when you photograph the woodland, light is key. While it might be less dramatic, one of the best light types is actually bright, but overcast weather. The level of contrast is low and manageable. As a result, the colour of foliage and woodland plants appears richer, and a polarizing filter will further help you to capture authentic colours. It is a good idea to avoid bright, overhead sunlight: while sun-dappled woodland floors might look attractive to the naked eye, the high level of contrast will typically exceed the camera's dynamic range. Highlights will burn out and results will appear to have huge contrasts and be ugly.

On the other hand, low morning or evening light can produce some of the best conditions for woodland photography. Beautifully diffused low sunlight, backlighting foliage and filtering between straight, thick trunks can create wonderfully atmospheric conditions. The long, inky shadows of trees, cast on the woodland floor, can provide strong, logical lead-in lines and implied depth.

Identifying the best viewpoint will often take time and consideration. You need to organize the elements in order to create a strong, logical composition. Paths, rivers, fallen trunks and stumps are an example of the type of things that you can base your composition around. Elements like this are often required in order to create a key focal point, not to mention a perception of depth and visual balance.

Longer focal lengths – in the region of 70–200mm – are often better suited to woodland photography than wide-angle lenses, as they allow you to isolate a smaller section of woodland, simplifying the scene to allow a more compact composition.

TIP: Be experimental with your approach. Low shooting angles or a fisheye perspective will distort and exaggerate a tree's height, making the woodland appear more imposing, while moving the camera during an exposure can create striking woodland abstracts.

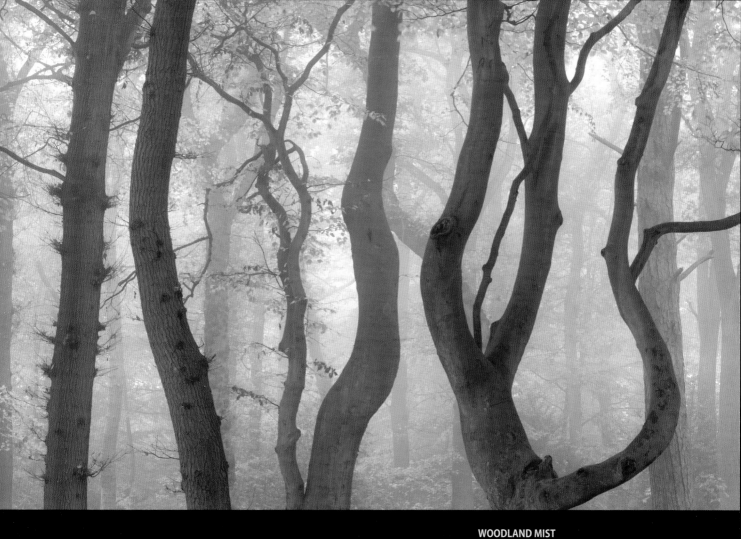

WOODLAND MIST
Diffused light often suits woodland interiors.
Trees can look particularly magical among
mist or fog: the conditions simplify the

RIVERS, STREAMS AND WATERFALLS

Water, in all its forms, plays a regular role in landscape photographs. Moving water is a particularly dynamic compositional element, with the ability to add energy and a three-dimensional feel to a two-dimensional image. Waterfalls are found most often in hilly and mountainous regions, while rivers and streams meander through valleys, woodland and open countryside. Each river, stream or waterfall tends to have its own character – something you, as the photographer, need to identify, utilize and emphasize in your photographs.

Rivers, streams and waterfalls are wonderful ingredients for adding shape, flow and movement to scenic photographs. The shape of a river or stream is particularly useful for directing the eye into, and through, the frame. Slightly elevated viewpoints – from a riverbank or bridge, for example – can prove effective when photographing rivers, as it will help you capture its shape, especially if it is snaking through the landscape or forming an attractive 'S' curve. The bend of a river tends to be a good place to position yourself, with curves proving pleasing to the eye.

Positioning the waterway so that it enters the frame from either the bottom left or right corner is particularly effective – corners are very significant parts of the frame from a compositional viewpoint. Placing the river or stream so that it starts or ends at a corner of the frame will not only help create an entry point, but it will also pull the viewer's eye into the shot toward a vanishing point. This will result in an enhanced feeling of depth within the landscape, and few other natural elements are as effective at doing this. Normally, it is best to avoid shooting across a river or stream – doing so can create rather static results that quickly direct the viewer's eye out of the image.

As with any type of movement within the landscape, how you decide to record the water's 'motion' will have a significant impact on the look of the final image. Faster shutter speeds will suspend motion and highlight the water's power and strength, while slower speeds will blur motion, producing more tranquil results. The type of scene, and your personal taste, will dictate your technique. Many photographers favour a shutter speed in the region of 1 second when photographing waterfalls or cascading rivers, as this is slow enough to create a visually interesting, attractive and intentional level of water motion, but still quick enough to retain the texture and energy of the water's movement. You may need to take a number of shots, using different shutter speeds, before you get just the degree of movement you desire, so be prepared to 'play'. By adjusting the ISO and using ND filters you can regulate the exposure time while still maintaining your chosen f/stop.

While elevated viewpoints might be best for highlighting the shape, length and course of a river, a lower, waterside perspective will produce more intimate and dynamic looking results. Take care when setting up close to deep, fast-flowing rivers, though, as they can be dangerous. Often wide-angle focal lengths work best, combined with getting close to the water's surface. While a low viewpoint will hide the river's shape and length, you can create the impression that the water is practically flowing into the lens, compelling the eye to follow it into the frame. Large or mossy boulders, jutting up through the water, create natural foreground interest, while frothy or swirling water can form interesting patterns.

TIP: Flowing water such as rivers, streams and waterfalls are often best photographed after rainfall, when the flow is more rapid and impressive. Mist can form over waterways after cool, still nights, adding mood and character to your shots.

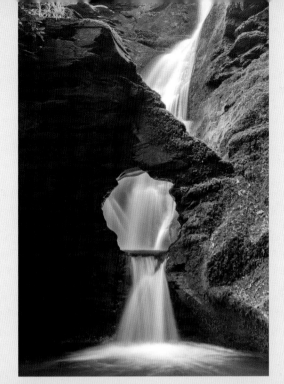

FRAME WATERFALLS

The largest, highest waterfalls might be impressive to the eye, but they often prove challenging to shoot well. They can be long and narrow, effectively dissecting images in two, and generating large areas of empty space unless you frame them carefully. Small, shorter waterfalls tend to photograph better, allowing tighter, stronger compositions. Unsurprisingly, shooting with the camera in a vertical orientation typically suits waterfalls best.

CAREFUL EXPOSURE

The exposure time will play an important role in the look of your river and waterfall images. In this instance, I wanted to creatively blur the river's rapid flow, but not so much that the water appeared overly smooth and milky and lost its texture and detail. In this instance, a shutter length of just over 1 second created just the look I was after.

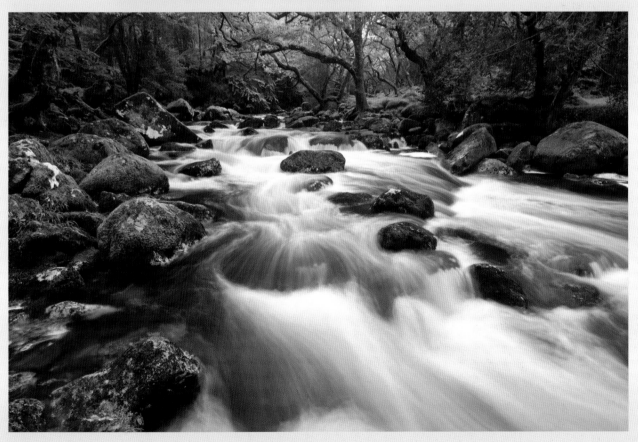

LAKES AND REFLECTIONS

Water is essential to life, which might just explain why we so enjoy the sight, sound and feel of it. It is perhaps no great surprise that water frequently plays a significant role in our landscape images. Large bodies of water, like lakes, lochs and flood plains, have particular appeal. When still, water has a calming effect that can greatly influence the atmosphere of our shots. Perfect, mirrorlike reflections add symmetry to compositions, and entice the eye. The enhanced feeling of tranquillity can add a unique quality to images.

Photographers are intuitively drawn to water and you rarely need to travel far to find it within the landscape. Ripples on the water's surface will break up reflections, so a still, windless day is best for photography. Calm conditions tend to be more common at dawn, while mist can form overnight and hang atmospherically over the water's surface. Large bodies of reflective water typically suit being the dominant compositional element. Mirror-like reflections are visually most striking when colour is evident: the natural cool blue hues found during twilight, or the warm pastel shades of sunrise and sunset, are ideally suited to taking photographs by the water's edge. Low shooting angles will often accentuate reflections, but simplicity is often key to creating a strong frame. We are so often told to adhere to the rule of thirds and avoid a centred horizon that it is easy to forget there are always exceptions to the rule. When photographing reflections, a centred horizon – with the same amount of subject as reflection – will produce symmetrical looking results, enhancing the strength and visual impact of the composition.

Foreground interest is certainly not a prerequisite when photographing this type of landscape, but when you need to add extra interest or scale to the reflected scenery, rushes, rowing boats and partly submerged rocks all work well as foreground elements. Jetties can be particularly useful compositional tools, and by positioning yourself either looking along a jetty, or from one side, you can use its length to lead the eye into the frame and towards the distant landscape.

Reflections can be 1- or 2-stops darker than the 'real' object, creating a visual imbalance. Therefore, you will either need to apply filtration, or make adjustments during processing. If opting for the filtration solution, align the transitional zone of your ND grad with the shoreline. Doing so should produce a balanced exposure and natural looking results.

REEDS AND REFLECTION
Without question, early morning is the best time of day to photograph water in the landscape. Conditions tend to be calmer, while mist can add a layer of visual interest and atmosphere. Although polarizing filters have the ability to eliminate reflections, they can also help intensify them by removing the sheen from the water's surface.

SYMMETRY

We can be so brainwashed into believing landscape images always require foreground interest to succeed that it is easy to include it just for the sake of it. However, when photographing a large body of reflective water, you can actually dilute the image's impact and mood by including unnecessary or unsuitable foreground elements. Simplicity is often the key to shooting this type of landscape, while a centred horizon will help generate a powerful feeling of symmetry.

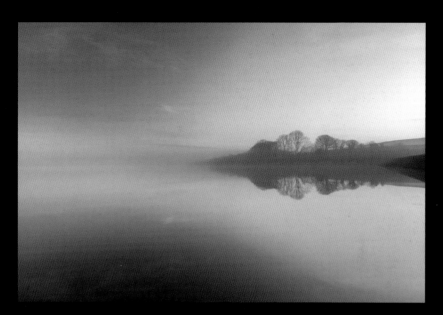

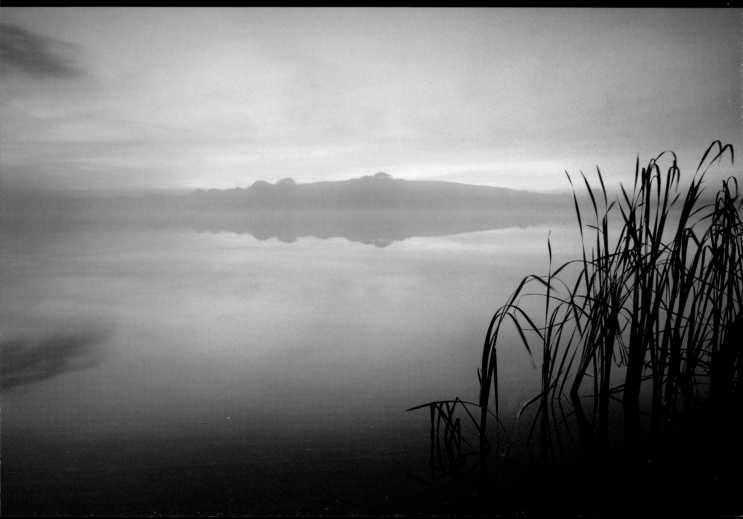

PEBBLE
The key to capturing exquisite detail and abstract compositions is the ability to previsualize. 'Seeing' the image is often the hardest task, and capturing it tends to be far less challenging – at least from a technical viewpoint. Training your eye to look at subjects more closely and creatively is not something you can do overnight, but with time and practice you will recognize how ordinary objects can be transformed when shot intimately.

THE MINIATURE LANDSCAPE

Landscape photography isn't simply about recording large, wide views. There is no rulebook stating we have to capture a sense of place or context in our pictures. Photographers such as David Ward – renowned for his eye for shape, form and graphic simplicity – have helped popularize the term 'the miniature landscape'. This photographic style involves taking a more intimate look at detail found within the landscape, by swapping wide-angle focal lengths for short telephoto or macro lenses that can emphasize texture, shape and form.

There is no better provider of intriguing and fascinating detail than nature. 'Big landscapes' are understandably seductive, but do not overlook the many and varied photo opportunities found beneath your feet. Using a short telephoto lens allows you to capture a much narrower perspective and in doing so isolate and highlight colour, texture, rhythm, symmetry, shape and form in exquisite detail. Arguably, raw technique is less important than the skill and vision to 'see' the image in the first instance.

The coast is among the best environments to depict the miniature landscape. Ripples in the sand, shells, pebbles, rock strata, seaweed and even driftwood are the type of subject that neatly lends itself to being explored in greater detail and clarity. Woodland is another great place to seek out more intimate, abstract results. Study your subject closely, and look for points of interest that you can utilize to aid composition and direct the eye to your focal point. You will find repetitive shapes, curves, rough texture, and diagonal lines are hugely photogenic.

Normally, a camera records a subject with a high degree of realism. However, an object grows increasingly abstracted the closer you get to it, which is why – when shooting texture, shape and form – the subject itself is often less significant. Your images don't have to render the subject recognizable – when shooting the 'miniature landscape', form is primary; content is irrelevant.

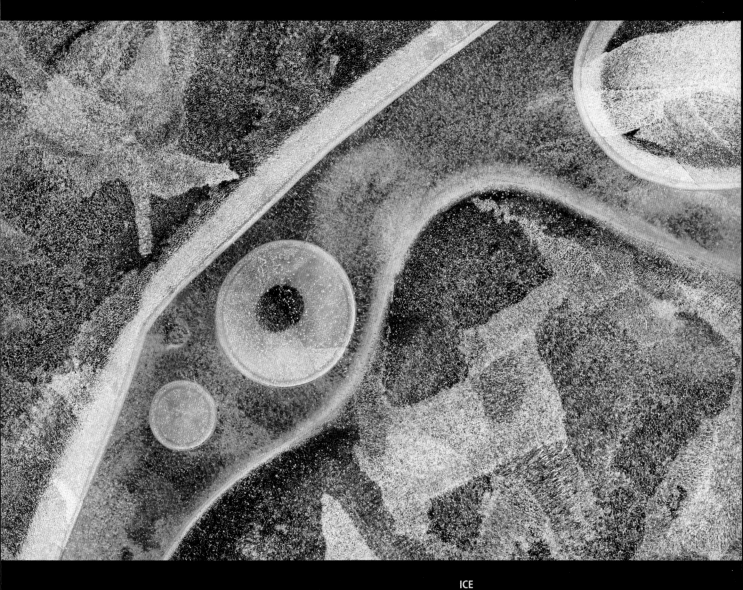

ICE
Seasonal changes create fresh and unique
opportunities for intimate landscapes. Freezing

▶ CHAPTER EIGHT > **PROCESSING**

Processing is an incredibly important part of the digital workflow, which is comparable to darkroom work in black-and-white film photography. In fact, digital photography gives colour photographers a level of control that was once the preserve of highly skilled black and white printers (and possibly an even greater level of control than that), so its significance should not be underestimated.

Some photographers feel that carrying out any processing work is somehow 'cheating', and that if you 'get it right in camera' it shouldn't be necessary to edit the image any further. However, this is missing the point of processing, as 'getting it right in camera' and editing images in software packages such as Adobe Lightroom or Photoshop are not mutually exclusive – they play an equally important role in achieving a good result. They go hand in hand, in much the same way as skill behind the camera and skill in the darkroom do with black-and-white film photography. For this reason, many photographers consider the Raw file recorded by the camera to be a 'digital negative'.

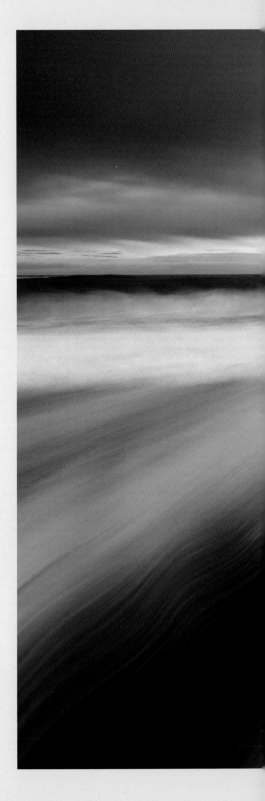

ICE BEACH
The image-making process does not end when the shutter fires. This image of a beach in Iceland, strewn with blocks of ice, was shot in Raw and several adjustments were made to the image before it was ready for publication. These mainly involved local contrast and brightness adjustments to help make the ice stand out from its surroundings. Despite this, the final image remains faithful to the scene at the time, and to how the end result was previsualized.

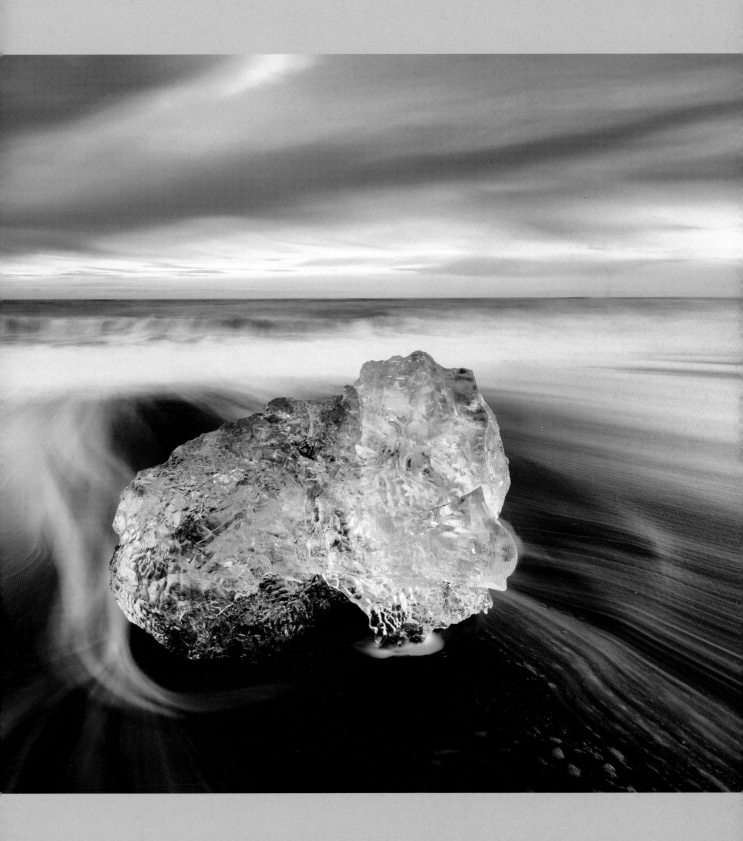

SOFTWARE

Post-processing is an essential part of digital photography, but it would be impossible without the right software. There is a wide array of applications available, ranging from free programs to those costing considerable sums. The industry standard applications for Raw processing and image enhancement are Adobe Photoshop, Adobe Lightroom, Apple Aperture and Phase One Capture One, but there are good alternatives, as well as excellent plug-ins that can be used to expand the capabilities of your processing software.

ADOBE LIGHTROOM

Lightroom is a highly versatile program, designed specifically for photographers. As such, it has impressive Raw processing capabilities. Other than the ability to work with layers, there is very little that Lightroom doesn't offer. It is so well specified that many photographers work almost exclusively with it, rarely making the trip to Photoshop.

As well as high quality Raw processing, Lightroom also has an excellent Library module where you can organize and keyword images; a Print module that includes soft-proofing, versatile page layout facilities and effective output sharpening presets; and a Book module from which you can create, design and order photo books.

ADOBE LIGHTROOM
From within Lightroom, it is possible to organize, keyword and search for pictures, as well as produce high quality Raw conversions, photo books and prints. For some photographers that's everything they need.

ADOBE PHOTOSHOP

Photoshop is probably the world's best-known graphics program, and photographers have used it since the beginning of digital photography. It has its own Raw converter, Adobe Camera Raw, which utilizes the same processing engine as Lightroom, as well as having the same functions and features as Lightroom's Develop module. Photoshop goes beyond Lightroom's capabilities, however, with a number of other features. For photographers, the most important of these is arguably the ability to work with layers, which makes techniques such as exposure blending, focus stacking and stitching possible.

Since late 2013, Photoshop has only been available via a monthly subscription, which may not suit all users. However, Photoshop Elements is still available for a one-off payment. Although it is a cut-down version of Photoshop, it has an impressive feature set, including the facility to use layers. For many photographers, the combination of Lightroom and Photoshop Elements will cover pretty much everything they want to do.

APPLE APERTURE

Like Lightroom, Aperture combines Digital Asset Management (DAM) features with a wide range of image manipulation tools. Aperture is only available for Apple computers, but has proved very popular with Mac users, and produces high-quality Raw conversions.

CAPTURE ONE

Phase One's Capture One software has an excellent reputation for producing high quality conversions from Raw files and, like Aperture and Lightroom, it also includes DAM features. Local enhancements are possible, as is the ability to work with adjustment layers. It is available in two versions: the fully featured (and more expensive) Pro version and the Express version. Both are Mac or Windows compatible.

FREE ALTERNATIVES

Aside from the industry standard applications noted previously, there are other options, some of which are available for free. GIMP (or GNU Image Manipulation Program, to give it its full title) is an alternative to Photoshop that has many similar features, although some users find its interface somewhat unintuitive. RawTherapee is a non-destructive Raw editor with a comprehensive set of processing tools, including highlight detail recovery, and various methods of sharpening and noise reduction.

PLUG-INS

There is little you can't achieve in Lightroom and Photoshop, but it can take time to master the skills necessary for advanced image enhancement. Image-editing plug-ins can make this easier, by providing you with pre-programmed routines that can transform your images. One of the best known is the Nik Software Collection. There are various plug-ins in the suite, including Silver Efex Pro 2, which makes it easy to produce excellent monochrome conversions.

SILVER EFEX PRO 2
Silver Efex Pro 2 is the favourite software of many black and white enthusiasts, with high quality conversions and a number of film effects.

Many conversions simply involve choosing from one of the presets, but these can also be tweaked quite heavily, and the look of many popular films can be recreated. Silver Efex Pro 2 features Nik's U-Point technology, where 'Control Points' can be placed on the image, enabling you to make intelligent selections for local enhancement. Nik's Viveza plug-in uses the same control points for making local adjustments to colour images and there are also plug-ins for sharpening, noise reduction and HDR in the suite. Alien Skin is another company that produces powerful image-editing plug-ins, including Exposure, which allows you to simulate film effects, create custom colour effects and convert images to monochrome.

Pixel Genius also creates useful plug-ins for colour adjustment, film effects and creative sharpening, while for HDR images, Photomatix Pro is the first choice of many. For noise reduction, Noiseware and Neat Image are both well-respected solutions.

CROPPING

Cropping is perhaps the most basic step in processing, but it can have a profound effect on an image, altering the balance and mood of a picture and the prominence of the main subject in the frame. Cropping gives you the freedom to explore other compositional possibilities, although severe cropping may not be possible unless you are working with a very high resolution original. Therefore, it is important to frame the shot as precisely as possible when taking the image, but if in any doubt, it is better to frame slightly 'loosely' to allow for cropping later.

Cropping also frees you from being restricted to the 'native' aspect ratio of your camera, which may not necessarily suit all compositions. A 3:2 aspect ratio is the full frame standard, based on 35mm film, but less elongated formats, such as 5 x 4 and 6 x 7 (5:4 and 6:7) have been popular with landscape photographers who shoot film. Now, largely as a result of the Micro Four Thirds system cameras, the 4:3 ratio is becoming increasingly favoured. This slightly squarer format makes it easier to exploit foreground interest in landscapes without the need to switch to portrait format and it is more naturally suited to vertical orientation than the 3:2

ratio. The square format was a popular choice with roll-film users, partly because it can be cropped easily to a landscape or portrait orientation, but it also has unique compositional properties as well. A 1:1 aspect ratio is not always easy to work with, but it lends itself very much to symmetrical compositions.

Minimalist compositions also work well in a square frame, especially with the subject centred, or placed boldly towards an edge or corner. The square aspect ratio also encourages photographers to break away from the traditional 'rules' of composition and place horizons across the middle of the frame. With the resurgence of monochrome photography, and the trend for minimalist long exposures, the square format is becoming an increasingly popular option.

Of course, there is no reason for photographers to limit themselves to cropping images to 'standard' aspect ratios: photographs can be cropped to whatever format best suits the scene, although you will generally get better results if you frame the shot with a particular crop in mind, rather than simply relying on cropping as a means of tidying up a poor composition.

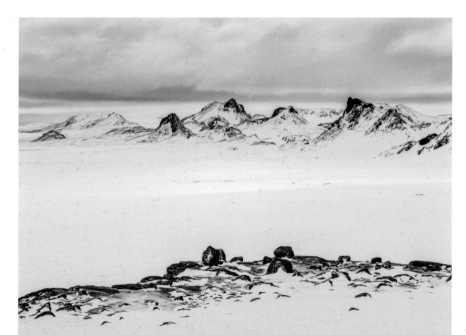

MOUNTAINS
I was drawn to this scene by the lighting conditions, which gave it the appearance of a pen and ink drawing. I sought out a viewpoint where the foreground rocks echoed the shape of the mountain range in the background, but found that it did not sit well within my camera's 3:2 format: detail at the edge of the frame took attention away from the peak at the right, and there was too much empty space at the left. Simply zooming in did not solve the problem, so I composed with a 4:3 crop in mind using the guidelines available on my camera's Live View screen.

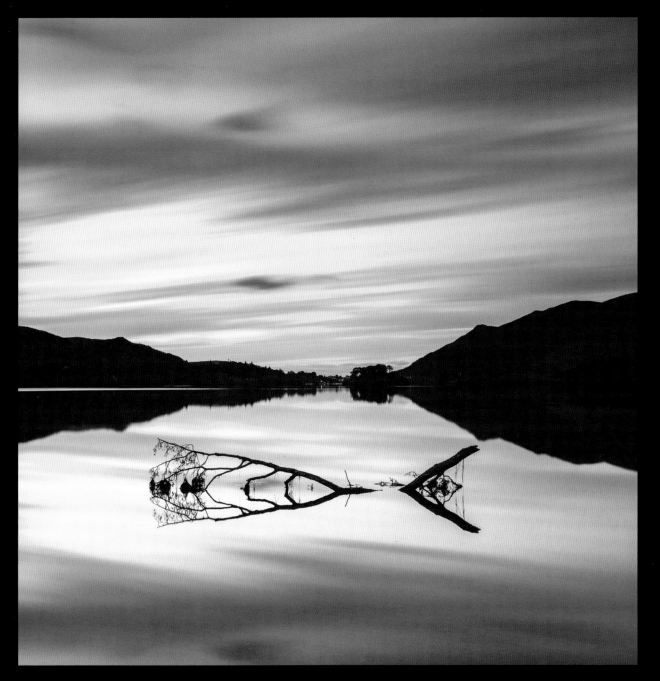

LAKE REFLECTIONS

Having too much interest stretching out at the sides of the frame would have diluted this bold, graphic composition, so it was framed with a square crop in mind. To keep the image as simple as possible, I opted for a long exposure to smooth out the ripples in the water and give the moving clouds a 'brush-stroke' quality. The camera height was important, as it was necessary to maintain visual separation between the tops of the foreground branch and the reflections of the hills above it.

CREATIVE SHARPENING

Sharpening is a necessary part of processing digital photographs. It works by increasing the contrast along edges in an image. The main controls available in most software packages are Radius, which controls the size of the edges affected, and Amount, which controls the overall strength of the sharpening. Threshold / Masking allows you to sharpen more prominent edges, while ignoring subtler edges, which can help to control noise that might otherwise be exaggerated by overly aggressive sharpening. Some applications also have a Detail slider that allows you to bias the sharpening towards fine detail, which is clearly useful for landscapes.

It's generally accepted that sharpening is a three-stage process. The first stage is 'capture sharpening', which is a small amount of sharpening that is applied (usually with a small radius) to offset the natural softness caused by the camera's anti-aliasing filter (if it has one), the demosaicing process and the lens. The precise amount will depend on your camera, lens and the individual picture.

The final stage, 'output sharpening', optimizes the image for output. The amount needed depends on the image size, the output device, the medium (glossy or matte paper, web use and so on) and the nature of the image itself. It can be hard to judge the exact amount on screen, but for those who print using Adobe Lightroom's Print Module, the default settings are very good.

Between theses two steps, lies 'creative sharpening', which involves sharpening specific areas of a photograph. With landscapes, it can be used to enhance fine detail in areas that contain foliage, for example, and to bring out the texture in large surfaces. Applying it selectively means that you can avoid over-sharpening areas such as skies, where noise might be revealed.

This step-by-step guide to sharpening uses Adobe Lightroom 5, but similar results can be obtained using any application that has comparable sharpening tools and the facility to use layer masks or a history brush.

1. *For this shot, it was important to reveal the detail and texture in the poppy field, but without making the sky too noisy or 'rough'. My starting point was the Sharpen/Scenic preset in Lightroom. To locate this preset go to the Develop Module, and you will see the Presets tab on the left under the Navigator pane. Sharpen/Scenic is found under Lightroom General Presets. This gives values of Amount – 40, Radius – 0.8, Detail – 35, and Masking – 0. In this instance, it gave a pretty good result, but to preserve the soft nature of the sky, I decided to add some masking. Holding down the Option key (Mac) or Alt key (Windows) shows where the mask is applied.*

TIP: If you are working with Photoshop rather than Lightroom, you can 'paint on' sharpening to specific areas of the image using layer masks. For the less experienced user, there are some useful plug-ins which will enable you to achieve the same result. Photokit Sharpener, by Pixel Genius, is one of the most popular.

2. *There are several areas that would benefit from some selective sharpening. As they may require different amounts, I decided to work on them individually, starting with the flowers in the foreground. As these are key parts of the composition, it was important to reveal as much detail as possible. I selected the adjustment brush from the tools palette underneath the histogram, and set it to a small size with a feathering amount of 55. With Auto Mask and Show Selected Mask Overlay checked, I painted on the selection.*

3. *I unchecked Show Selected Mask Overlay and experimented with the Sharpness settings: an Amount of +65 does a good job of bringing out the surface texture of the petals.*

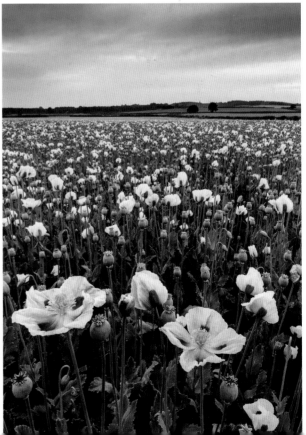

4. *I wanted to bring out detail at the far end of the field, so selected this area and set the sharpness Amount to +100. The effect is subtle, but reveals some texture in the background.*

LOCAL ENHANCEMENTS

There are various techniques you can use to guide the eye around the picture and highlight the main subject or focal point, many of which take place at the picture-taking stage. However, just as darkroom workers will dodge and burn to highlight some areas of an image and hide others, there are a number of tricks that can be applied during the processing of a digital image to achieve the same effect. The following step-by-step guide uses the tools available in Adobe Lightroom.

1. *This image was shot on an atmospheric, misty morning, but out of the camera it seemed pale and lacking in contrast. This is partly because the image was 'exposed to the right' (see page 37) to capture as much tonal information as possible, which is reflected in the histogram.*

2. *Basic processing steps include setting the white balance, black and white points and mid-tones. For this image, I didn't set the black point too aggressively, as this would have added too much contrast and made the misty scene look unnatural. The white balance was tweaked from the Daylight setting it was shot at, to cool the image down slightly and remove a magenta cast. This atmospheric shot still lacks 'punch' though: the sky is washed out and the main focal point, the trees rising from the mist, needs greater clarity.*

3. *I pulled a Graduated Filter down over the sky, feathering it a moderate amount so that it didn't interfere too obviously with the trees or the top of the hill (to do this you simply 'grab' one of the lines and pull it to adjust the amount of feathering). This mimics the effect of a soft-edged graduated filter. I then lowered the Exposure and Highlight sliders to darken the sky and reveal detail in the brighter areas.*

To add definition to the clouds I increased the Clarity and Contrast. These sorts of adjustments can often reveal noise in the sky, so it's worth checking for this and adding noise reduction to the filtered area if needed, although with this image, it proved unnecessary.

4. *With the sky improved, I wanted to increase the definition of the trees and the top of the hill. For this, I used the Radial filter tool (found on the tools palette underneath the histogram), drawing around the area I wanted to work on, then adjusting the shape of the filter by pulling on the squares at the outer edge. To adjust the orientation of the selection, hover the cursor over a line between the squares, then click and drag. By default, any adjustments will be applied outside the filter, so I clicked on Invert mask and set the Feathering to 65 so my adjustments would blend into the surrounding areas. I then increased the Clarity and Contrast and pulled down on the Shadows a little. These adjustments revealed a little noise, so I also added a touch of noise reduction.*

5. *The mist still looks slightly dull and grey, but this is easy to fix with a Graduated Filter and/or the Adjustment Brush. This time, I pulled a Graduated Filter up from the bottom of the picture, making sure it didn't affect the top of the hill, and then increased the exposure until the mist looked bright and clean.*

6. *This was a big improvement, but the mist at the left of the hill still looked a bit drab. The Graduated Filter wouldn't work here, so a manual selection using a mask was needed. I clicked on Show Selected Mask Overlay so I could see where I was applying the mask, and checked Auto Mask so Lightroom would find the edges of the hill, making applying the mask less painstaking.*

7. *I used a medium sized brush and set the Feathering to 100, and then painted over the area I wanted to work on. If at any point you paint over an area by mistake, you can undo the selection with the Eraser tool. I unchecked Show Selected Mask Overlay and increased the exposure to subtly brighten the area. Again, a touch of noise reduction was necessary, but beyond that it was just a case of tidying up – dust spotting and removing some distracting plane trails from the sky.*

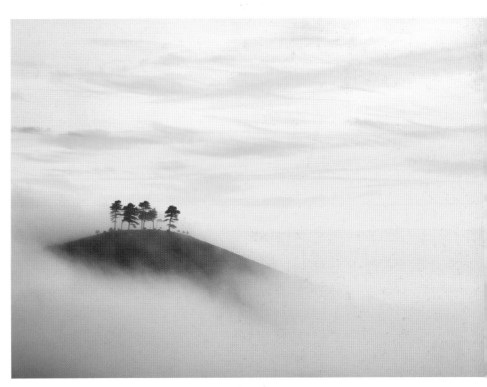

FOCUS STACKING

Sometimes, it isn't possible to get the depth of field you need for a particular shot without using a tilt-shift lens. However, tilt-shift lenses are beyond the financial reach of many photographers, they can be fiddly to use and they are not available for all systems. If this is the case, then another way of extending depth of field – which is achievable with any lens – is to use an image-blending technique called 'focus stacking'.

The principle is relatively straightforward: with your lens's aperture set at it's optical 'sweet spot' (usually around f/5.6 – f/8), you take a sequence of images, each focused at a different point in the scene, and then merge them in software. The result is an image that exhibits far greater depth of field than would be achieved in a single shot at the same aperture. The main problems when employing this technique are that the camera must stay in the same position during the sequence and there can be no movement in the scene that can change radically from one shot to the next, such as waves crashing on the shore. Cloud movement is less of an issue, because if necessary, a single shot of the sky can be added after the focus stacking sequence has been merged.

When you make your exposures you will need to focus manually and the number of pictures required will depend on the focal length you are using and your composition. The wider the lens and the further away the nearest object is, the fewer shots you will need. Often it is possible to focus stack with just three or four images, but it is better to err on the side of caution and shoot too many, rather than too few. When composing, allow a little extra space around the edges of the composition, as the sides of the final stacked image are often slightly blurred, so you may need to crop the image.

Having captured your sequence, you will need to blend the shots together in software. There are dedicated applications for focus stacking, such as the paid-for Helicon Focus and the free CombineZM, but it is also possible to carry out the process in Photoshop, which is what I did here.

1. Open Photoshop and click on File > Scripts > Load files into stack. In the dialogue box that appears, select your files and click OK. Keep the files in the order they were shot in.

2. The files will be opened with each image forming a layer. Select all of the layers and choose Edit > Auto-Align Layers from the main menu. In the dialogue box, click Auto and wait for the layers to be aligned.

3. Click Edit > Auto-Blend Layers. Check Stack Images in the following dialogue box and click OK. Photoshop will now take the sharply focused parts from each layer and blend them to produce an image with enhanced depth of field.

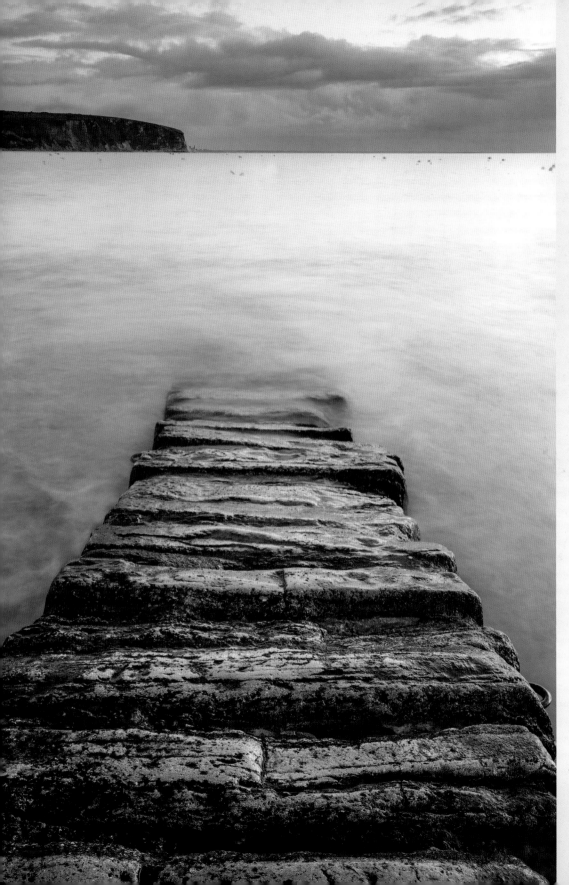

4. If necessary, crop the image to remove any blurred edges, and then flatten the layers and continue to make your usual image adjustments to contrast, colour balance, saturation and so on.

PANORAMIC STITCHING

The panoramic format has always been popular with photographers, largely because it replicates the way in which our eyes scan across a scene. A well-executed panoramic photograph probably gives a greater impression of actually being at the location than any other format. Compositionally, panoramas work differently to squarer aspect ratios, so look for scenes with strong horizontal planes that encourage the eye to travel across the frame. A strong focal point, such as a building, clump of trees or a hill, will help to break up the horizon and slow the eye down on its journey across the image.

Over the years, there have been a number of specialist panoramic film cameras, such as the Fuji 617, with its truly 'letterbox' format 6:17 aspect ratio. There are very few digital options, and those that exist are expensive. Cropping from a single frame to create a panorama is an option, but it requires an extremely high resolution file if you want to produce anything larger than a moderate sized print. Because of this, most photographers prefer to take a series of pictures across the scene and then stitch them together in software.

The key to successful stitching is aligning the pictures successfully. To prevent parallax error, the camera needs to rotate around the optical centre of its lens – the 'nodal point'. There are specialist panoramic tripod heads that allow this, but in practice, parallax error is only really a problem if there is foreground interest close to the camera. If you only make the occasional panorama, it is probably not worth investing in specialist equipment; just make sure you avoid close foreground interest in your compositions.

When shooting the sequence, you don't want any variations in the exposure, white balance and so on, between the frames. To prevent this, take meter readings from the whole scene, average them out and set exposure manually. White balance and focus should also be set manually, and polarizing filters should be avoided, as the effect will vary across the sequence. Use a spirit level to make sure that the camera is completely level, so that vertical lines don't converge and the horizon is perfectly straight.

Many photographers prefer to shoot stitched panoramas in portrait format, taking seven or eight images at a time. This not only reduces the amount of distortion and makes it easier to merge the pictures, but it also results in a higher resolution image when the shots are stitched together. However, in practice, many scenes will stitch together perfectly well from a horizontal sequence of three or four images, and the advantage of doing this is there's less chance of conditions changing from one image to the next.

Regardless of the camera's orientation, each frame in the sequence should overlap by about 25 per cent, as this will make them easier to line up. You should also shoot slightly wider than you think is necessary, to allow some margin for error when lining up the different frames, and to give yourself cropping options. Once you have made your exposure sequence you can stitch it together. There are dedicated stitching programs available for this, such as PTGui, which has some particular advantages, but for this step-by-step guide we'll be using Photoshop.

TIP: Getting the camera as level as possible is of paramount importance when shooting stitched panoramas. A geared head, such as the Manfrotto 410 Junior, will make precise levelling of the camera a much easier task.

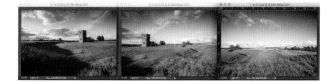

1. *After shooting, download your image sequence and make basic adjustments, ensuring that these adjustments are exactly the same on each image. This is what my individual images look like all lined up together.*

2. *Open Photoshop and choose File > Automate > Photomerge from the menu.*

3. *In the dialogue box that appears, choose your option for merging the images. In most instances, Auto will work well, but Cylindrical and Perspective are also effective; be prepared to experiment and see which works for you. Click on the Browse button, select your images and click OK.*

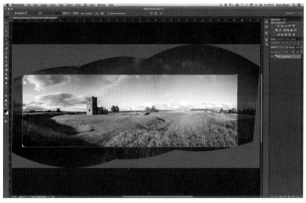

4. *It can take a little while for Photoshop to process the images, but when they are merged each one is automatically placed on its own layer. There will be some blank space around the edges, as you can see in this example. This is a result of the way the images have been lined up, so select the Crop tool from the Tools palette and crop the image to remove the blank space.*

5. *Flatten the layers and carry out final adjustments to colour balance, contrast, saturation and so on.*

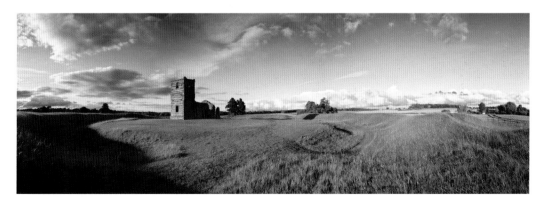

EXPOSURE BLENDING

With the ever-increasing dynamic range of digital sensors, capturing a full range of tones in a scene is becoming much easier. However, there are still plenty of occasions when the contrast range of a landscape exceeds the dynamic range of the sensor. In many cases, graduated ND filters will solve the problem, but there are occasions when this isn't possible – either the contrast is just too great, or an uneven horizon means that the transition line of the filter would be obvious in the image. In these situations, taking two or more shots of the same scene (usually one exposed for the sky and another for the foreground), and then blending them can be the answer.

It is possible to blend bracketed shots automatically, using software such as Photomatix Pro to create a High Dynamic Range (HDR) image, but you have far more control and can get better results by blending your images manually using layer masks. In this instance, we have used Photoshop for this exposure blending step by step.

1. *Open the images in your Raw converter. One should have an underexposed foreground (left), with full detail in the sky, while the other should be correctly exposed for the foreground, but with no or little sky detail (right). Process the first so that the sky looks correct, and the second so that the foreground looks good. It is best to do this by eye and ignore the histograms, as you will only be interested in a part of each image. When you have finished, convert the Raw images to TIFFs, and open them in Photoshop.*

2. *Click on the lighter of the two images. Select the Move tool from the Tools palette, and drag the lighter image over the darker one. Hold down the Shift key while dragging, to ensure that the two images line up precisely. The lighter image is added as a new layer in the Layers palette, on top of the darker image. Click on the Add Layer Mask icon at the bottom of the Layers palette to create a layer mask.*

3. *Select the sky using either the Polyganol lasso tool or the Magnetic lasso tool. Feather the selection heavily. In this example, I have feathered it by 250 pixels (as you can see in the dialog box).*

4. *Select the Brush tool from the Tools palette and set its Opacity to around 50 per cent. This will allow some control when painting in detail from the layer below. Next, choose a medium-sized, soft-edged brush. Set the foreground colour to black; this will allow you to brush away the top layer, revealing the darker layer beneath. Use multiple strokes to do this gradually. If you think you've overdone it at any point, change the foreground colour to white; this allows you to paint back the top layer.*

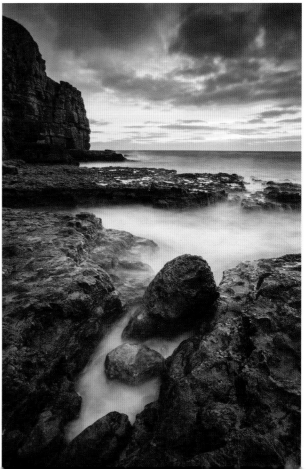

5. *You may find that you need to tidy up the edges of your selection – in this example, the tops of the cliff have gone a little too dark. To remedy this, deselect the sky, change the foreground colour to white and set the brush's Opacity to around 25 per cent. Gradually paint back the lighter top layer in areas that need it. You can then make final adjustments to the Levels, Curves, Saturation, etc. of the individual layers, and when you're satisfied, flatten the layers down.*

CONVERTING TO BLACK AND WHITE

Nearly all digital cameras have a monochrome mode, but even if you know the final image will be monochrome, it's better to shoot in colour (raw) and convert to black and white in post-processing. This retains the maximum level of flexibility, allowing you to carry out the same level of enhancement as you would have when printing a negative in a traditional darkroom.

There are dedicated programs for black and white conversion, including the excellent Silver Efex Pro 2 from Nik Software, but both Adobe Photoshop and Lightroom are capable of high quality mono conversion. In Lightroom's Develop Module, the 'Basic' panel on the right offers the option of black and white treatment. Scrolling down reveals the 'Black and White Mix' panel, where you can recreate the effects of colour filters (e.g. a red filter for darkening blue skies)

with great precision. Alternatively, in the left pane of the Develop module, there are also a number of presets which mimic the effects of colour filters.

For those who wish to go a little further than basic monochrome conversions, and enjoy the kind of control that darkroom workers have, it is possible to make local adjustments to exposure and contrast – the equivalent of darkroom 'dodging' and 'burning'. In Lightroom version 5 or newer, this can be done using the graduated filter tool, radial filter tool and adjustment brush, all located in the tools palette under the histogram on the right of the Develop Module. I've used Lightroom (version 5) to demonstrate this, as it works non-destructively on Raw files. Similar tools are available in many other Raw converters.

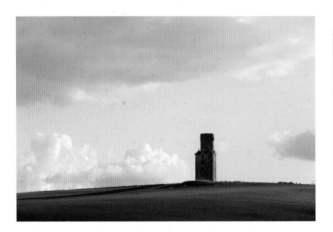

1. This is the original Raw file. The lighting is quite nice, and the sky has potential, but overall the shot lacks impact. A black and white conversion that adds contrast and burns in detail in the sky, could inject some much-needed drama.

2. There are several options for converting an image to black and white in Lightroom. You can click on Black and White in the Basic tools pane in the Develop module and then tweak tonal relationships using the Black and White Mix in the Hue, Saturation, Lightness tools pane; you can pull the Saturation down to -100; or you can try one of the B&W Presets in the panel at the left. It's worth experimenting with the presets, as they often provide you with an excellent starting point. In this case, I opted for B&W Look 5, which gives a nice punchy look to the tower and foreground, but leaves the sky a little washed out.

3. *I wanted to 'burn in' the sky a little more, so pulled a heavily feathered Graduated Filter down over the sky. I then reduced the Exposure, Highlights and Shadows, while boosting Contrast and Clarity. This makes the top part of the sky a lot more dramatic, but also darkens the top of the tower.*

4. *The darkened tower needs 'dodging' (lightening) so I painted a mask with the Adjustment Brush and increased Exposure and Shadows.*

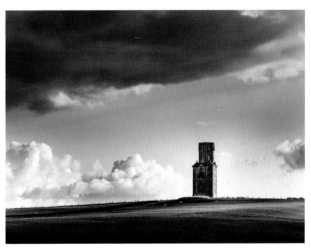

5. *This is already a huge improvement, but the sky looks a little unbalanced, and the clouds just above the horizon need more work. I selected the area using the Radial Filter and checked Invert Mask so that any adjustments would be applied inside the circle. I reduced the Exposure and Highlights, and then make a similar adjustment to the clouds at the other side of the tower. The black and white version is definitely an improvement over the original colour image, with a lot more impact.*

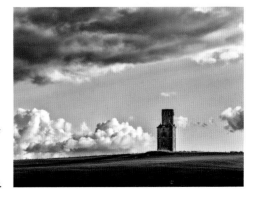

SILVER EFEX PRO 2

For comparison, I converted the same image using Nik Silver Efex Pro 2. The end result is as good as – and perhaps better than – my Lightroom conversion, and it took a fraction of the time; just some very minor adjustments to one of the presets. If you do a lot of black and white photography, then Silver Efex, which works as a plug-in for Lightroom, Photoshop, Photoshop Elements and Apple Aperture, could be a worthwhile investment.

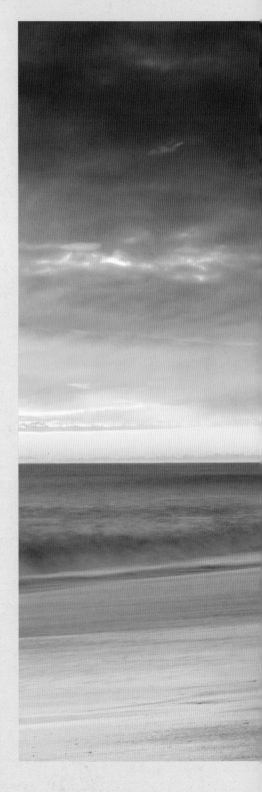

▶ CHAPTER NINE >
DEVELOPING A PERSONAL STYLE

Once you have mastered your equipment and have a good grounding in composition, you will probably want to create images that are recognizably yours; your own personal style. Establishing this is no easy task, as it depends on you developing a unique way of seeing the world and understanding what it is you want to express through your photography. A style should be identifiable and individual, the product of the many choices that you make in the process of creating a photograph. Whilst this will vary from one image to another, most photographers tend to favour certain types of lighting, viewpoint, angle of view and so on, which will help them put their own stamp on their images.

A personal style is not the same as a broad style, such as minimalism or Impressionism, but the chances are that your work will fit into one of these categories – familiarity with them will certainly help you to understand what is involved in forming your personal style. Therefore, we begin this chapter by examining some of the established landscape photography styles.

ICELANDIC SUNSET
This image bears many of the hallmarks of the author's personal style. Shot with extensive depth of field in dramatic light at the end of the day, a shutter speed of 5 seconds records movement in the water, adding texture to the foreground. The basic design of the image is straightforward, with strong diagonal lines leading through to the main focal point and a clean and uncluttered foreground. As far as possible, the shot was framed to position the shiny rocks to balance the large, reflective area of sand and sea on the left.

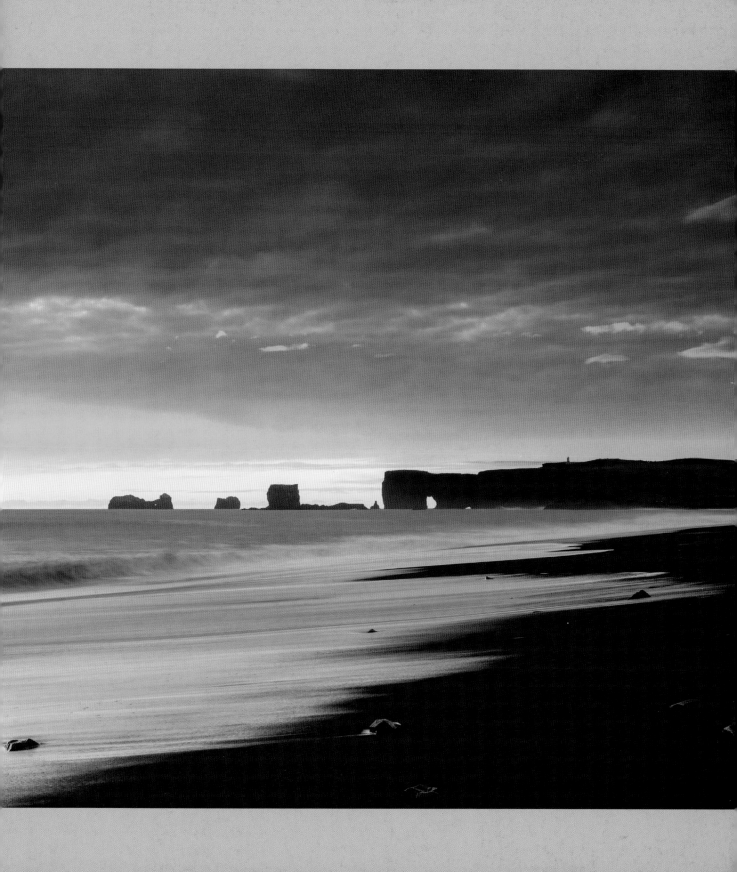

TRADITIONAL COMPOSITION

Most photographic styles have their roots in a traditional or classical style of composition, in which simplicity, order and regularity are emphasized. Many of the ideas discussed in this book are drawn from a traditional style, which is somewhat conservative and bases compositions around what we subconsciously find comfortable to view. The aims of traditional style are harmony, balance and a satisfying division of the image, often based around an established framework such as the rule of thirds or Golden Section.

This possibly makes a traditional style of composition sound rather dull and unchallenging, but it is arguable that it is more difficult for photography to push the boundaries than it is for the other visual arts. Photography is, after all, based in reality and does not always provide the opportunity for creative interpretation of a scene. This is particularly true of outdoor photography, where the framing or placement of the main subject may be forced upon the photographer by the available viewpoint and lighting. Furthermore, classical composition pervades in landscape photography, because the aim of the majority of landscape images is, naturally enough, to appeal to the viewer's sense of harmony and beauty rather than to challenge and disturb.

Perhaps the exceptions to this are with regards to focusing, camera movement and shutter speed, which all allow for more creative expression. A traditional style of landscape photography usually involves extensive depth of field and front-to-back sharpness, but in the right circumstances there is no reason not to choose a narrow depth of field. Intentional blurring of the subject or scene can give a photograph an impressionistic look, and the availability of extreme ND filters has encouraged many photographers to experiment with the creative effects of movement.

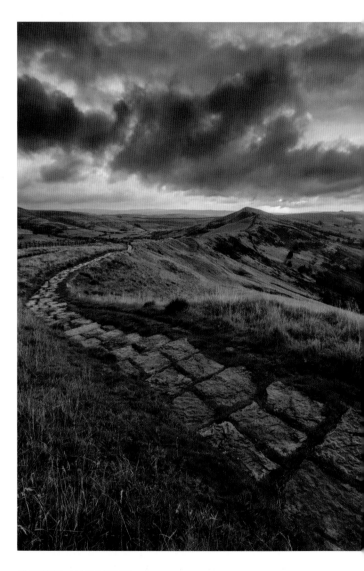

CLASSICAL COMPOSITION
This image exhibits many characteristics of a classical composition. It is a wide view, with extensive depth of field and strong linear perspective created by the dominant foreground, converging lines and texture gradient. The frame is divided according to the Golden Section, with a clear focal point – the sun rising behind the peak – placed very closely to an intersection on the Golden Section grid. It is shot in dramatic light at sunrise, with the darker foreground forcing attention through to the lighter parts of the frame, where the main interest lies.

An important sub-section of the traditional style (and arguably a genre in its own right) is the 'big foreground' landscape developed by large format landscape photographers, which combines strong foreground interest with exaggerated perspective and extensive depth of field. These landscapes are usually shot with dramatic lighting during the golden hours and the results are often striking. It's hardly surprising then, that many photographers have attempted to recreate this look.

Digital SLRs have made this technique accessible, as it's relatively easy to get close to a subject with small-format wide-angle lenses and get sufficient depth of field without the need for camera movements. With the high-resolution capabilities of current full-frame sensors, very large prints are now possible from digital cameras, meaning that the 'big foreground' look is no longer the preserve of those who shoot with large format film. For those who are really keen to make the most of this style, tilt-shift lenses can help you get the 'large format look' without compromising image quality by having to stop the lens down (see page 20).

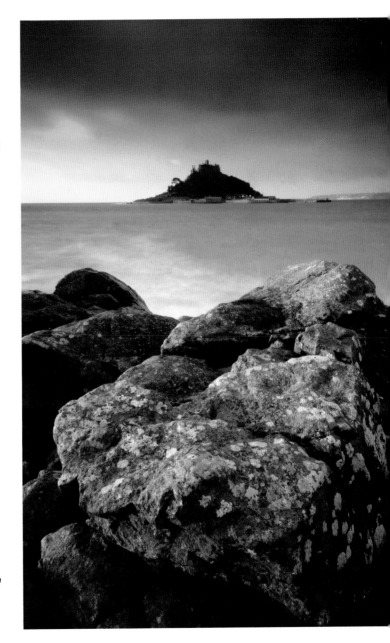

THE BIG FOREGROUND

The 'big foreground' has become something of a cliché in landscape photography, especially when big rocks are used as the foreground interest. However, when done well, this is still a perfectly valid technique. In this instance, it helps to provide an alternative view of a well-known landmark. This type of composition works best when its foreground complements the background and in this instance, the foreground rock was not chosen at random. As well as drawing the eye into the picture and helping to create perspective, it serves two other important purposes: it reduces the impact of the empty space in the middle distance, and the dip in the rocks provides a frame for the island and monastery in the background. The strong sidelighting adds depth to the background focal point and reveals texture in the foreground rocks.

MINIMALISM

Minimalism emerged in western art, architecture and design in the 1960s, although its origins are slightly earlier than that, in the reductive trends of the Modernist movement. The main thrust of minimalism is the belief that 'less is more' and it involves a stripping down of composition or design to its bare essentials, utilizing clean, simple lines and shapes, and placing an emphasis on 'negative space' (the space around and between the subject).

Simplicity is important in traditional composition, so minimalism could be viewed as an extension of that. It is also a natural progression for photography, as composing an image revolves around framing a scene to exclude what is unnecessary and distracting, paring down a potentially chaotic scene so that there is a sense of order in what remains.

THE MINIMAL LANDSCAPE

Minimalism is a relatively straightforward concept, but there is more to it than simply not having much in the frame. When applying it to landscape photography, there are a few things we need to consider. Your choice of subject is important. Geometric lines and shapes are important in minimalism, so look for subjects that lend themselves to this treatment. Many minimalist landscapes make use of man-made structures such as barns, jetties, groynes and so on, but there are options from the natural world as well – trees are one obvious example.

Long exposures are common (but not obligatory) in minimalist compositions, as they can help simplify a scene by smoothing out texture in the sky and water. Certain lighting and atmospheric conditions, such as mist and fog, have a similar effect.

Precise framing is clearly important, as it is with all composition. Identify the key elements and exclude all others. In a minimalist composition, negative space is as important as the main subject, so make sure it forms an interesting shape, with consistent tone and texture. Minimalist images tend to have a muted palette with little variation in colour and tone, so it's a useful approach to take in bad weather. Unsurprisingly, black and white features a lot in minimalist photography, with both high and low contrast approaches working well.

MINIMALIST SEASCAPE

Some scenes lend themselves strongly to a minimalist treatment, this empty beach being a case in point. With no obvious foreground interest and rather flat lighting under an overcast sky, the best thing to do was to work with the restricted range of tones and open space to create a minimalist composition. To simplify the scene, the background focal point – the large rock – was silhouetted, and an extreme ND filter was used to generate a 3-minute exposure. This smoothed out the texture in the water, so the sea merged with the wet reflective sand in the foreground. The clouds have moved towards the camera during the exposure, fanning out towards the corners of the frame, and this is reflected in the foreground, which creates interesting texture throughout the negative space.

MINIMALIST MONOCHROME

Black and white is a natural medium for minimalist images. With an empty beach and rain sweeping towards the shore, the temptation at the time of taking the picture was to leave the frame completely empty, but the deck chair helps to tell a better story. As well as providing foreground interest, its clean lines help to direct the eye into the negative space in the middle distance and background and its presence adds to the overall mood of the picture. The texture of the negative space is important, so a long exposure was used to blur the boundary between the sea and the shore and to help create the smooth layers of clouds in the sky.

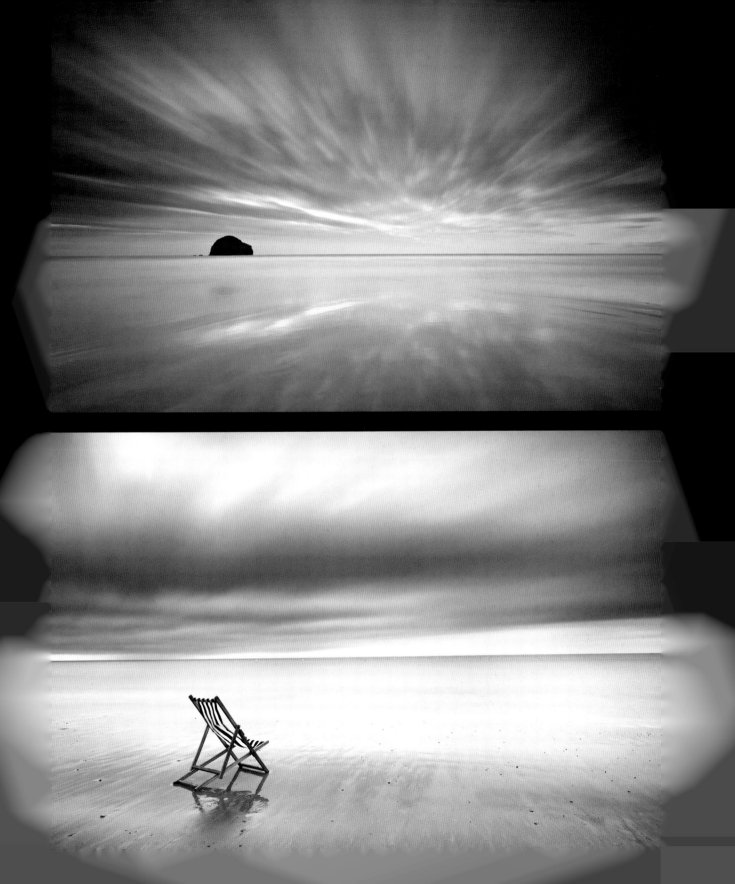

IMPRESSIONISM

The term 'Impressionism' was first coined in 1874 to describe the work of a group of artists, including Monet, Renoir, Pissarro and Degas, who were exhibiting in Paris. Although Impressionism is now one of the best-loved art movements, at the time the movement was not well-received by the conventional art community.

Impressionism is characterised by its use of pure, bright colours and the fact that it shows visual effects rather than the details of a scene. It is often concerned with movement and the changing quality of light over time, and the impressionist painters often worked with complementary colours to make colour appear richer. The intention was to convey the experience of how we first view a scene, perceiving a mass of colour and light rather than detail.

There are many aspects of Impressionism that should appeal to landscape photographers, such as the use of colour and light, although Impressionism has never really gained the popularity it might amongst landscape photographers. This is perhaps because many photographers see their craft as representational, so place greater importance on the rendering of fine detail. Nevertheless, there is no reason not to experiment with Impressionism, even if it is only occasionally. Impressionistic effects are easily achievable in post-processing, but for many this is regarded as 'cheating'. Therefore, in-camera effects are more commonly seen.

A technique that was popular with film photographers was to use fast, grainy film, often push-processed to enhance the grain, in combination with a soft-focus filter or diffuser to soften the image. This combination would reduce detail and give photographs a soft, dreamy quality, especially when shot in appropriate lighting.

However, manufacturers were intent on reducing the appearance of grain in their films and with the advent of digital, the range of films available has been severely reduced, with many of the grainy films no longer available. For digital shooters, the in-camera options are to use specialist lenses such as the Lens Baby, double exposures where one shot is in focus and the other defocused (the 'Orton effect') and intentional camera movement (see box).

IMPRESSIONIST LAKE SCENE
A combination of film stock and filtration has given this lakeside scene a painterly quality that emphasizes shape, form and colour, rather than detail.

INTENTIONAL CAMERA MOVEMENT

Intentional Camera Motion – or ICM – is a hugely subjective style of photography, so you will either love or hate the results. The idea is to move the camera during an exposure in order to creatively blur static subjects. The results are Impressionistic and eye-catching, with a painterly look that can convey mood and a sense of motion. It is a technique that is easy to replicate and any focal length can work. To capture ICM images, a shutter speed in the region of half a second is needed, but feel free to experiment with longer or shorter exposure times. Trigger the shutter and move the camera during exposure. You can either do this handheld or with a tripod, using a panning action to blur your subject. For smooth results, begin moving the camera before opening the shutter and continue panning until after it shuts again.

Different types of motion will yield varying results: vertical and horizontal movement is most popular, but moving the camera back and forth, panning diagonally and rotating the camera can also create striking ICM images. Moving the camera parallel to existing lines and edges within your composition will help emphasize them. You will find no two results will quite look the same – this is a real hit and miss technique. The final image will not closely resemble the subject itself, but instead it will be an abstract representation of it.

ICM
It is typically best to combine intentional camera movement with views containing strong shapes that will remain recognizable even when blurred – for example, woodland. Areas of strong colour, lines and contrast also suit this type of movement.

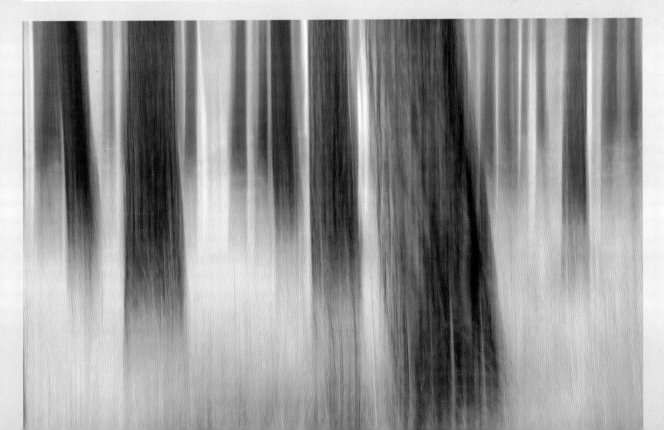

ABSTRACT

Traditional art aims to produce an illusion of reality, using perspective effects, among other devices. Abstract art, on the other hand, uses form, colour and line to create works that do not directly reference external reality. Similarly, abstract photography concentrates on shape, form, colour, pattern and texture, rather than a literal representation of the subject. This does not necessarily mean the subject has to be unrecognizable, just that it's not important for it to be identified: as with other abstract art, the aim of abstract photography is to engage the viewer emotionally rather than intellectually or logically.

Abstract composition, as with all landscape photography composition, is based around the art of subtraction. In this case, however, it is about removing clues to reality and reducing the image to the fundamentals of form, colour, texture and shape. In doing so, it will hopefully strengthen the viewer's emotional response.

However, it isn't always easy to achieve abstraction with landscape photography, as the starting point is the natural world; it can be very difficult not to compose scenes in a literal way. Focusing on details that the unaided eye can't perceive is one way to do it, as is choosing an unusual viewpoint (looking straight down on a section of landscape, for example). 'Miniature landscapes' and textural studies shot with macro lenses also make good sources for abstract imagery.

Executed badly, abstract photography becomes little more than a guessing game about what the subject is. To be successful, an abstract image needs to be composed as carefully as any other, with balance and harmony in mind, and all the usual rules of composition apply. When composing abstract shots, see if it's possible to divide the frame up according to the rule of thirds, Golden Section, Golden Spiral and so on. If there is a natural focal point, place this in a key area, as you would with any other composition. Look for lines and patterns in the subject; is there a natural 'flow' to the lines? Is it possible to use them to lead into the frame?

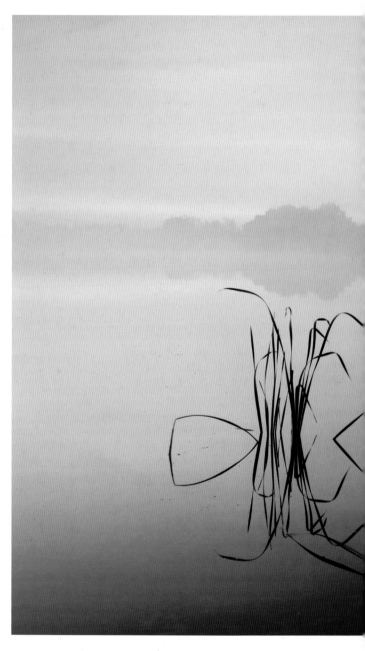

SEMI-ABSTRACT
The subject in this photograph is clearly recognizable as reeds on the shore of a lake or river. However, the treatment is somewhat abstract, as the reeds have been silhouetted. As there is no detail visible, the emphasis is placed very much on line and shape. A fairly tight crop also places attention far more on the tone and colour in the background. The result is that mood and emotion become more important than the subject.